Glynn 1998

Glorafilia
The Ultimate
Needlepoint
Collection

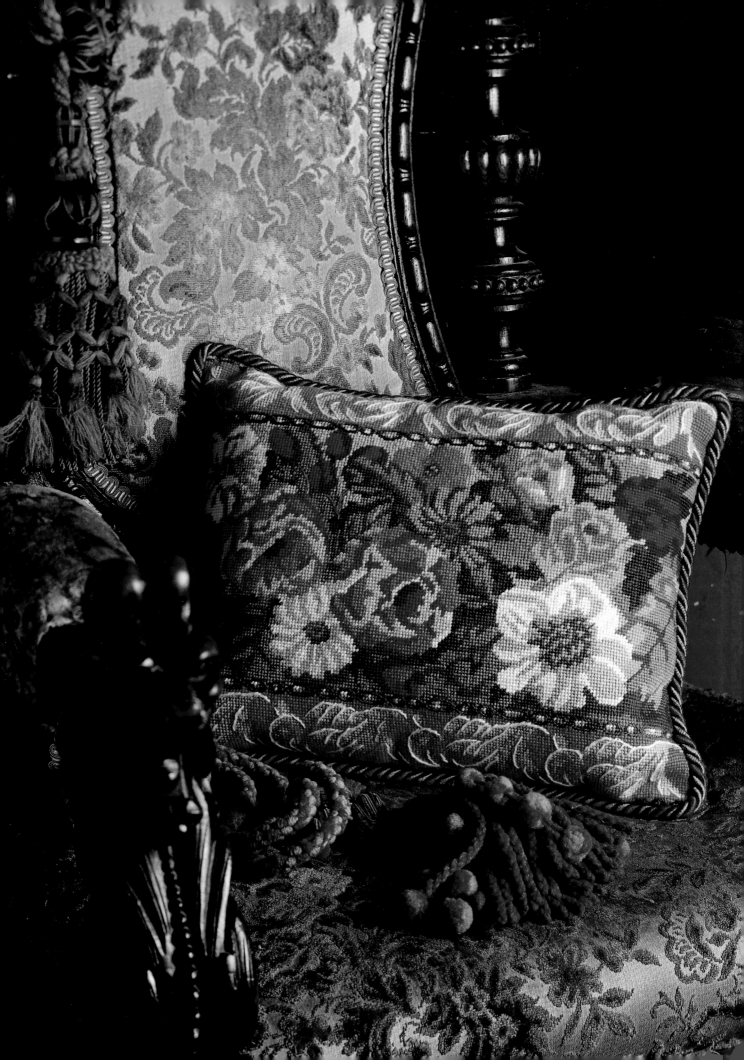

Glorafilia
The Ultimate Needlepoint Collection

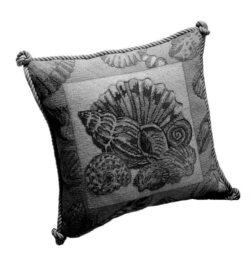

Carole Lazarus and Jennifer Berman

A Bulfinch Press Book
Little, Brown and Company
Boston New York Toronto London

We dedicate this book to each other and
Glorafilia's coming of age

First North American Edition

ISBN 0-8212-2330-5

Library of Congress Catalog Card Number 96-84779

Illustrations by Sally Holmes, except Koalas template (p.189)
by Stephen Dew.
Additional charts on pp. 121, 123, 124-5, 133, 142-3, 149, 152-3,
168-9, 172-5 and 180-1 colored by Raymond and Helena Turvey.

Bulfinch Press is an imprint and trademark of Little, Brown
and Company (Inc.)
Published simultaneously in Canada by Little, Brown &
Company (Canada) Limited

PRINTED IN ITALY

Contents

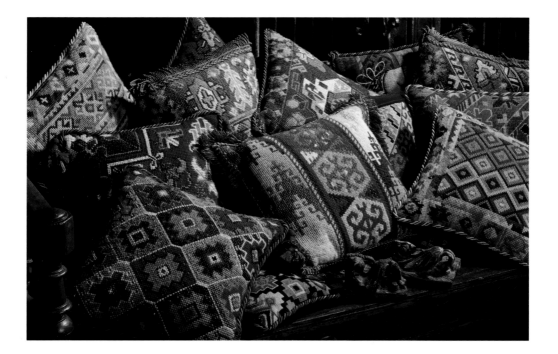

Introduction

THE OLD MILL HOUSE
*The Glorafilia shop houses the entire collection of
needlepoint kits, as well as gifts and antique accessories.*

Glorafilia sits on a hill, the Mill Field and Abbey rolling away to one side. Horses trot by, geese fly overhead; in summer we smoulder in our unshielded position, in winter the wind whips ice through our ancient window frames, and the shop looks like a little jewel in the surrounding grayness. We insulate, we fan, the building is Georgian and has a will of its own, permitting us to shore it up and hold its ricketed limbs in calipers, but little else. It is cranky and old, given to mood swings and the sulks, an appropriate home for its inmates.

Glorafilia has now come of age: 21 years old in 1996, longer than most marriages. A magazine feature writer once asked: 'how is it that these two women don't kill each other?', to which there are several answers, but an enigmatic smile will have to be enough. There is the zappy one who runs the business, and the dreamy one with the paintbrush and word processor. One dressed in Armani, the other in camouflage blankets. 'Ah, which are you?', customers ask, 'Are you Gloria?' In long marriages, those involved often grow more alike, and while we finish each other's sentences and supply forgotten details, on the whole we resist similarities. Our homes, our tastes are quite polarized, and this creates a dynamic that works very well. When one goes off on a tangent avenue of exploration, the road traffic control of the other appears, in the name of taste and commercialism.

We look back on photographs of ourselves when we began: unspectacled and sleek of jaw, and realize that no matter how many facial exercises are done while at traffic lights, nothing stops the attraction of gravity for flesh. Each year we promise ourselves that we'll have our eyelids fixed; each year the tax man takes priority. When we started Glorafilia as a flower display business in the sixties, we had wild hair, petals painted around our eyes and luminous pale lips. Happily, we have changed, and through all the different trends in fashion and furnishings, our needlepoint has changed with us, to encompass geometrics, Victoriana, gorgeous ethnic influences, designs both fragile and hectic, and a lot of nostalgia.

The Glorafilia collections
Since our first book in 1989, there have been three others: *The Venice Collection, The Impressionists in Needlepoint* and the (appropriately smaller) *Miniature Collection*. We have received so many touching, grati-

The Abundance of Fruit design (see pages 32-3), but this time stitched with a rich navy blue background.

fying letters by people moved to tears, particularly by our Venice book and the memories it evoked, usually with a partner no longer alive. We read them and weep and keep them all. Other letters that we receive fall into distinct categories, either panic: 'Dear Gloria, I dropped my needlepoint in the cat litter', or advice: 'Dear Mrs Filia, I have rose floral curtains, green and gold carpet and an apricot sofa, what can you recommend?' 'Dear Madam,' we'd like to reply, 'burn your curtains.' Dear Gory Phobia, Dear Jennifer and Carole, Dear Sirs...

This book is a continuation of the first one, and we hope has something for everyone, jumping as it does between themes that we return to again and again because they are so richly inspirational. And it has been particularly relevant to do now because the air is full of millenium nostalgia. We've included an abundance of retro subjects like Arts and Crafts and twenties china, as well as designs that we're always

being asked to revive, like butterflies and shells in pastel colors, more kilims (never possible to have too many kilims), more designs based on beautiful porcelain, and an excuse to look further at African and Indian sources, which we need little arm-twisting to do. We have no loyalties to any particular theme or period, only to the canvas muse. We are fickle, and leap cultures and ages.

Our designs are done in groups, to complement each other; the philosophy being that if one cushion looks good, three must look even better, and cushions usually benefit by being seen en masse. It began with *The Venice Collection* – all those brocades and damasks piled up together looking gorgeous, then the tartans, more and more, richer and richer ... and finally, the kilims, our best example of overkill – pile them braided in a classic room of antiques and Oriental carpets, or wildly tasselled in a minimalist interior, but do pile them up. We have one customer who averages one kilim a week and who must needlepoint in her sleep. It can be compulsive and obsessive, just wanting to finish this little bit, then that little bit; 'No, no, you go to bed darling, I'll just do this piece of background here. Then that leaf there.' Glorafilia may have inadvertently been responsible for many a marriage breakup (whom God may join, let needlepoint put asunder).

Needlepoint is therapy
Needlepoint is a superb way to stop smoking and nibbling, and unlike counted cross stitch also allows the mind to wander. It's such a terrific thing to do, we can't understand why everyone isn't doing it! How do people watch television without holding a piece of needlepoint, or endure plane journeys? Why doesn't the 5.20 train to the suburbs look like a sewing class? Some swear the continuous movement helps arthritis, and perhaps we should do blood pressure tests before and after to see how therapeutic repetitive stitching is (rather like dog stroking, but without the smelly breath). Needlepoint has the magical ability to turn anonymous yarn and canvas into beautiful pieces of textile, allowing people who have never considered themselves creative to be very creative.

Having the shop is a marvellous way of meeting some of our customers. It always impresses us the journeys people make to come here, sometimes breaking a flight to stopover in London to stock up on kits, or coming half-way around the world and arriving, catalogue in hand. Quite a number of incensed businessmen leave a taxi outside with meter running and driver grinning, having obviously been told, 'while you are in London can you pick up this kit for me', not realizing we are thirty minutes from the center. As is inevitable, we become involved with certain customers, who just let a word slip, need some needlepoint to do at a child's hospital bedside, need to talk.

Some people say proudly, 'Of course, I'm a perfectionist', and the tempting reply is 'How awful for you'. By whose standards? A simple marble floor in Venice has a deliberate mistake in the design to remind us that we mortals are not capable of perfection. The satisfaction achieved when a geometric border works perfectly is very desirable, but a changed dye-lot in a forest of green leaves? This is neither here nor there, when in nature there are more greens than could conceivably be documented, and we feel that flexibility is a word to keep in mind with needlepoint. And life in general, for that matter. If there is no flexibility how can preferable alternatives be recognized? Needlepoint can be relaxing, satisfying, soothing, fun. It should never be a grim discipline approached with gritted teeth, as so many of us were taught at school.

The Old Mill House

On a typical Glorafilia day it would be nice to say we rise at dawn, do 20 minutes of t'ai chi, sip Lapsang Souchong while writing place cards for that evening's dinner party, quickly oil the lawnmower and change batteries in smoke alarms, berate ourselves for not having time to make quince jam (oh, damn), then a serene drive to the Old Mill House to the strains of Brahms' Third. It wouldn't be true. We all arrive here in the morning in varying degrees of fragility. London is always being dug up, in ways intended to maximize rush-hour dementia, and the first few minutes are spent comparing stress levels. Then the questions follow. Has a horse flicked its fetlock and broken a window while its rider window-shopped? Has the computer blacklisted people in Hartlepool? Is the Mouse Circus back? – the word having gone out in the rodent community about the floor-to-ceiling wool.

Every day is unpredictable. Perhaps a tour of American needlepointers or an event for our Club Members is planned. On such days, whichever law it is that governs such things also delivers a container-load of kits printed on the wrong canvas, tattooed blokes in vests replanting window boxes, a computer angel in search of those people in Hartlepool, a distributor from Greenland needing undivided attention, a family crest needing to be deciphered from a bad photocopy, somebody building shelves, someone else showing us lots of beautiful tassels, and a customer standing in the shop using the 'perfectionist' word.

We have wonderful people working with us, some almost since the beginning (in the very beginning it was just us and an Appletons wool chart). We call them our 'Glorafilia Girls', though as the years progress we find that most of us are wandering into rooms for forgotten reasons in a way more menopausal than girlish.

Daphne has been with us since the days of 'wool in the garage' when Tamsin was two. Tamsin called Daphne her brother, since this was something she wanted and appeared not to have, and used to go to Daphne's house for tea. She once came home aghast that they kept a *car* in their garage – where did they keep their wool? Daphne and her serenity preside over the top floor like gurus, Malu ditto with the mail

ACCESSORIES
Above are examples of gifts in the Glorafilia shop,
all allied to needlework. Opposite is a door in The
Old Mill House, a testament to our past.

order, Julie B. continues to make our cushions as spectacularly as she ever did, Djien paints our hand-painted canvases with military precision, complaining loudly at designs she doesn't like: 'this is horrible, horrible'. 'Oh, good,' we say to each other, 'a winner'.

Sousan, Julie C. and Helen all began here by running the shop, then started babies and now work for us in other capacities, always somehow involved with the company. We watch their children grow, disbelieving the sliding years. Those of us with older children share angst-ridden stories, knowing that there is no need for exaggeration, life itself is bizarre enough. We feel sure they couldn't avoid lesson learning from watching their mothers juggle balls in the air. Women seem to have the ability to chop themselves into independently functioning bits – which is not as difficult as joining the bits together again when required.

Then there is the new generation, Katrina, Shilpi and Clare: enthusiastic, with minds brilliantly intact, who can still smile when they reach the top of the stairs, as well as remembering why they went up there. And, of course, Sorel, First Daughter of Glorafilia, who made a slice of time between accademia and a long look at India to help with the designs in this book, bringing to a lifetime of Glorafilia indoctrination a marvelous vitality that is her own.

Visitors from abroad are charmed by the Englishness of our little shop. The locals walk their dogs, play ball with their children, fly kites. We could be in another century up here on the hill, a possibility borne out by our lack of technology. Although the mail order and distribution are quite state-of-the-art, cutting-edge, here on the second floor we sympathize with the woman who put her computer mouse on the floor and tried to use it as a sewing machine treddle.

From the room where we give lessons, the view of the garden leading into the Mill Field is beautiful – in spring, awash with apple-blossom; in summer, with roses; in fall, golden hops loop the conifers; and should we have snow, then our spectacular view across to the Abbey includes tobogganing children. Sometimes in summer we spread the grass with needlepoint rugs and piles of cushions, and guests at our picnic must think that life at the Old Mill House resembles a Merchant/Ivory set.

Returning as we have in this book to so many familiar themes, has been enormously enjoyable, like revisiting places from the past, and indulging ourselves in places from the present. We hope our world-wide network of Glorafilia needlepointers and those new to the delights of canvas, yarn and needle, will enjoy it just as much.

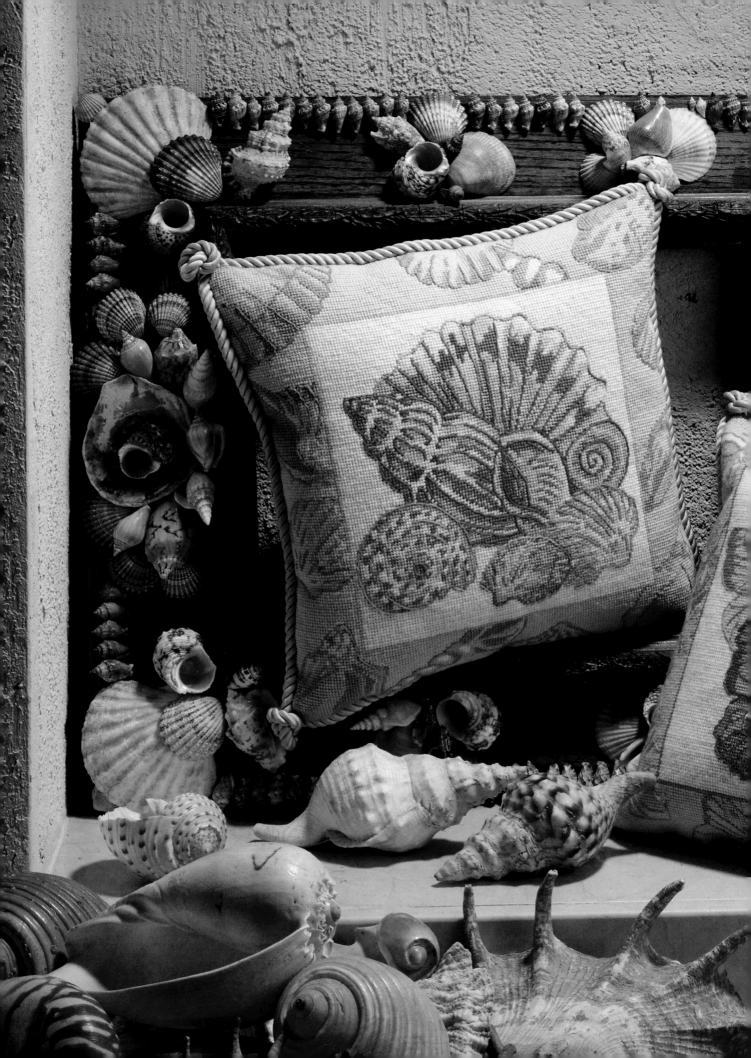

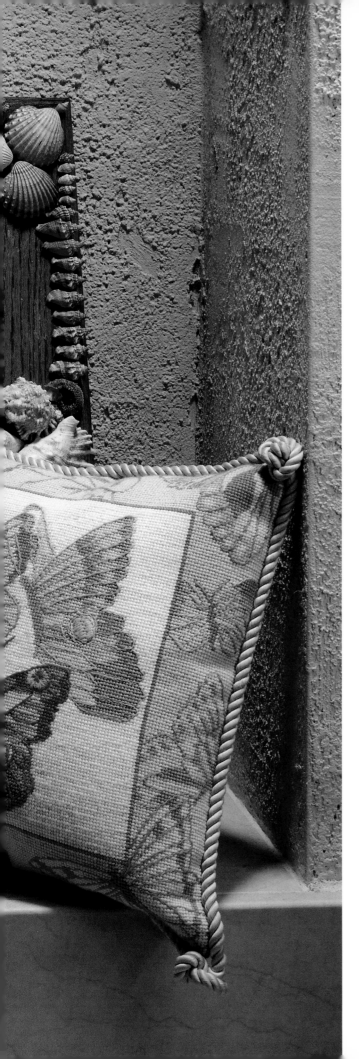

Shells & butterflies

*I*t is said, in chaos theory, that the gentle flapping of a butterfly's wings can cause a hurricane on the other side of the world. It is also said that shells are traditionally a symbol of female power.

We have been pairing them since we began needlepoint: two of nature's extraordinary achievements. Butterflies are the ultimate kinetic art, the Sistine Ceiling of the insect world – and shells, impossibly twirled and curled, fragile yet withstanding immense pressures, their shapes gorgeous and multiple.

We take them all for granted, so exotic yet so much a part of life. Can there be any of us who has not at some time collected shells, wandered on a beach picking up exquisite treasures?

THE PAIR OF PROJECT CUSHIONS SHOWN HERE (SHELLS AND BUTTERFLIES) GAVE US THE OPPORTUNITY TO RETURN TO THE LOOK THAT MANY PEOPLE STILL ASSOCIATE WITH US: PASTEL SHADES OF MOTHER-OF-PEARL AND DELICATE BORDERS. THE CHARTS AND MAKING INSTRUCTIONS ARE ON PAGES 120-3.

Shells & butterflies

EARLY CUSHIONS
*Above are two of our earliest shell and butterfly cushions.
Right is Venetian Shells in mirror images, bordered by scrolled
panels interlaced with seaweed.*

We often see antique shell boxes at fairs, in wonderful bleached colors, astonished at how they survive intact. The Victorians loved shells, even shell furniture, flamboyant and ludicrous tables and contorted seats, an ultimate indignity for one of nature's miracles.

Within what seems a quiet and limited palette, shells have a range of exquisite colors: the mauves of bruises, blue of powdery old eye-shadow, earth and carrot colors, silver and pink, ochers that flake to show glitzy white. The haphazard designs, too, are so inventive they look like random scribbling, lie-detector zigzags, or painstaking leopard spots. Yet here they are, repeated again and again, an extraordinary range of shapes that can be played with indefinitely for different forms of design.

Britain is not well-off for butterflies. Buddleia is planted in the hope of attracting some and everyone jumps up and down if a beautiful piece of silk flaps by. The American Monarch migratres to Mexico living by the thousand in trees protected by law, yet in Britain everyone becomes lyrical over a Red Admiral.

Butterflies are so modest, quite nondescript and camouflaged when the wings are closed, but when open in flight or basking in the sun, neon signs flash 'Look at me, am I not gorgeous?'. The function of the butterfly is to mate, lay eggs and die. Do you suppose they know this? Some live only a few days, although some can even hibernate through the winter. In any event, a great part of the butterfly romance is their transience and perhaps one of the reasons that we like to stitch them is to anchor something of that ephemeral quality.

We wanted our Butterfly and Shell designs to express that fragility, and in some places are so delicate that the colors barely lift off the background. To achieve the fine outlining for both of these designs, it is necessary to divide the wool into separate strands and sew in stem stitch.

OVERLEAF *Butterflies are Free is very different. This is a celebration of over-the-top butterflyness, exaggerating their fantasy element and working an intense background to emphasize the fine outlining.*

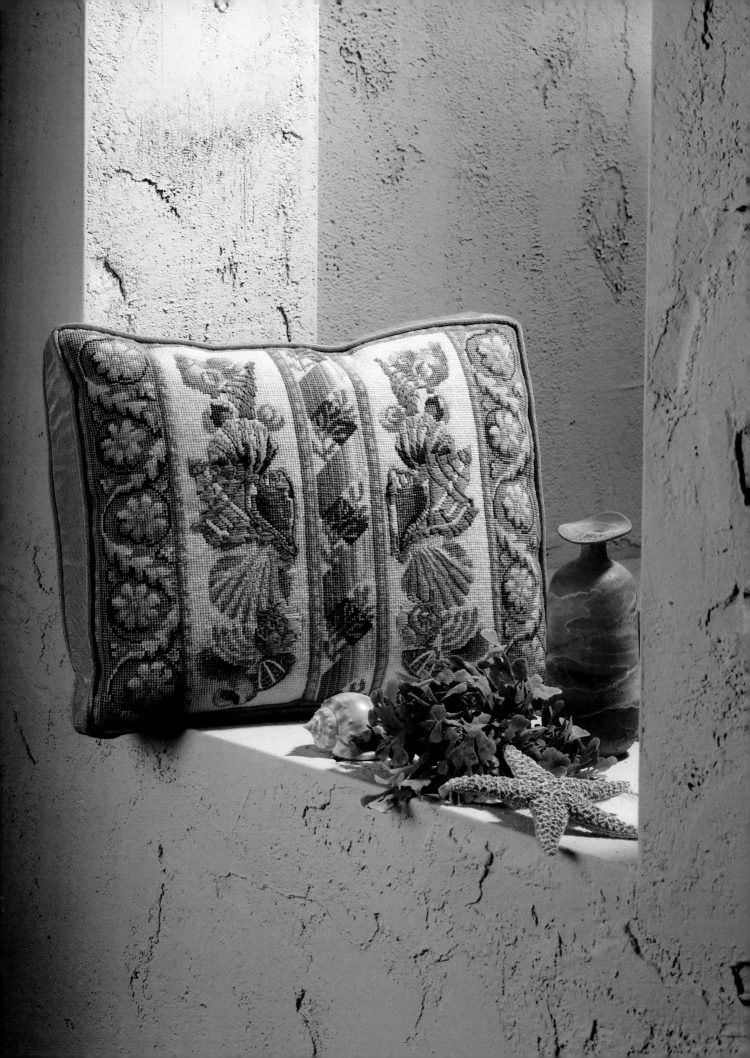

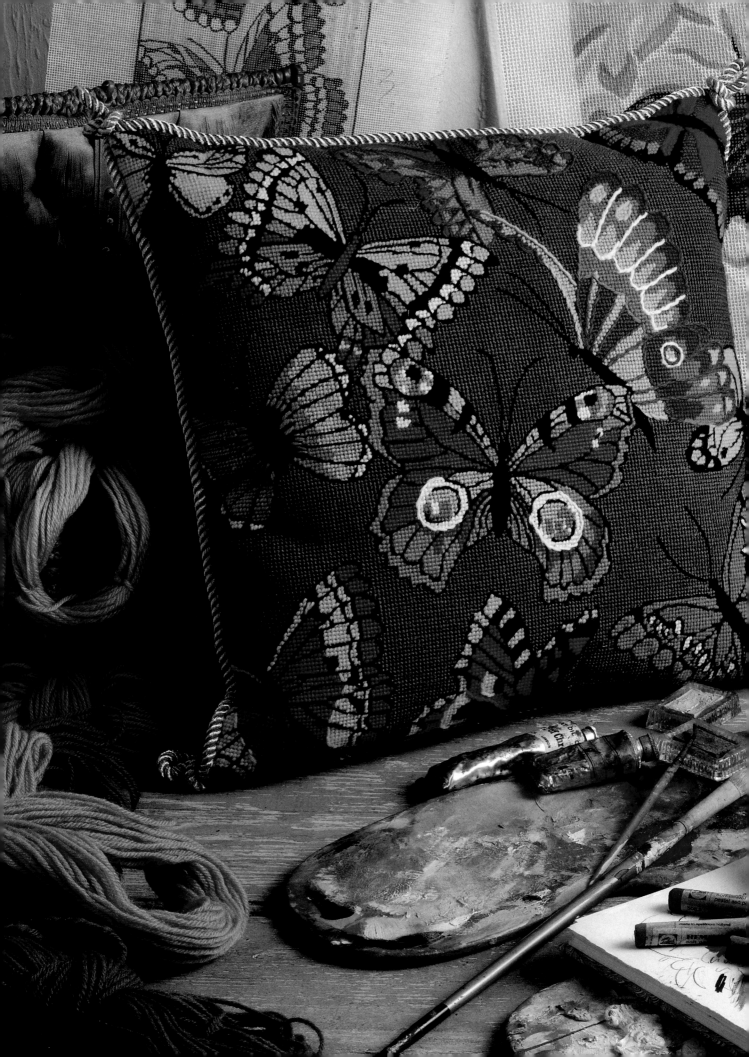

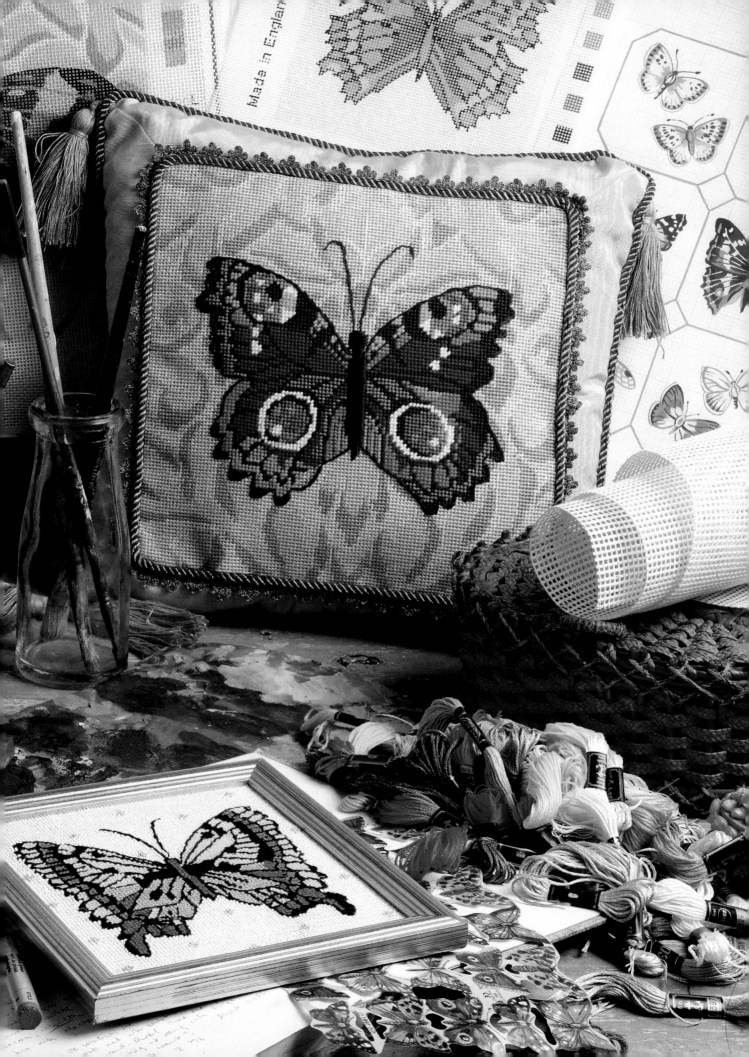

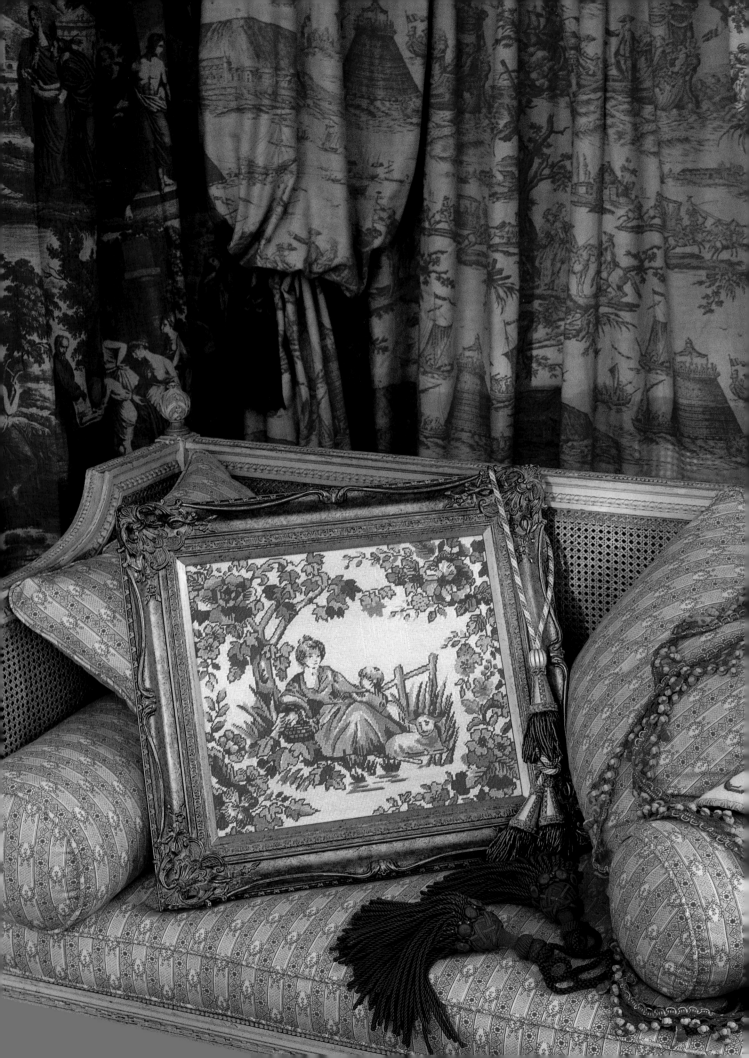

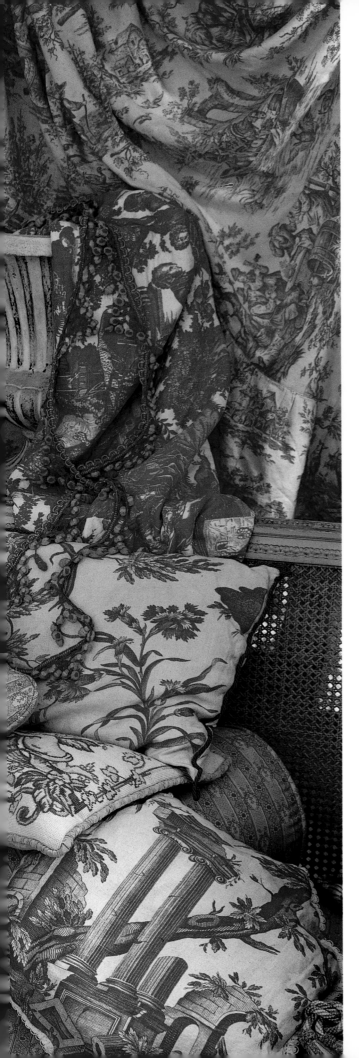

Antique
textiles

*T*o us, antique textiles are irresistible – fringes through fingers, papery taffetas, chiffons like poppy petals. A fragment of silk can evoke genteel daintiness, or a bordello; dust, mustiness, tassels that make you sneeze, cobwebs from another era, in need of attention.

Past styles, past tastes, some translating beautifully into needlepoint. Over the years, we have used Oriental embroideries and carpets, Victorian chintzes, paisleys, Fortuny's gorgeous creations, silk damasks, and – shown here – toile de Jouy, the unique pastoral scenes from eighteenth-century France, which take on new textures when adapted to needlepoint.

In these days of high tech, the eye may dictate the natural and simple, but how many of us could put our hands on our hearts and say we wouldn't sigh over a trunk full of excessive brocades, embossed velvets, the lace-edged froth of a silk cloak?

PASTORAL SCENE. THE CHART AND MAKING INSTRUCTIONS ARE ON PAGES 124-6.

Toile de Jouy

BLUE TOILE DE JOUY
Original fabrics, old engravings, musty books, French stamps;
all these bring their rich influences to bear on our contemporary
design, such as the blue cherub seen here.

We love toile de Jouy, not only for the glorious images of eighteenth-century France that it evokes, but because it looks truly marvelous as needlepoint. After working in multicolor, we were excited about the limited palette of these fabrics, with their several tones of the same terracotta shade. With equal fervor our printer disliked the several tones of the same terracotta shade. We loved the cherubs, garlands and typical little curly scrolls so much that we did another version in blue, again received with a clenched jaw by our printer. Then came more cherubs, one tangled in vines, one blowing his own trumpet, and then the pastoral scene shown to the right and on the previous pages: mother, child and lamb, lots of essential white space (the needlepoint equivalent of transcendental meditation), a gentle evocation of rural France.

Christophe-Philippe Oberkampf was the grandson of a Rhineland dyer, and he came to Jouy-en-Josas in 1760 attracted by the reputation of the waters of the River Bievre for dyeing fabrics. He originated the look that we now call toile de Jouy, hanging the fabrics from the eaves of his house and spreading them in the fields to dry. Printing began with woodblocks, progressed to copper plates, and then on to roller printing. It is said that when there was a shortage of copper, Napoleon confiscated cannons from the Vatican and sent them to Jouy to be melted down for printing plates.

Oberkampf's designs appealed to everyone, from commoners to aristocracy, and it is much the same today. The toiles can look both sophisticated and simple, and this is their charm. Of some 30,000 patterns engraved, in the familiar reds, terracottas, blues, greens and black that were used, the most interesting are the bucolic scenes that depict stories, or describe fashion or inventions – all captured by the toile de 'journalists' pen. We think toile looks its best as it fades. Washed-out and sunlight streaked, it takes on a mellowness that suits the subject.

Chintzes

The cushion opposite, which we call Floribunda, was inspired by a chintz design done around 1790 by an artist named William Kilburn, and came from the Victoria and Albert Museum, London. We have kept quite faithfully to the original watercolor which is quite exuberant, with its colors so deliciously clashing. In the textile rooms upstairs at the Victoria and Albert Museum, thousands of beautiful fabrics have been preserved like butterfly specimens on huge panels and in drawers, though few with such vivacity as this. It is a little like going into a textile showroom, except that you can't order lengths of what you fancy. They are the rooms where students research and designers plagiarize, and unfortunately are among the least user-friendly in the museum.

We have spent a lot of time in the Victoria and Albert Museum, particularly when we were doing a series based on the Devonshire Hunting Tapestries, and are never as comfortable there as at the British Museum, which without doubt has parts that are even more formidable. It may be that some law operates whereby those who favor one, dislike the other, rather like *Winnie-the-Pooh* and *Wind in the Willows*. Ask around. People who love Toad, dismiss the Bear, whereas the rest of us believe Pooh should be up there with Ulysses, Gatsby, Nicholas Nickleby and the Little Prince, as one of literature's real treasures.

Back to museums. One of our greatest privileges was photographing our British Museum Tapestries in the museum, out-of-hours. Being in the Egyptian Hall in the early morning without even the cleaners around was unforgettable, and amazingly warming. And outside, in Bloomsbury, forward 5,000 years, London was starting to go to work.

Floribunda cushion with its colorful flowerheads and green foliage, inspired by a chintz design from 1790.

The paisley pattern

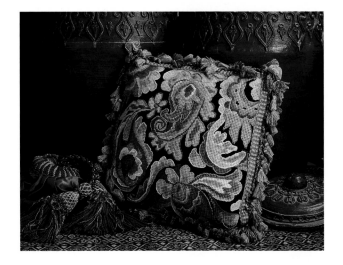

TEARDROP MOTIFS
*Above and opposite are two favourite designs inspired
by traditional paisley motifs. In both of them, the
'teardrop' is clearly the basis of the patterns.*

What we know as paisley shawls were originally worn by men and produced only in Kashmir, and lusted after by every eighteenth-century lady of fashion. The shawls took up to three years to make from particular mountain goats' underfleece, were outrageously expensive and exceptionally beautiful.

At first, the European copies of the Indian originals were crude, based on the Palm Tree of Babylon 'teardrop' design. European cities fought fairly – and otherwise – to outrival each other to develop better techniques and colors. The Scottish town of Paisley triumphed, and produced such quality and quantities of shawls that the name Paisley became synonymous with these particular gorgeous patterns.

The designs we love for needlepoint are the overall patterns, where no plain fabric shows; they resemble computer-image fractals, patterns repeating indefinitely. They are not the simplest thing to do in needlepoint, and rely on contrasts and curving stem stitch to keep the flow of the pattern. Given the right colors and making up, however, the designs can look marvelous in exotic as well as traditional homes.

Paisley goes in and out of fashion, originally falling from grace when the bustle was introduced in the 1870s and ladies resented the way that their new look was hidden by wearing a shawl. Subsequently, the shawls have enjoyed periodic revivals, but since the enthusiasm for all things nostalgic, and eyes turning towards the Maharishi's east in the sixties, they have become the ubiquitous accessory, whether small enough to wear, or large enough to throw over the top of a grand piano.

Notes from a travelogue: recent wild-goose chase in the hills around Jaipur when Kashmir shawls were mentioned...dark, fog, elephants swaying down center of road, crashed trucks along roadside, turbaned Kamikaze driver, certainty that death was imminent, wished we'd never heard the words Kashmir Shawl...shawl emporium closed, but surprisingly driver knew cousin of cousin and all lights were lit to reveal shawls, trades description accurate, but poor, minimally embroidered things. 'But madam, madam, these are shawls from Kashmir!' 'Yes, they may well be, but they are not *Kashmir shawls*!'

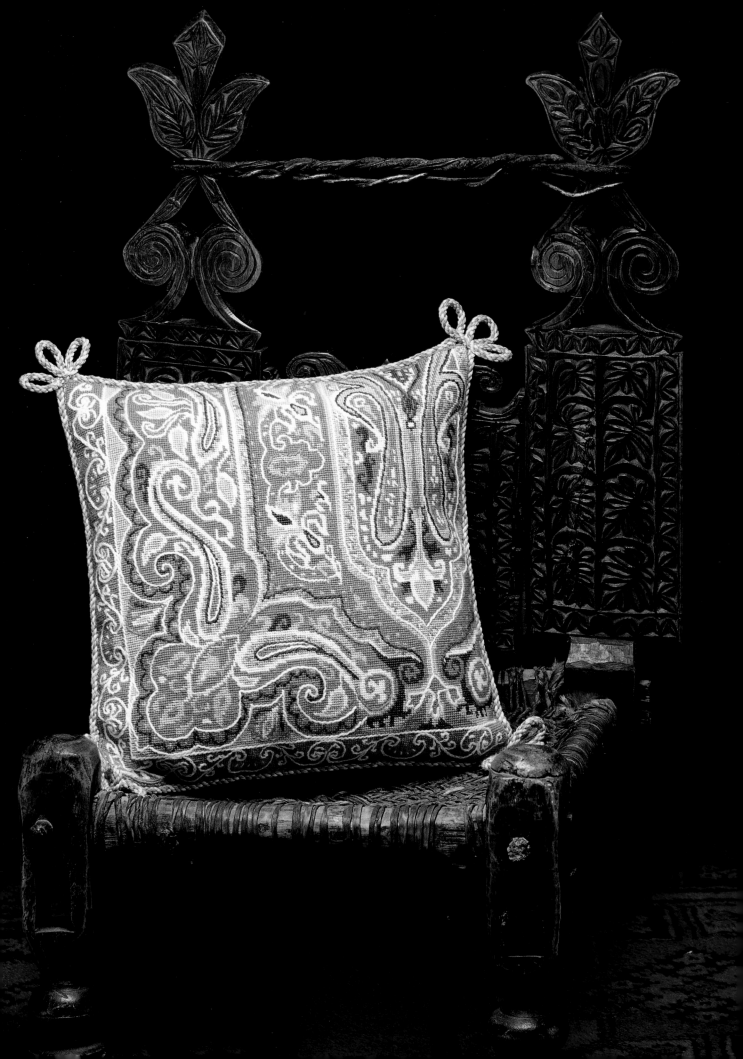

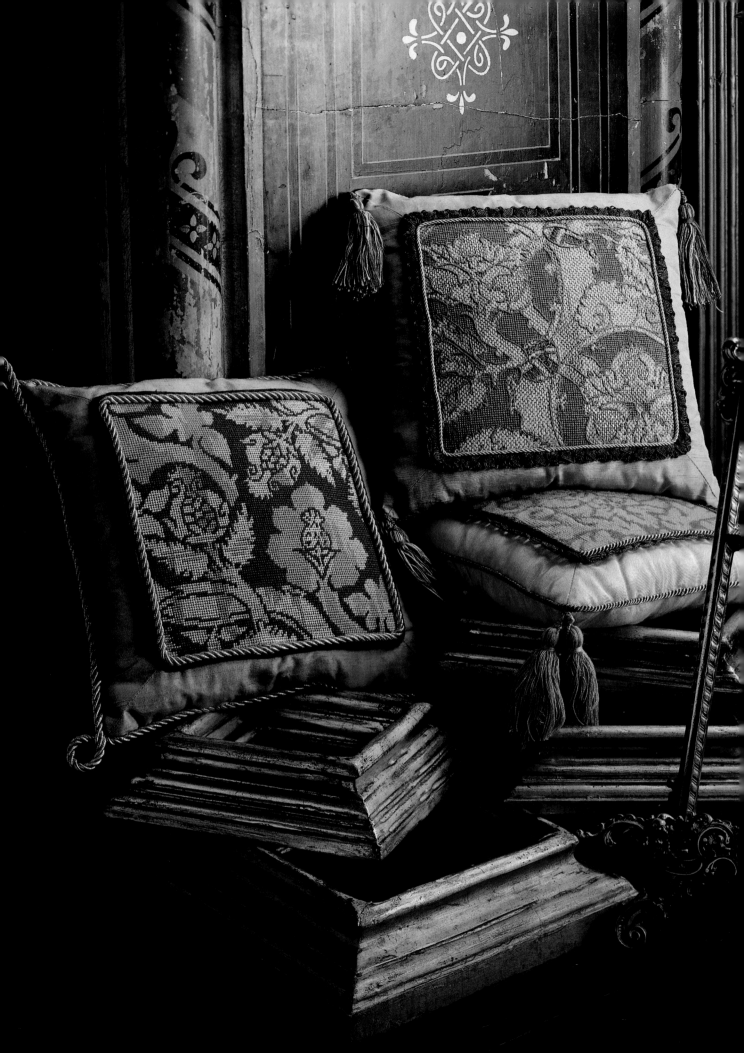

Fortuny & Aubusson

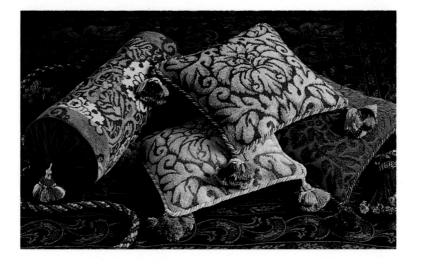

VENETIAN INSPIRATION
Opposite are three tiny cushions redolent of Fortuny's fabric treatments
and, above, damask designs worked in just three toning shades.

Fortuny, the master magician, is the genius of textile alchemy. Researching our Venice book, being in his home and studio, it was impossible not to fall in love with the man. His inspirations were classical, and his treatment of fabrics as revolutionary as those of Issey Miyake's today.

We have taken fragments and coaxed them into needlepoint, worked silks and metal threads to imitate the velvet sheens. We have attempted to take almost weightless materials and recreate them in our own, densely-worked medium in homage to the maestro. Why? Because they are so absolutely gorgeous, and are hidden away in a Venetian museum that seems only to open on alternate Tuesdays/when reconstruction work isn't being done in the street/when there's no high tide/and when, if you're lucky, someone agrees to find the key to the textile room at the top of the building.

Fortuny velvets that shimmer in the light led to the damask designs shown in the photograph above. There were bolsters, and seats and waistcoats, and our printer loved them because for once something was straightforward and simple.

Aubusson tapestry inspiration
Overleaf are three little pieces from Aubusson tapestries. Aubusson is usually associated with pale backgrounds and distinctively stylized flowers in peach, pink and gold, but Aubusson also produced 'verdures', the rich forest foliages that we show here. We imitated the crude weave of the tapestries by mixing the colors of wool, and adding cotton for sheen. Try mixing in one needle a length of wool, cotton perle, and some metallic thread. Fiddly it may be, but it can look fabulous. You see, no mystique, just a deep breath and a bit of courage. A single branch, a few leaves, worked in a matter of hours on 7-gauge canvas and then made into these elaborate little cushions is an excellent and painless way of achieving needlepoint impact – maximum effect for minimum stitching.

OVERLEAF *Three small needlepoint cushions and the two Aubusson originals that inspired them.*

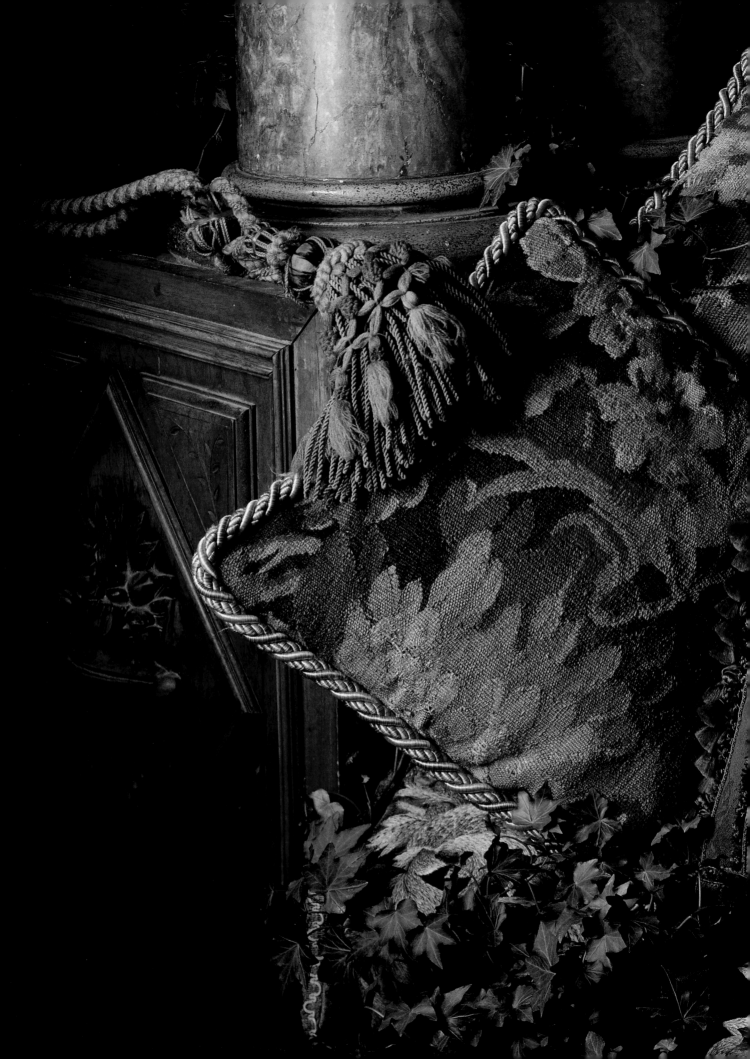

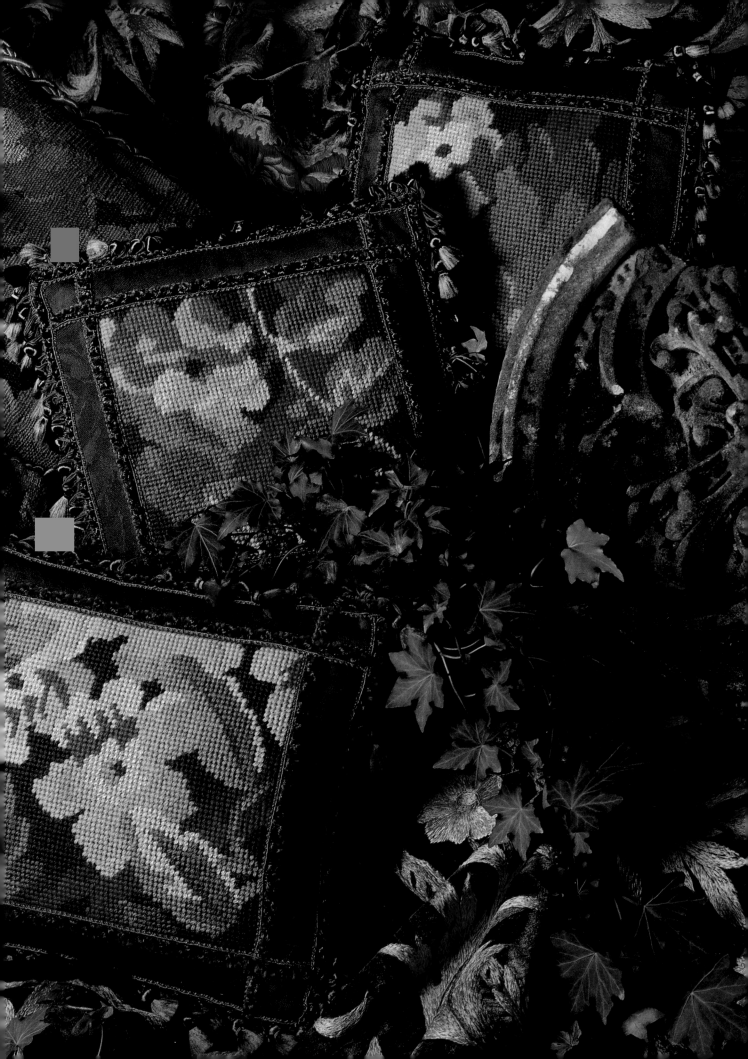

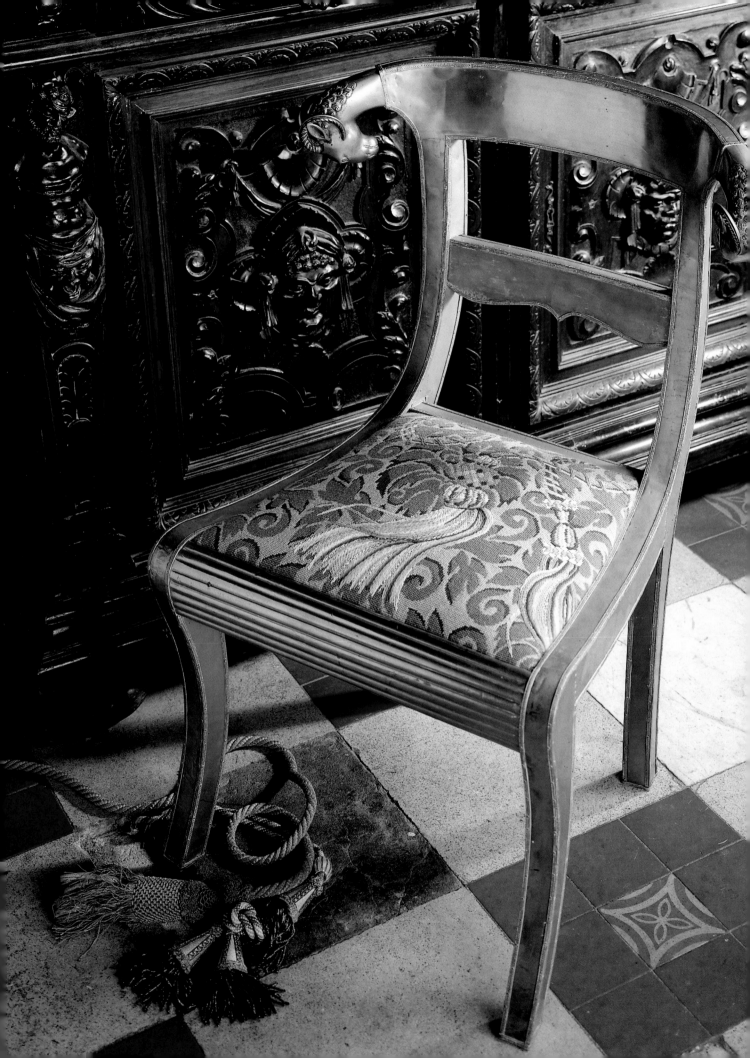

Textiles into needlepoint

BROCADES & TASSELS
Above is a section of a life-size Elizabethan figure worked by
Anne Miller from our painted canvas. The stitchery is exquisite*,*
creating dimensions that probably surpass the original textiles.

We made the first Tassel cushion some years ago, again inspired by opulent Venetian damasks. A gorgeous tassel strewn across the background was irresistible – every strand of the tassel could be worked in stem stitch and fell in just the way fine twisted twine would fall...delicious.

The design for this silver chair, though not of the right period, is very theatrical and looks superb in the blue and ivory room for which it was commissioned. Sometimes a particular piece of furniture will suggest a needlepoint pattern very strongly. The pieces we are asked to do most often are either Victorian, when bold flowers are required, or French, when usually a fine design of ribbons and posies and baskets looks best. We have done heavy Spanish, days-of-the-Raj wicker, Georgian pole-screens, Chinese chairs, piano stools where specific music was requested, and many pieces copied from textiles.

Very often what can prevent a 'textile translation' from looking right is the scale of the image. It may be better to take a detail of the pattern and give it some air, remembering that the design of a dainty cotton chintz, however faithfully imitated, will look dense and textured translated into wool. If the fabric is silk, and the needlepoint for decoration rather than heavy abuse, work it in stranded cotton or cotton perle and it will seem nearer the original.

There is something extraordinary about old textiles. We take them into the office and unfold their dustiness: ballooning silk on heavy lining, cross stitch full of dusty old smells (we call them cough stitch), linens whose colors have become out of focus, permanently folded in brittle creases. We once had a huge Chinese piece, with cream cranes and flowers embroidered on cream silk with fantastic fringing. The cranes were perfect, the background silk shredding as we looked at it, leaving the cranes flying through cobwebs. The piece was the size of a double bed and the time and investment involved in re-applying the cranes to another background, as they do at the Royal School of Needlework, seemed inappropriate, as the piece was gorgeous rather than 'precious'. It joined the cupboard that is full of wonderful, useless textiles, testament to thousands of hours of Needle Work.

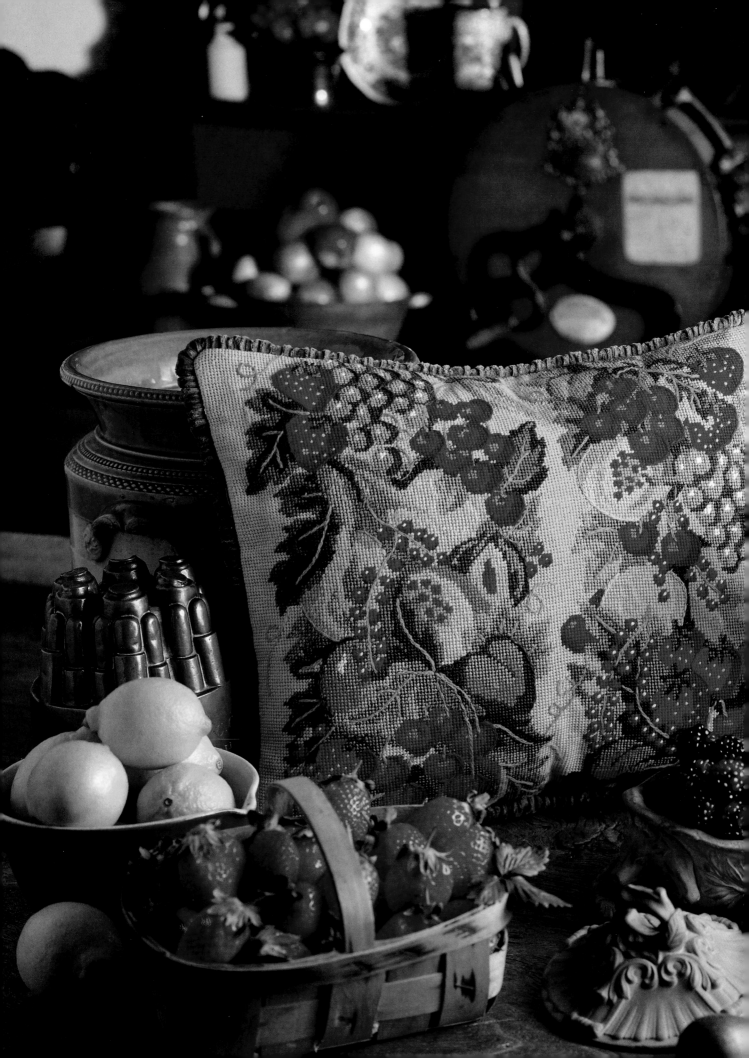

Fabulous fruit

*F*ruit has forever been a favorite subject for artists – from seventeenth-century symbolism to Cézanne's apples that heralded Cubism and all that followed. What other still life objects were so practical that they could be eaten when the picture was finished? Such color, shape, such fecundity; and such a sexual language for the written and visual arts. Think of the unforgettably juicy eating scene in Tom Jones, *or DH Lawrence's diatribe about the fig in* Women in Love.

To us, fruit is more expressive than flowers, so much richer and with such interesting textures. Opposite is our Abundance of Fruit cushion, columns of lush fruits, ripe and bursting, both exotic and home grown, worked in wool on a background of bright cotton. We have also worked this with a navy background (see page 8) which gives an entirely different look – Victorian rather than Mediterranean. Small fruits are particularly effective to stitch; little round shapes, shadowed and highlighted to suggest their curves, and finely edged in stem stitch to keep the outline and stalks flowing.

ABUNDANCE OF FRUIT. THE CHART AND MAKING INSTRUCTIONS ARE ON PAGES 127-9.

Abundance of fruit

THE GREEN CUPBOARD AND DELICIOUS FRUITS
*Above is the green cupboard from our Impressionist book, with
panels of fruit from Cézanne, Monet and Renoir; and opposite is
Delicious Fruits, our all-time favorite fruit design.*

Since the apple that Eve proffered, fruit has been a metaphor for sex. In the nineteenth century, few fruits were more graphically described than by Keats in *The Eve of Saint Agnes*. We blush to copy it:

> *while he from forth the closet brought a heap*
> *Of candied apple, quince, and plum, and gourd*
> *With jellies soother than the creamy curd,*
> *And lucent syrops, tinct with cinnamon;*
> *Mana; and dates, in argosy transferr'd*
> *From Fez; and spiced dainties, every one,*
> *From silken Samarcand to cedar'd Lebanon.*

When this was published it caused outrage. However, when we design needlepoint of fruit, we design fruit and fruit only; good old-fashioned strawberries, cherries and pomegranates without a thought for their symbolism, just for their shapes and colors.

In many paintings, the symbolism is quite blatant. There can be little ambiguity about a strategically placed pomegranate, for example, or the transience of

life represented by deteriorating fruit. In the seventeenth century, it wasn't uncommon to commission Dutch or Flemish paintings which could be 'read' by decoding the fruit. Each item had a specific meaning. So, a painting of open fruit, two perfect fruit, and one withered fruit could be translated as a couple married for four years with three children, one of whom had died. A peach with one leaf symbolized heart and tongue and was an attribute of truth. The grape, in Christian art, symbolizes the blood of Christ; in secular art, it represents the god of wine. The pomegranate is the symbol of spring and regeneration of the earth, and also the symbol for unity and chastity. Take your pick. Apples, by tradition the fruit of the tree of knowledge, were perhaps borrowed from the golden tree of Hesperides, golden apples meaning vigilance. Cherries are considered the fruit of paradise. Quite a fruit cocktail.

Fruit is one of the most obvious ways in which the world has grown smaller. We used to get excited over the first strawberry, but can now get them all the year

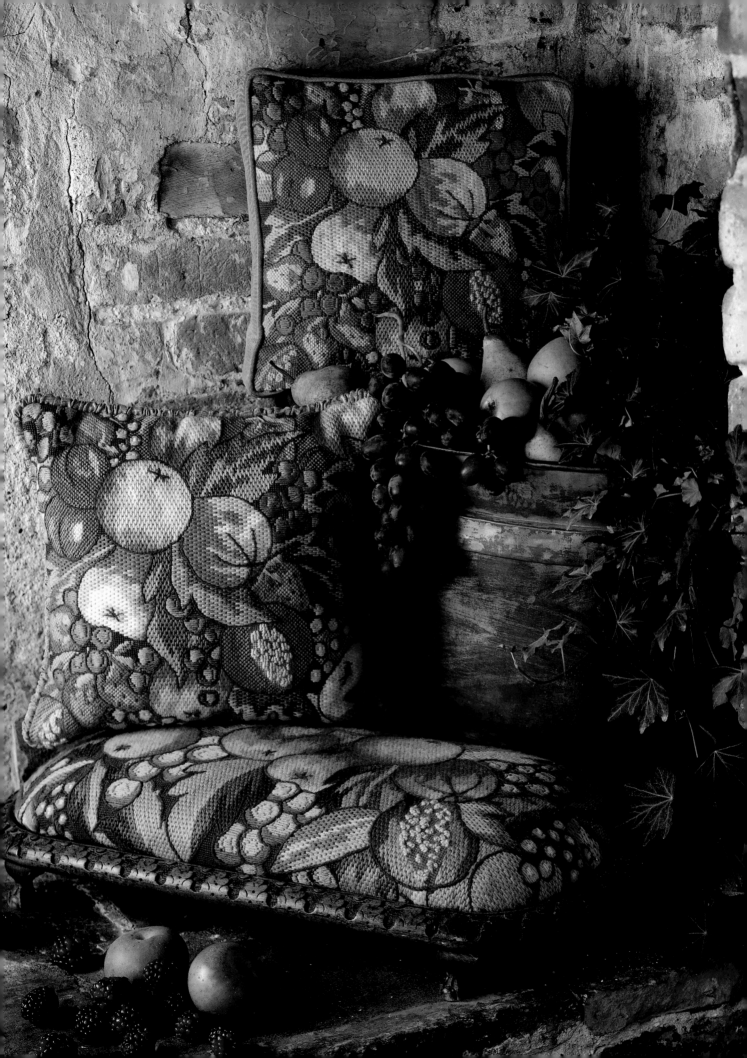

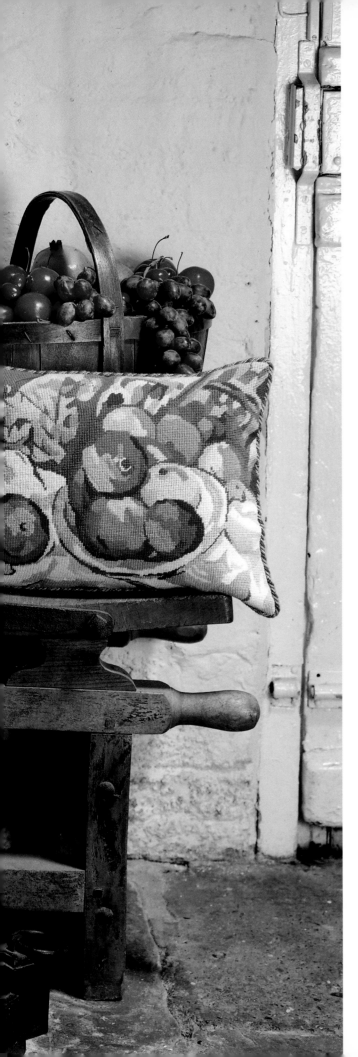

round. Many Second World War children remember eating their first banana, the mystery of this oddity and how it tasted. As the population swells with exotic additions, so do the supermarket shelves with guava, persimmon, papaya, passion fruit, grenadines, custard apples and star fruit. Mangoes are now almost commonplace (though not as commonplace as having them drop from the trees overhead on to the pavement, as they do in Caracas. Would you not think you were in heaven with mangoes dropping at your feet?).

We often use fruit for table decorations, with beautiful vegetables like ornamental cabbages, or asparagus and artichokes. They have an earthiness that is more relevant to a dinner table than flowers, and make wonderful still-life arrangements.

If you are tempted to design your own needlepoint, the shapes and colors of fruit are an excellent way to start. For example, a bunch of grapes with its repetitive overlaid shapes is not as complex as it looks. The shadows on one side and highlights on the other give all the form needed – just see how our chart is done on pages 128-9, and adapt it. Apples, too, are given their unique identity by the dent of the stalk, like a big dimple. Half close your eyes and look for the dominating feature – the rest will follow. Cézanne's Apples shown opposite are worked with few colors in bold areas. Cézanne had already started breaking objects into their different planes – of course, we believe he had needlepoint in mind when he did so.

OPPOSITE *Here are three very popular designs, Orange Tree picture, Cezanne's Apples and Summer Harvest combined in a suitably rustic location.*
PREVIOUS PAGE *A Bouquet of Fruit rug, worked in one piece using a limited palette of colors on 7-gauge canvas – large enough holes not to make this a life's work.*

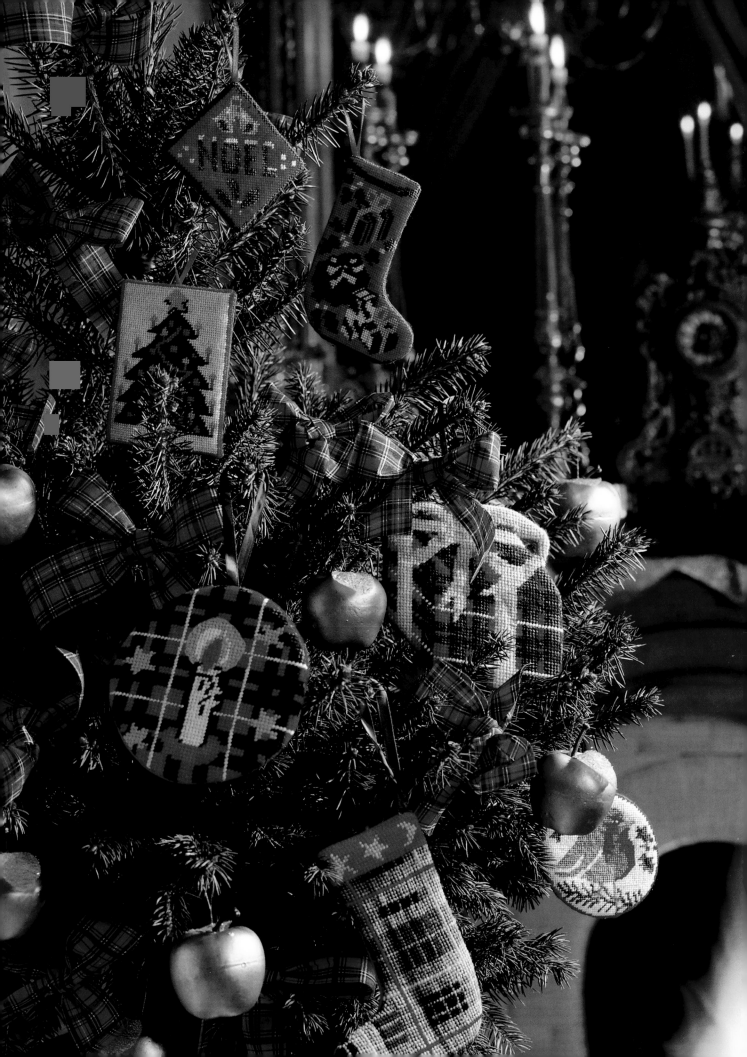

Tartan patterns

*T*here is nothing quite like tartan. Just the sight of it conjures up mists and reels and the skirl of the pipes. Tartans have such personality, with muffled shades of heather, gorse, foliage – indeed, this was tartan's origin, as a camouflage in the thirteenth century. Tartan needlepoint looks superb. It is quite possible to be a purist and painstakingly imitate the diagonal tweedy weaves, but we prefer a more cavalier attitude, working blocks of color, like a geometric patchwork.

It was Queen Victoria who first used tartan as a decorating accessory when she draped the interior of Balmoral castle in it, and put together with Victoriana it still looks wonderfully flamboyant – in fact, barely an item remains that has not been decorated with tartan. If we changed our decor from summer to winter, these would definitely be winter designs: a fireside, a wee dram and the shutters bolted against the wind howling over the braes.

TARTAN CHRISTMAS DECORATIONS. THE CHARTS AND MAKING INSTRUCTIONS ARE ON PAGES 130-1.

The 'Glorafilia' tartans

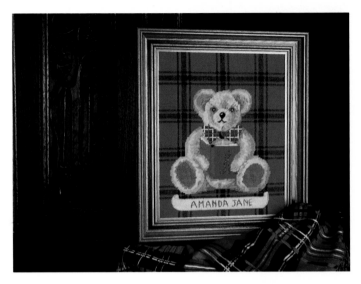

TARTAN VARIATIONS
Tartan Teddy, above, and, opposite, Golfer and Fisherman and
a tartan frame worked on very fine canvas, all using
'Glorafilia' tartans.

It is quite feasible today to have one's own tartan designed, so perhaps these tartans – with which we've taken a lot of artistic licence and which only approximate to one or another of the clans – should be logged as Glorafilia Tartan. Over 2,000 designs are registered and strictly speaking only if it is a family tartan should a man wear the full dress tartan. We visualize the romance of isolated highland weavers, but in reality only a couple of professional weavers weaving by hand remain, the rest use nineteenth-century machines or new technology – and all points that lie between.

The patterns have strong identities covering a spectrum from brooding and black to victorious red, and it can be fascinating to try to reproduce them exactly on canvas. It is only when you examine the weave closely that nuances of shade become obvious and the marriage of colors where they cross may be a surprise. The combination of red and green may need a muted peat, blues may need gray, sometimes colors will be exaggerated, sometimes muffled.

One year we produced an entire tartan catalogue. We began with a Scottie, who was usurped as favorite by a white West Highland Terrier. When we like something it gets the Glorafilia overkill, so we have them large as cushions, small as pictures, we have them on spectacle cases, footstools and doorstops.

We have a weakness for many things Scottish, particularly ghost stories in cold castles, small tartanware pieces from Mauchline, malt blends, Argyle socks, anything cashmere, and a certain Scotsman given to wearing full regalia whenever formal attire is specified. Perhaps the most spectacular wedding we ever saw was that of a Sikh to a Scot – not greeted with ecstasy by either family – but the photographs really were quite wonderful, for turbans and tartans and sporrans abounded. It was rather like the bird world, with the men looking considerably more magnificent than their women.

OVERLEAF *A range of designs from our Tartan collection which include dogs of various shapes and hue.*

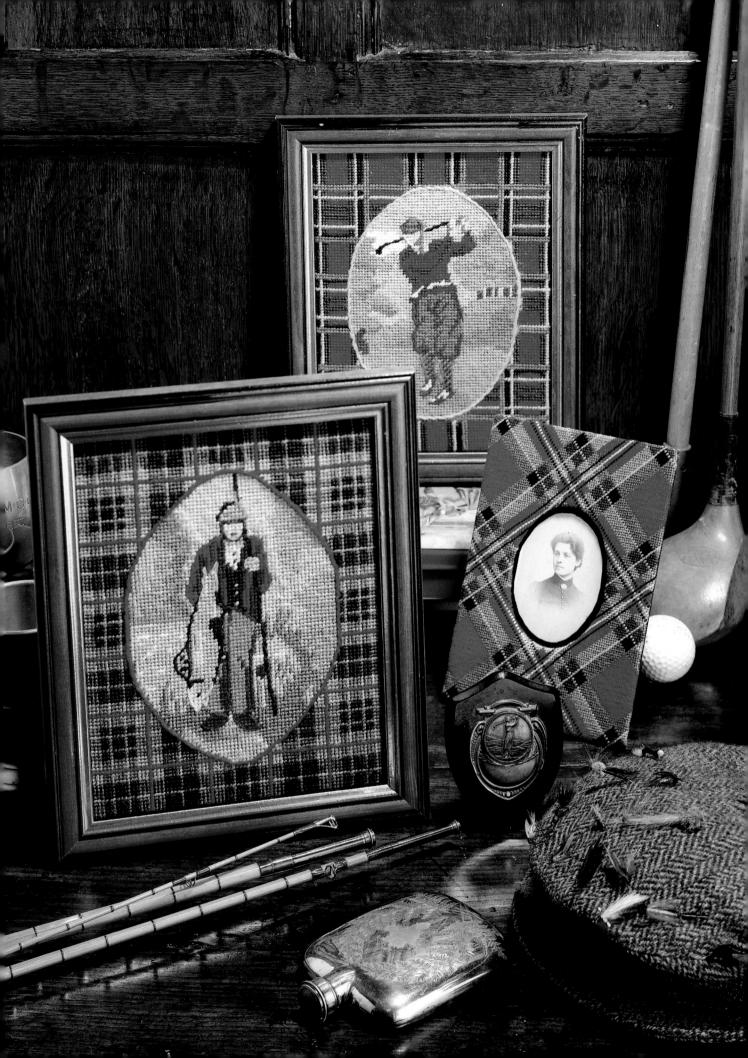

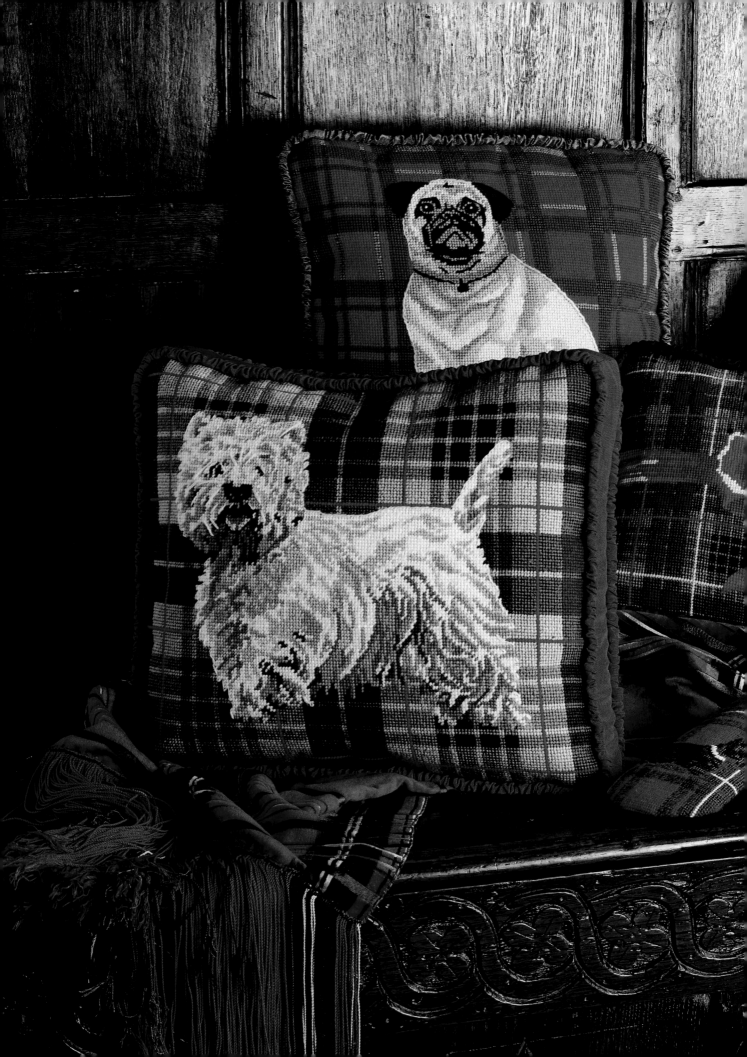

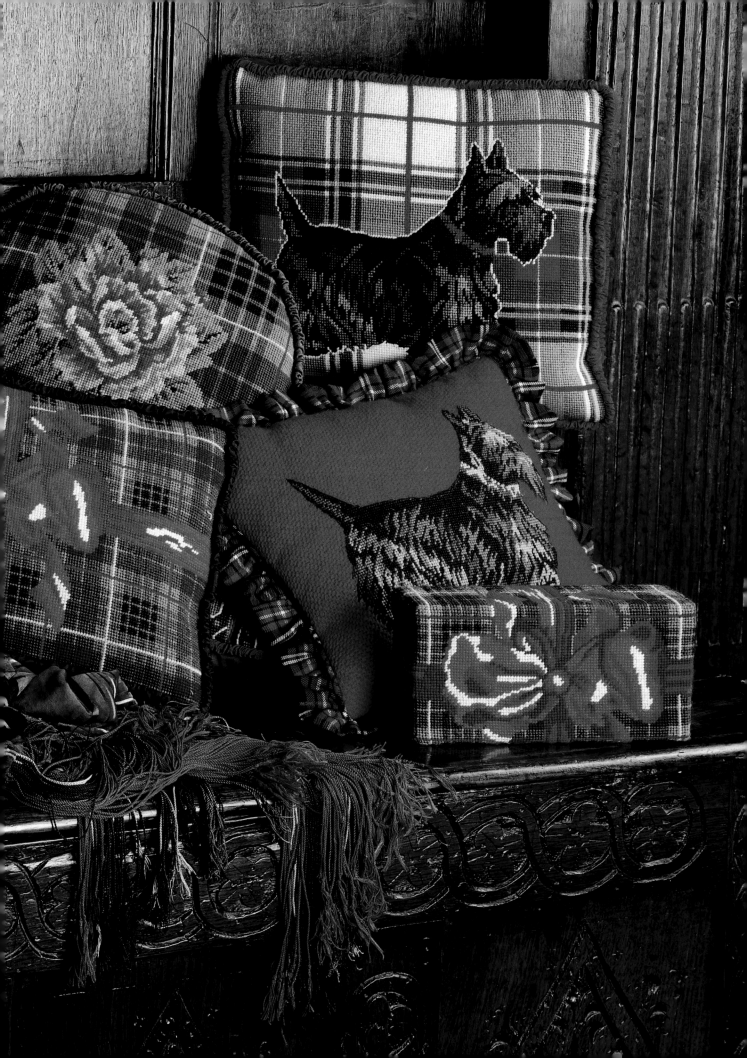

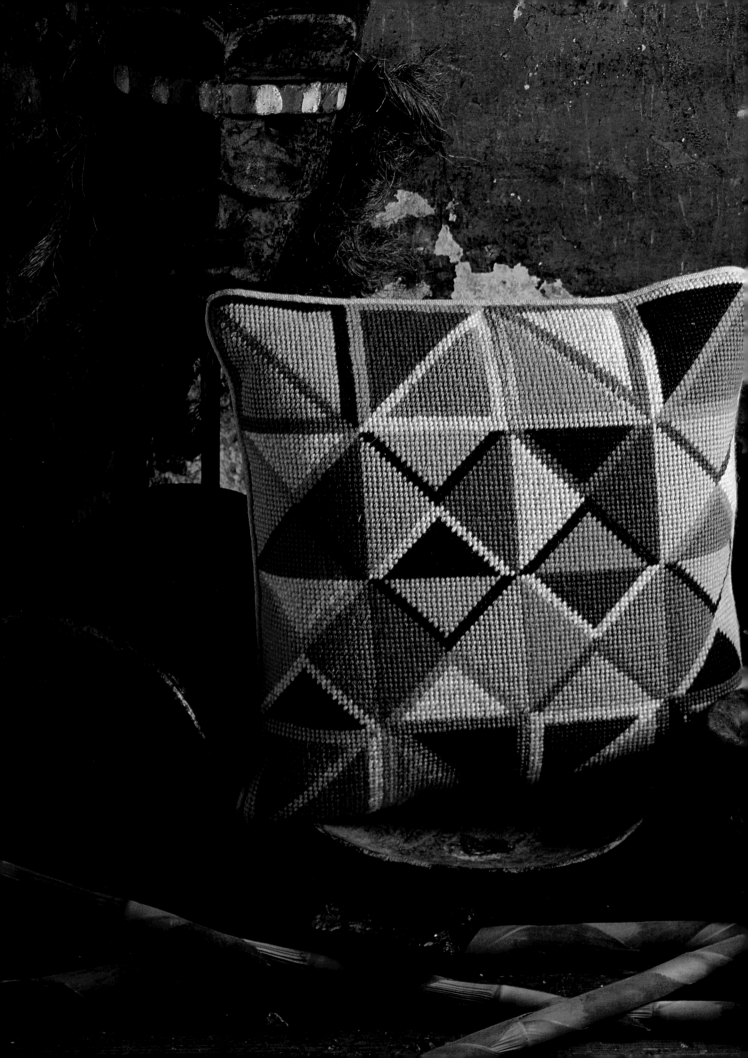

Tribal designs

*I*n all areas of the world there is a creative desire to decorate, to beautify, not necessarily as art, but as something much more fundamental. In certain cultures, the concept of art as we know it does not exist. Each country, each tribe, follows its own path of aesthetics, based on tradition. For example, through their creativity, Australian Aborigines keep the spirits of their ancestors alive, relating to them constantly as if they were gods. They use no templates for their designs, which rarely change, but repeat patterns as a homage to what has gone before, perpetuating the past.

As well as the Aborigines, we have taken designs from the Sahara (opposite), from Northern Ghana, and from the Sind desert in India. We find them marvelous. Do they excite us because they are unfamiliar, or simply because they are able to communicate without the reference of words?

SAHARA, INSPIRED BY WALL-DECORATION IN MAURITANIA. THE CHART AND MAKING INSTRUCTIONS ARE ON PAGES 132-3.

The Sahara & Indian cushions

After some years of surrounding ourselves with Indian and Afghan paraphernalia in our homes and clothes, dazzling, hot, we reached saturation; so when eyes turned to things African, and good old-fashioned earth colors, it was a great relief. We can even persuade ourselves that it looks new and full of integrity. We wear ten shades of potato with a little slate gray for hilarity. We look like breadcrumbs. So, in the sincere nineties, does everyone else.

Our first African cushions, shown opposite, were inspired by the painted mud houses of the Kassena people of Northern Ghana. The walls are periodically restored with mud, dung, straw and millet and bound with urine and oil. We are thinking of using the same techniques on the Old Mill House. Decoration is communally done by the women, with paint made from seed pods or pigments, or coal tar mixed with sand and boiling water. Patterns are traditional symbols: the triangle represents a broken calabash, the zigzag is the wing of the vampire bat, the 'V'-pattern a handshake saying 'welcome' – they do not change with fashion, but have that precious commodity called continuity, the heritage a mother passes to her daughter.

Our project featured on the previous page was inspired by wall paintings found inside mud houses in Mauritania. The villages on the edge of the Sahara have burning days and freezing nights and life is conducted mainly indoors, which explains the extraordinary attention given to the interior walls. When a girl marries, she makes her home as beautiful as she can, and has to use what's to hand, and what's to hand are pigments. Every inch of wall will be covered in the patterns shown on our cushion, as well as rows of triangles, diamonds, chevrons, squares, geometrically divided and subdivided like kaleidoscopes.

The Mauritanians love material acquisitions and proudly display any colorful Western pots they can acquire. We, in our 'first world' aspire to basic values by acquiring African utensils, and hopefully can laugh at the irony of what we do.

The Indian cushion (overleaf)

India is a kick in the head, a punch in the stomach, a claw at the heart, and generally involves many bodily functions. In a dark little palace in Jodhpur a woman materialized from an archway and asked 'Aren't you from Glorafilia? Are you here researching an Indian book?' The shocked reply was no. While kilims and Oriental patterns are marvelous for needlepoint, Indian designs are generally too complex, relying on fine and fiddly detail for their impact. Nevertheless, the fine and fiddly have been tamed for our cushion, and the original myriad tiny threads and squiggles and overlaid silks and underlaid stitches have been adapted into one of our favorite designs in this book (see the photograph overleaf). The complexity is suggested without sacrificing the effect of the patchwork fragments. The effect of inserted mirrors typical of this work has been suggested by using a combination of cotton and fine metallic thread.

Mirror work, or shisha, originated in the Sind desert. The mirrors are not for the evil eye, as one would think, but to imitate the sparkle of water. It probably started when Europeans brought a profusion of glass to India to trade, particularly in Gujarat. Farming and pastoral castes used it, buying chunks in bazaars and cutting off pieces. Shisha work is done for the trousseau, theoretically by the girl who will have started stitching at five, more often by Grandma – and will be presented at the wedding, along with hammocks for babies, quilts, and trappings for animals. The nomad mother has to make all the clothes, so this is a symbolic test (look favorably on me – I am good with needle!).

Each caste has a range of motifs and colors that identify it. And it is the duty of the mother to pass these to her daughters, and so-on through the generations, clearly stating: we are who we are.

OPPOSITE *Two cushions inspired by the painted mud houses of the Kassena tribes people of Northern Ghana.*

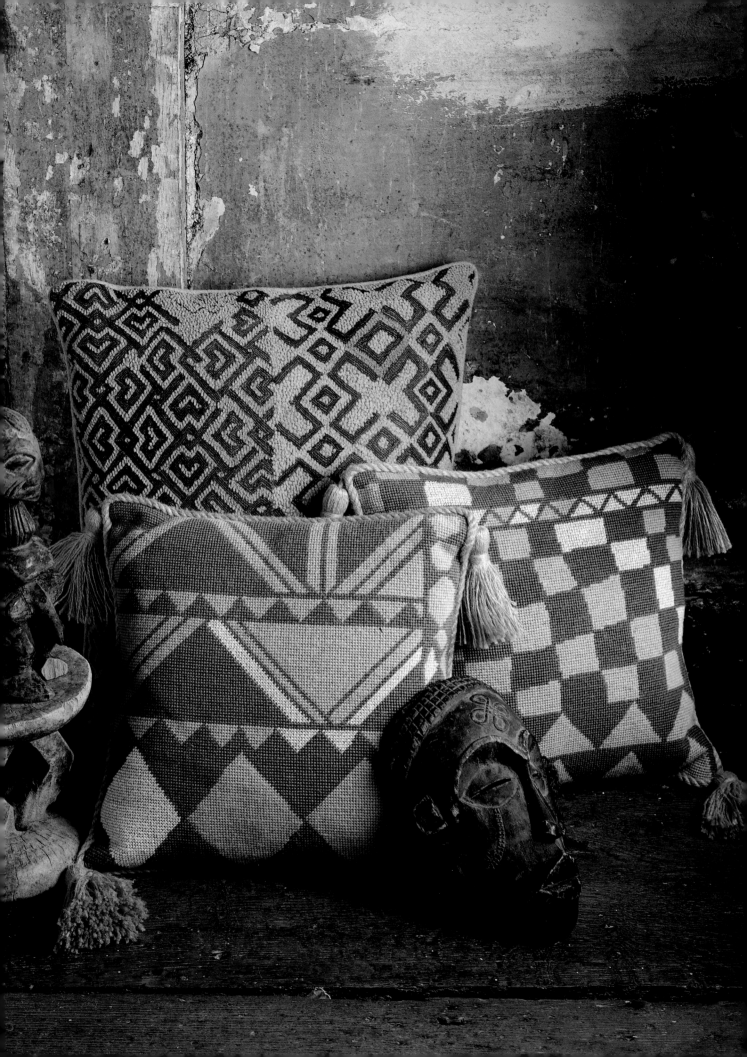

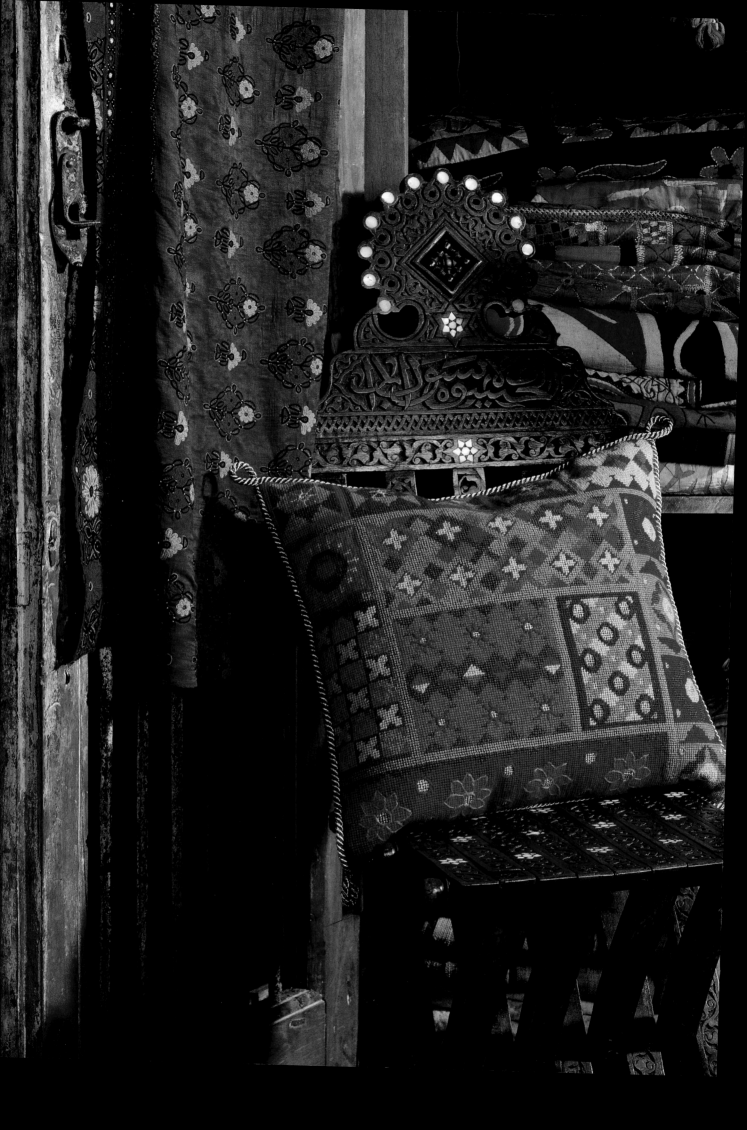

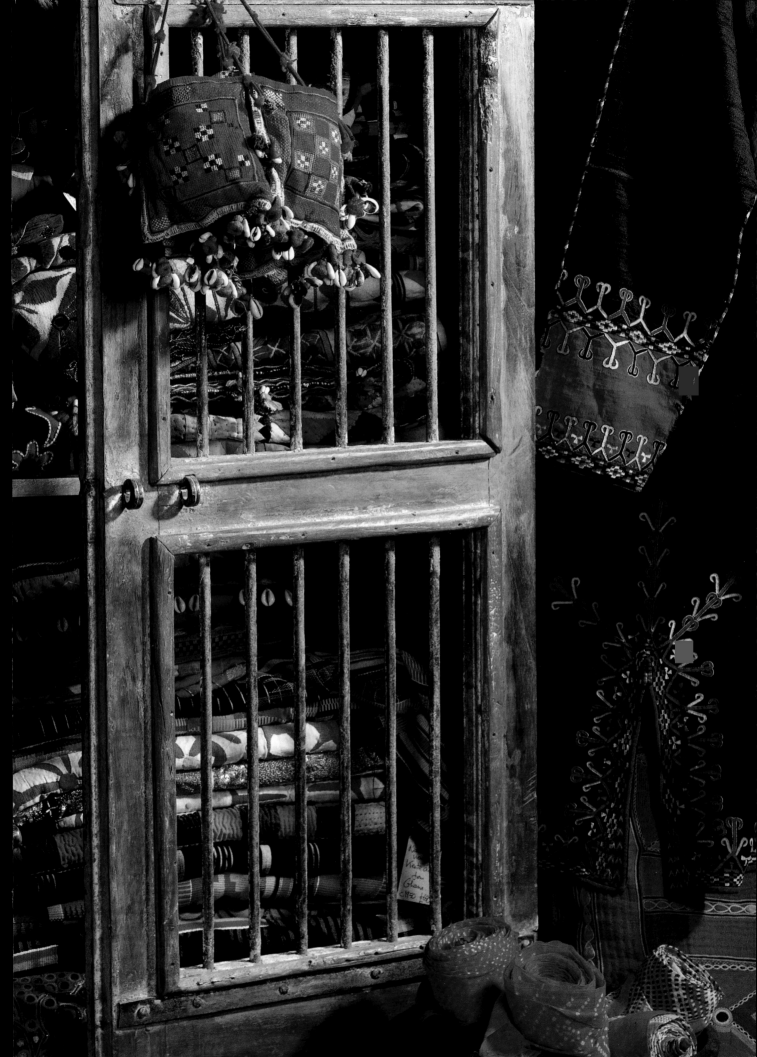

Australian Aboriginal art

THE RUNNING FEET
*Detail from Australian Aborigine painting worked in
needlepoint (right). The picture depicts a mother and child
running in a storm from the cave where the child was born.*

Traditionally, the art of the Western desert was expressed with rock paintings and engravings, sand and body painting, none of which traveled well. Now that conventional painting equipment is available to these communities, their art is actually accessible to us outside their desert homes. As with the generations of women who do Indian shisha work, it is the Aboriginal women who are the 'custodians' not only of their land, but the designs, songs, myths and ceremonies that they hand down.

Our wallhanging was inspired by a painting by an artist called Millie Skeen, from Kamirarra, and depicts a mother and child, sheltering from a raging storm in a cave where the child was born, eventually becoming so frightened that they run away. Ritual songs and dances recount this same story, and go back to the formative period of Dreamtime, the mythological age when all was magical, as it is in a dream.

We were asked to paint this on canvas by Judith Todd, an Australian customer, and were intrigued by the 'dot dot' technique used, forming pattern, not a realistic representation like the pointillists. With this style of painting, acrylic dots are painstakingly applied, the smaller and neater, the better. Judith chose to work the wallhanging in cross stitch, and it was an excellent decision because somehow the converting of the little dots into canvas-grid squares creates cubes of color that lose nothing of the impact of the original for sheer strength. In fact, the whole piece dazzles like some gorgeous firework, with its swirly shapes and solid masses. The running-away feet are worked in cotton perle, and the yarn's twist has a luminous sheen that really contrasts with the wool.

These brilliant colors are less usual than the more earthy burnt tones of the outback, which always evoke the dryness of rock and scenery. After years of native art being suppressed, such Aboriginal paintings are finally being acknowledged. And we're delighted they are because they effervesce with such great energy.

PREVIOUS PAGE *The Indian cushion. The chart and making instructions are on pages 134-7.*

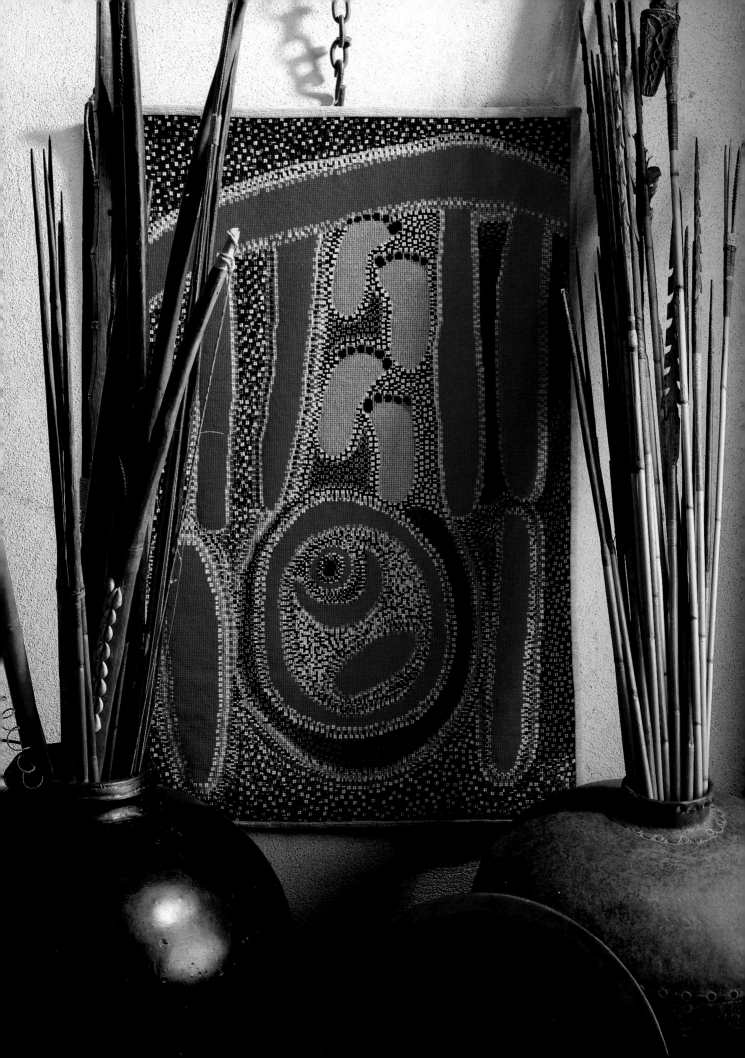

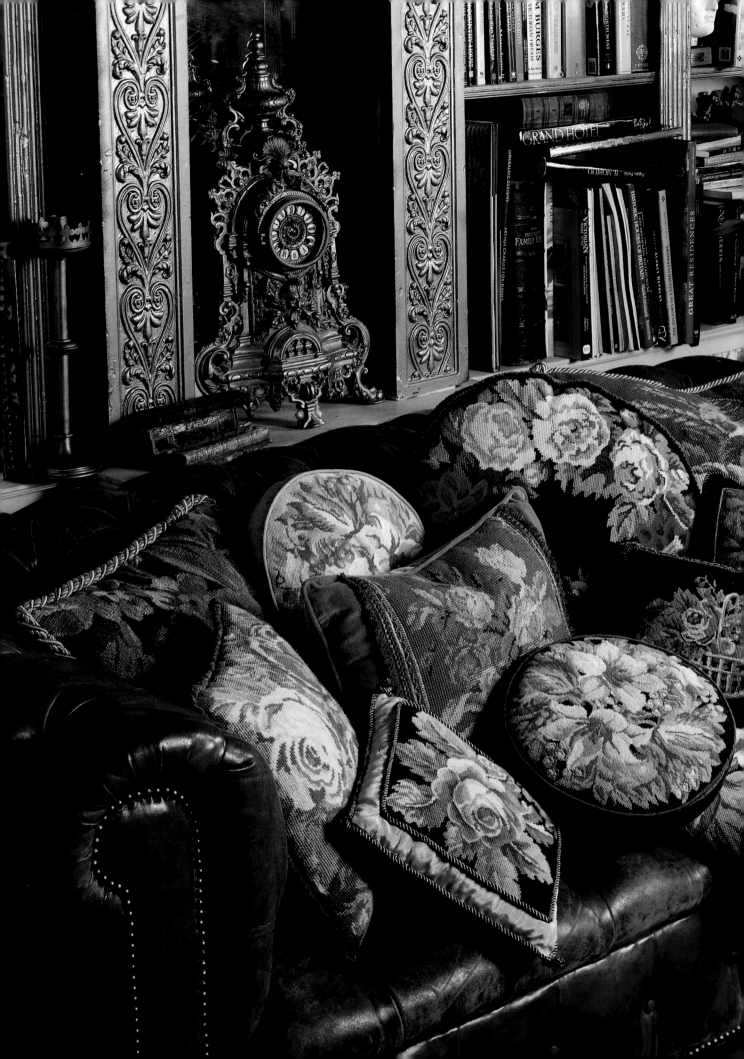

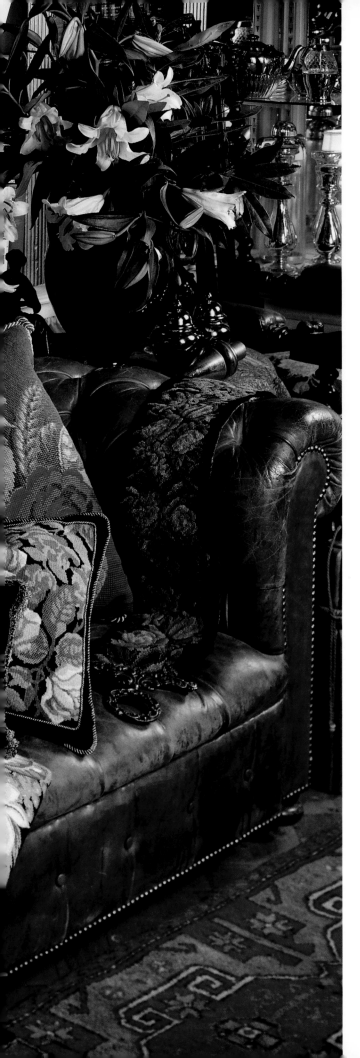

Victoriana

*T*his is the chapter we didn't want to do, because we've done it so often! Glorafilia has been so laden with Victoriana that our identity could have been mistaken. But how could we not include more Victorian designs? It is still one of the most decorative needlepoint styles, and it is easy to see why.

The key is to be excessive, the more the better. Anything that the Victorians could overdo was overdone: an abundance of roses, of lilies, of garlands; dainty, less dainty, vulgarly large; overstuffed, overblown, blooms on rich backgrounds; stools, cushions, bolsters; a sofa-full, a room full. The source material is so wonderful and the original Berlinwork charts unimprovably gorgeous. We thought to call such a range Glorafilia Berlin, Ber from Berman, Lin from Lindey (Carole's married name). Cute, non?

Rather than the charts, we tend to use pieces of Victorian needlework that we buy for the shop, restore if necessary, make into cushions, and en route adapt the design a little for professional etiquette – though as far as Victoriana goes, the motto has to be Plagiarism is Good.

A SELECTION OF OUR VICTORIAN-STYLE CUSHIONS, PILED HIGH IN A FABULOUSLY RICH SETTING.

Victorian garlands

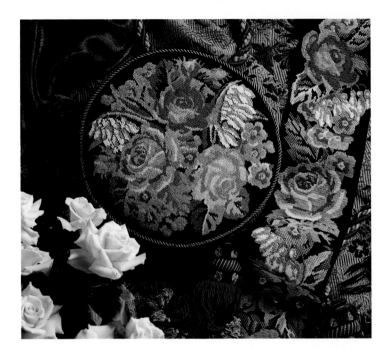

ROSES IN NEEDLEPOINT
For a while we became very excited about beadwork (above),
but were unable to communicate how great this is to do, nor
convince customers that, really, the beads wouldn't fall through
the holes. To the right is Victorian Garlands; the chart and
making instructions are on pages 138-40.

We compulsively rummage at antique fairs knowing that apart from the pieces on display, there is always a box hidden under the table, full of scraps gloriously faded and frayed. We drool over the old wool colors, but turn a Victorian piece over and the unfaded colors on the back are quite neon, tinted with lurid aniline dyes that we would shudder to use. The ostentatious taste the Victorians had is always such a surprise. All that stuff about modest piano legs, when smouldering beneath demure tasselled folds, all bustled and restrained, was an emotional riot.

To imitate the faded look we love now is quite difficult, substituting odd mauves and grays for browns and greens. In our shop we do a lot of special commissions, and probably the majority of these are adaptations of our floral Victorian designs for cus-

tomers' stools, sets of chairs or rugs. The project opposite is adapted from a cushion we bought at an antique fair, with several generations of abuse worked into the stitches. Once cleaned, it looked truly superb, and we restored its frayed bits, using mixtures of crewel shades. Later, after Plagiarism Had Taken Place, we sold it, and have regretted it ever since. The list of pieces we regret having sold is extremely long, but had we kept them all, Glorafilia could resemble a padded-cell.

We have two Victorian designs that seem to go on forever, and we affectionately call them 933 and 675. One year we leave one out of the catalogue and the next have to reinstate it. At times we have made them larger, made them elongated to fit footstools, made them into rugs, converted them into ambitious chairs.

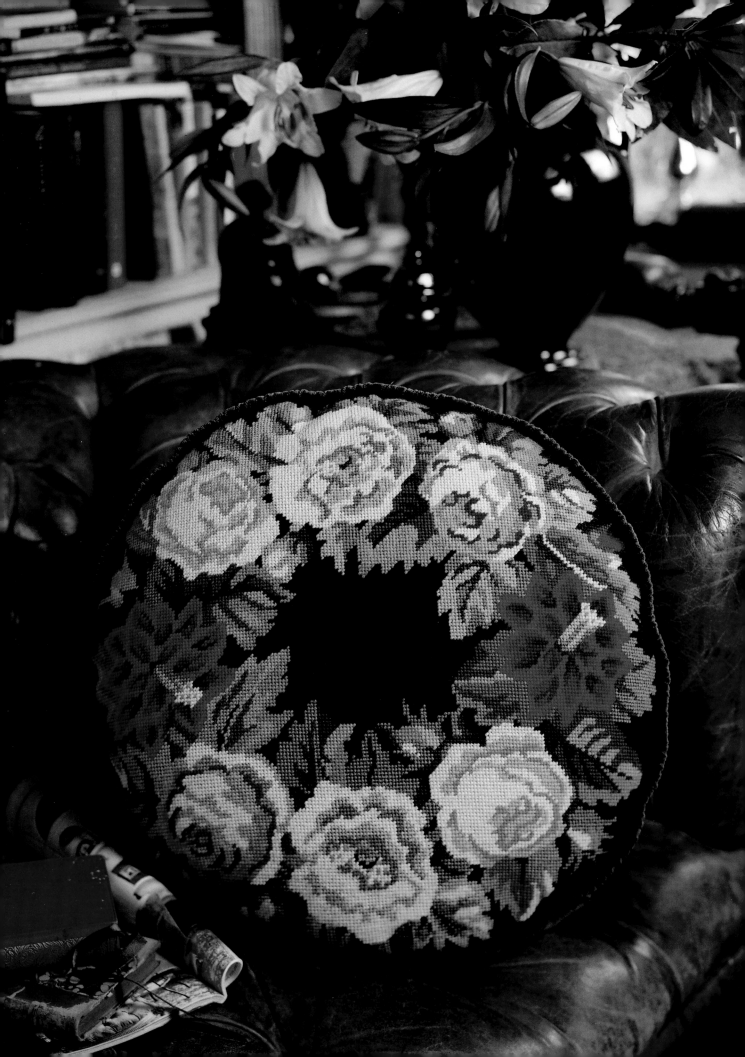

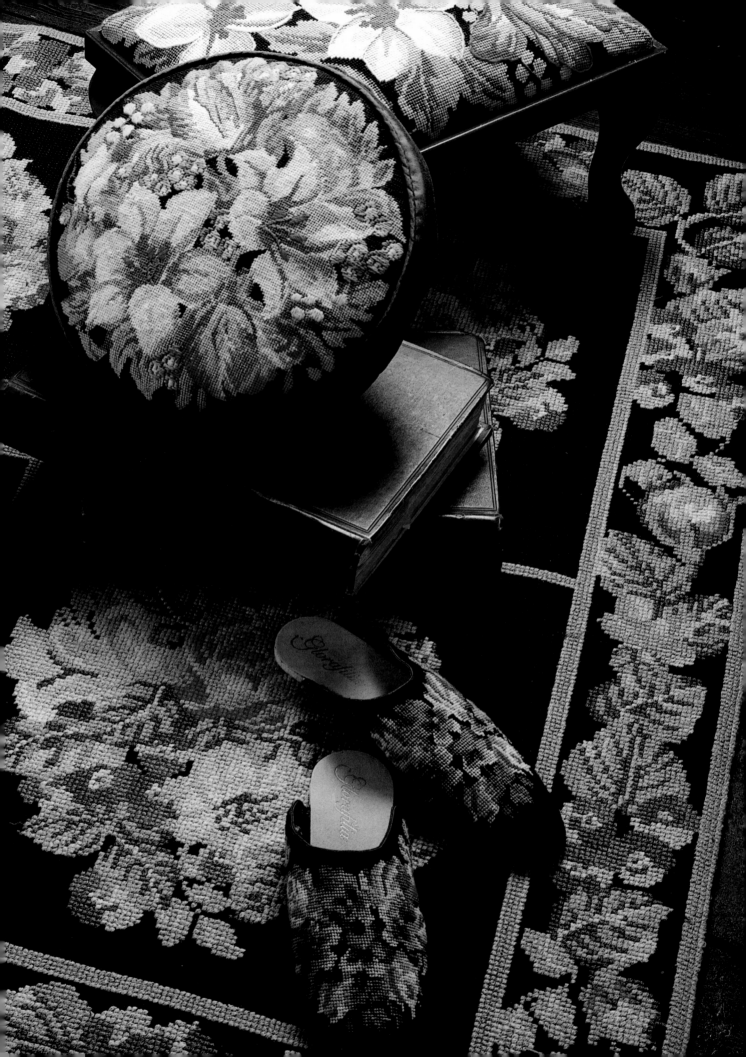

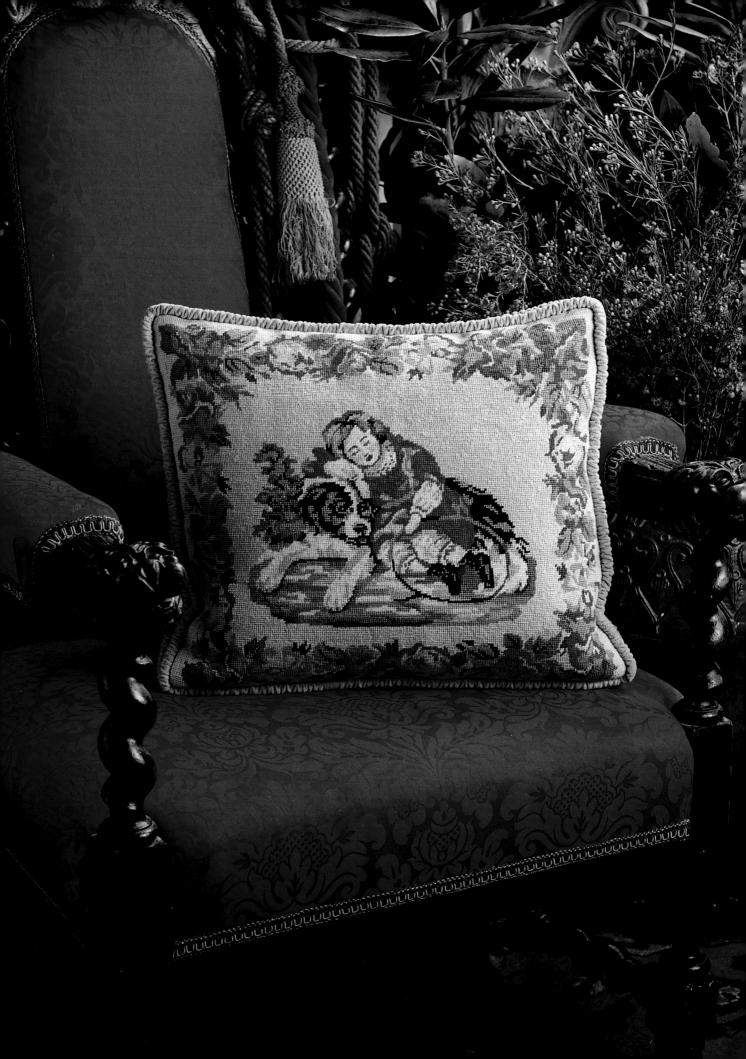

Other Victorian designs

VICTORIAN MINIATURE DESIGNS
The designs above are the first of our many mini-series, and are
still the richest and most jewel-like. Opposite is a cushion
featuring the Child and Dog design.

The Child and Dog design opposite was inspired by a Victorian original we found many years ago. Our version is worked on finer canvas, which gave the opportunity to define the features and form more sharply – also our dog is well-groomed, whereas the original had several forms of mange and foot-rot. We think it is a charming picture. The whole thing is worked in tent stitch to give the traditional flat look; for once we resisted outlining in stem stitch and just reversed the tent stitch on her mouth and eyebrows to prevent any distracting jagged lines.

The tiny kits shown above came about because we were often asked for 'something small' – needlepoint for people who just wanted to experiment, or just wanted something that would go in a handbag for waiting-rooms and journeys. One can look great set into an elaborately large and braided cushion, four can be joined together, or hung as a set of pictures, or set into a patchwork quilt, or made into coasters, or, or, or... They have been stitched very simply but could be made multi-dimensional by using stitchery.

We are always reminding our customers in the shop that we two are not stitching experts, which seems to be reassuring. The most important aspect of needlepoint is to enjoy it. In fact, one of us, who shall be nameless, but whose name starts with a 'J', has a blockage about french knots, they hang off her canvas like little yoyos. Fortunately, she has other gifts. Most of our girls at the Old Mill House are marvelous stitchers, as are the ladies who sew our samples so brilliantly. We sit and experiment with outlining and stitchery, work expressions on faces, and make alterations if something isn't quite right when completed: a bent antennae, an atrophied leaf (stitching can unnervingly emphasize a fault that doesn't show on the painted canvas).

We long for the day when we can sit peacefully and actually work a canvas to the end, in our own time, not because there is a deadline.

PREVIOUS PAGE *A Victorian rug, lilies, roses and a pair of violet slippers.*

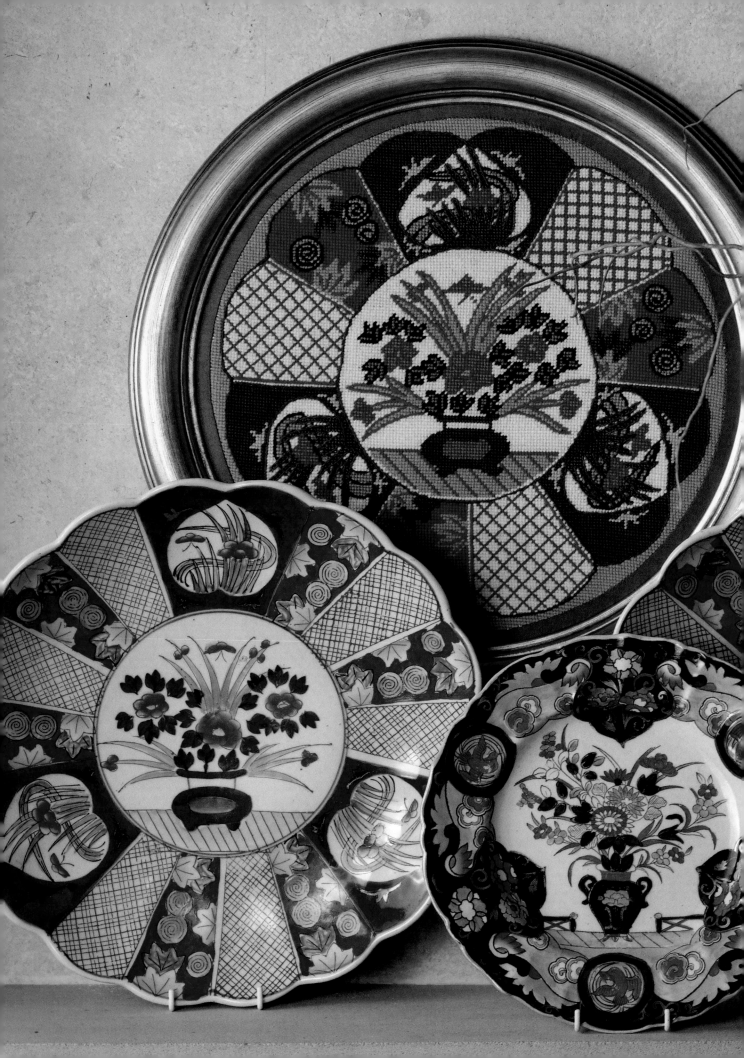

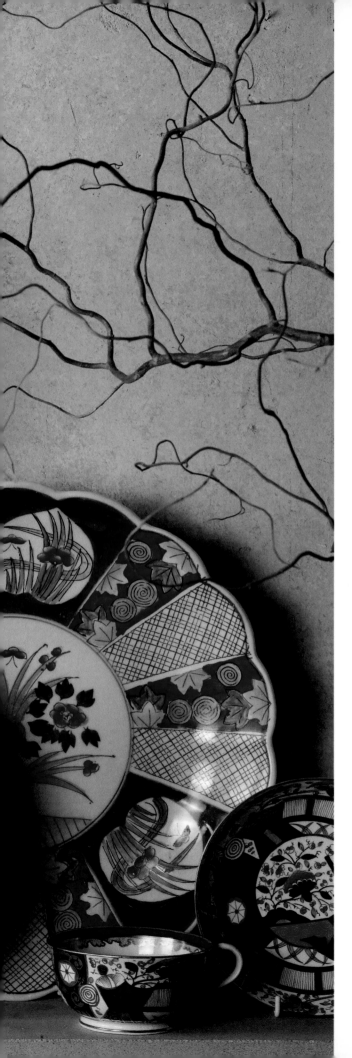

Porcelain
& pottery

*P*orcelain and pottery are a seemingly inex-
haustible source of inspiration, from the
discreetly fine to the brash and outrageous. On
the following pages are fabulous Majolica,
acquired-taste Staffordshire, love it/hate it
Clarice Cliff and, of course, the most collected
and popular of all: blue and white.

The inspiration for the circular needlepoint
design opposite was the pair of plates shown
below it. We found them one Friday morning
in London's Bermondsey Market and in the
winter gloom became excited about their mar-
velous somber colors, smoky browns and
greens. It was rather disappointing when the
encrustation of beautiful grime floated off in
washing-up liquid, leaving behind the bright
Imari colours you see here. We have to admit,
though, that the boldness makes a more dra-
matic needlepoint circle than the subfusc colors
we fleetingly loved.

IMARI PLATE, THE CHART AND MAKING INSTRUCTIONS ARE ON
PAGES 141-43.

Ceramics into needlepoint

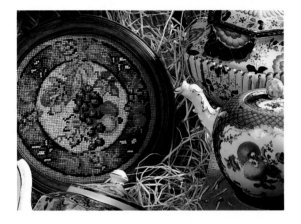

TEAPOT STAND AND BALLOON TREES
The design on a highly-decorated antique teapot inspired this
needlepoint stand, above. Opposite is the Clarice Cliff
Wallhanging, with her typical balloon trees. The chart and
making instructions are on pages 144-7.

Clarice Cliff's is a real rags-to-riches story – a working-class girl with seemingly limited prospects, who became one of her generation's leading pottery designers. Her work is unique and very collectable.

Clarice's original work had thick paint and exaggerated brush strokes as she wanted it to look hand-painted. We have imitated these streaks in our stitching, following the weave of the canvas. The design combines two periods of her work. The cottage and 'balloon' trees were typical of her style in the early thirties, following on from bold geometrical outlines such as those featured in the border. In a world when most china was dainty and tasteful, her work is a barely-contained explosion. The designs are deceptively naive, the colors fantastic: discordant emerald, puce, orange, yolk-yellow, child's sky-blue, blood red. All combined with extraordinary verve, wit and energy, what at first sight can shriek, when seen en masse just sings.

The Potteries were towns around Stoke-on-Trent in Staffordshire where few children continued their schooling beyond thirteen. Clarice became an apprentice in the enameling trade in 1912, learning to paint freehand onto pottery. At 17, she was employed to decorate earthenware, and spent most of her free time learning as much as she could about the technical processes involved – she also made little models in clay, taught Sunday school classes and made her own clothes. Her work absorbed her so much that it precluded any social life, and so it continued until 1924, when she began producing work with her name impressed on it, Clarice C., and moved out of her family home into some rooms above a hairdresser, which was thought highly improper for a young single woman to do. Her name also became scandalously linked with that of Colley Shorter, her employer, 17 years her senior and married.

Their relationship, both personal and creative, flourished for many years and after his wife died they were secretly married. When Colley died, 23 years later, Clarice was grief-stricken. For most of her life she had been ostracized by others, and Colley had been her closest friend, as well as her husband. She lived in seclusion, unaware of the growing excitement that her early work was creating among collectors from all over the world.

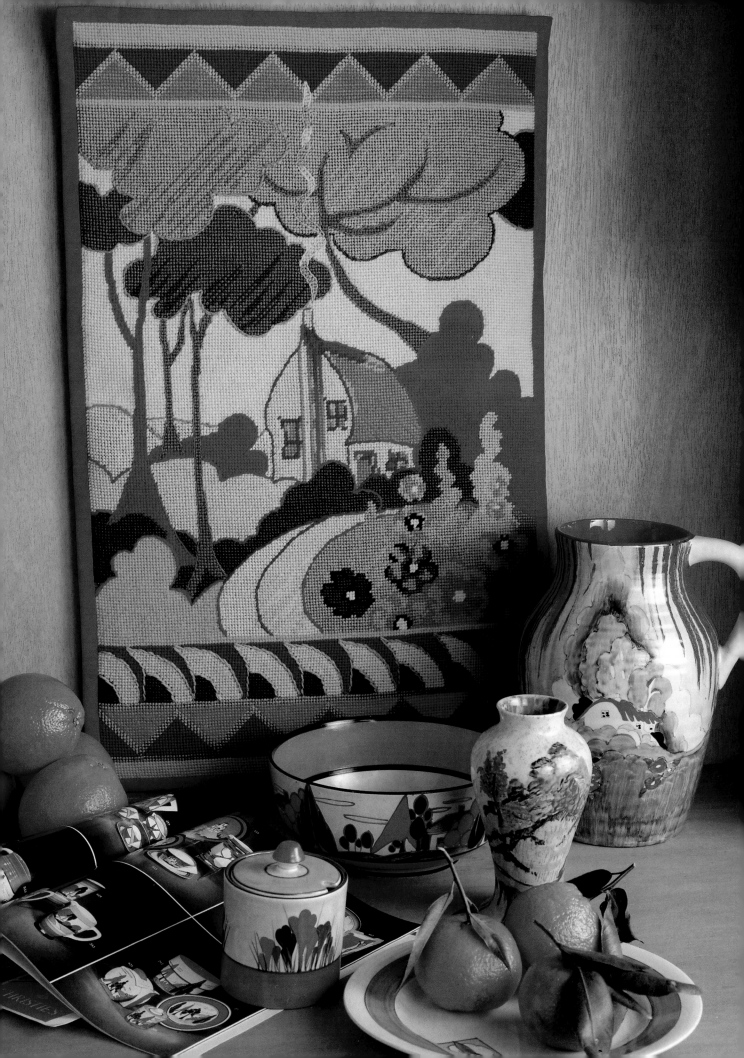

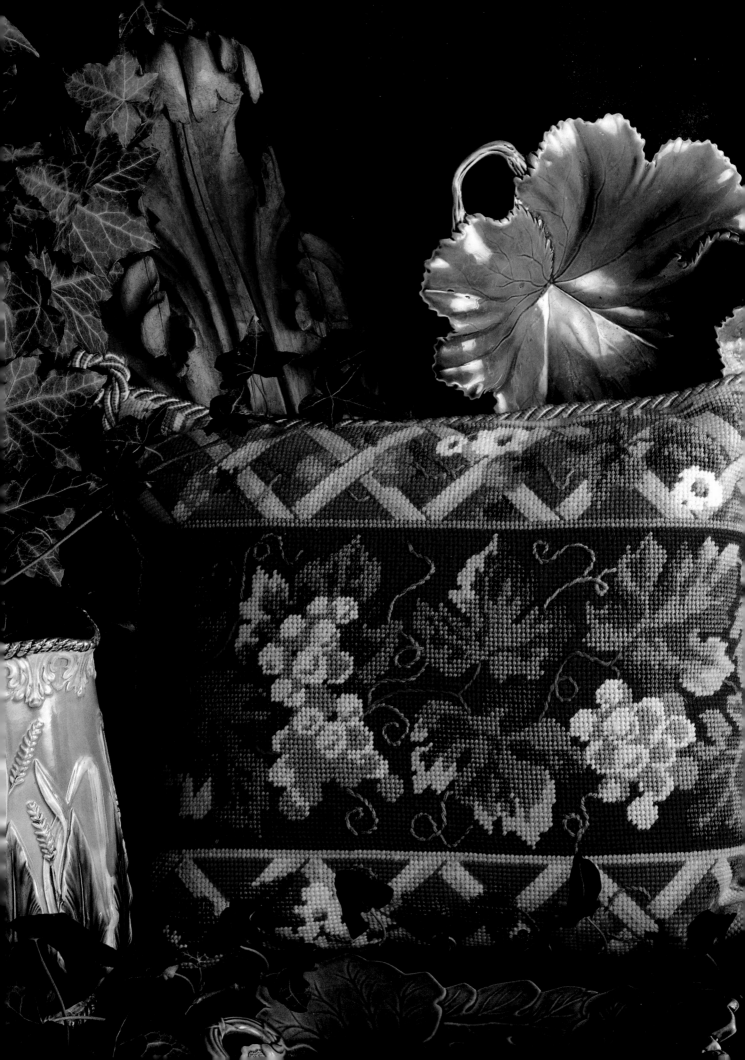

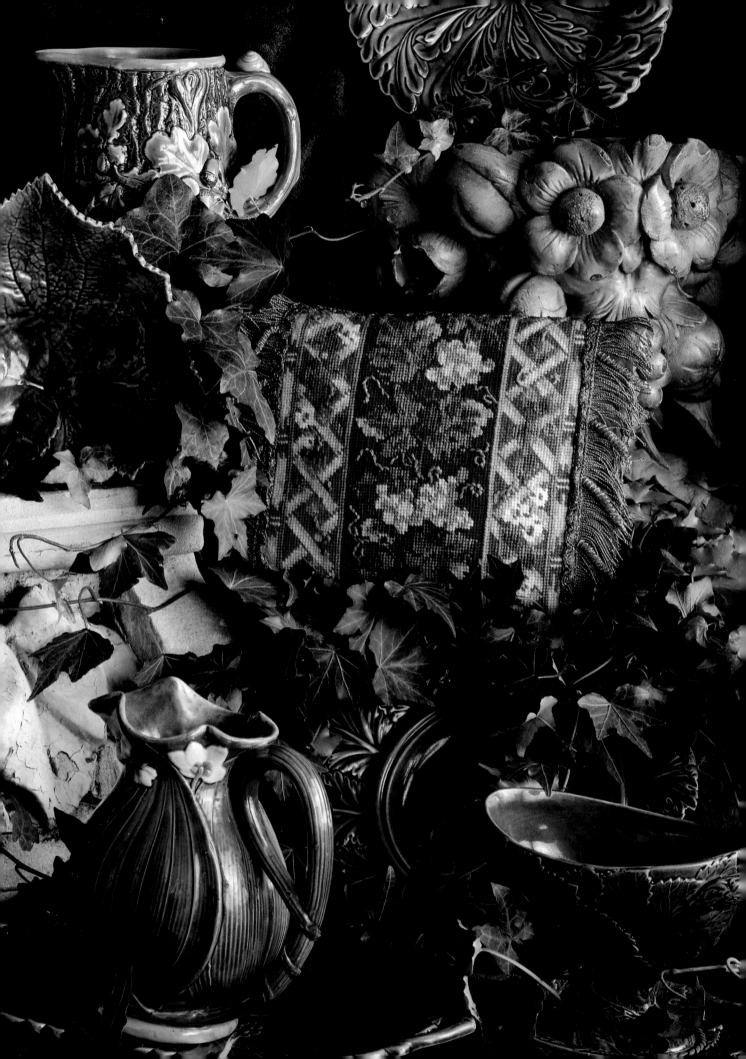

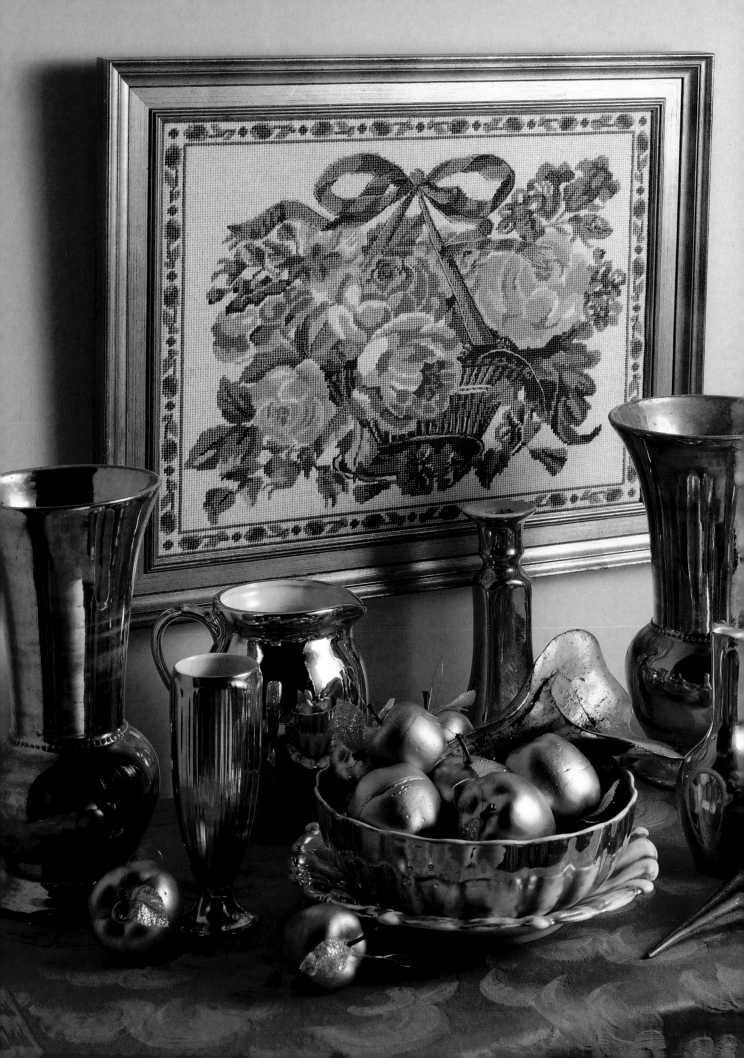

Sèvres porcelain

RIBBONS AND BOWS
Above and opposite: Romantic designs from a series adapted
from Sèvres porcelain, the characteristics of which are clear colors
and elaborate decorative detail.

The designs opposite and above were inspired by pieces in the Wallace Collection. For those who have not visited one of London's jewels, the collection is in a somber-looking house in Manchester Square, off Baker Street, and oozes vast amounts of romantic froth... French furniture inlaid and overlaid, paintings of such sublime sweetness as Fragonard's girl on a swing, tiny boxes, tinier boxes, marble cherubs with squeezable flesh, Boucher paintings you want to lick.

Among all this restrained stuff can be found truly gorgeous porcelain – beribboned baskets full of flowers and fruit in stunning colors. The royal porcelain factory at Sèvres used deep royal and cerulean blue backgrounds, and copied the brilliant turquoise used by the Persians.

On the previous pages are two cushions inspired by the glazes and motifs of Majolica, the Victorian form of opaque-colored glaze, loosely related to the multi-colored earthenware made in Florence four centuries before (Maiolica). The colors were achieved through laborious experimentation, testing glazes until their luster and vibrancy were perfected – although it was eventually realized that the lead in the glazes was highly toxic. The factories were closed, and the imitations that followed never matched the same brilliance. Wool, with its absorption of light, can never hope to achieve the same luminosity, but can certainly adapt the flamboyant ochers, sugar pinks, cobalts and particularly the fabulous hot spectrum of greens we have shown.

A far cry from the passion and extravagance of Majolica are the Staffordshire animals on the following pages. As well as looking disdainful, they look constipated. There is a wonderful, whimsical eccentricity about Staffordshire china, and having needlepointed dozens of cats and dogs over the years, we only tried Staffordshire when we did our Miniatures book, and realized how perfect is their stylized immobility for needlepoint.

PREVIOUS PAGE *Needlepoint adapted from Majolica pottery, using the colors of the ceramic glazes.*

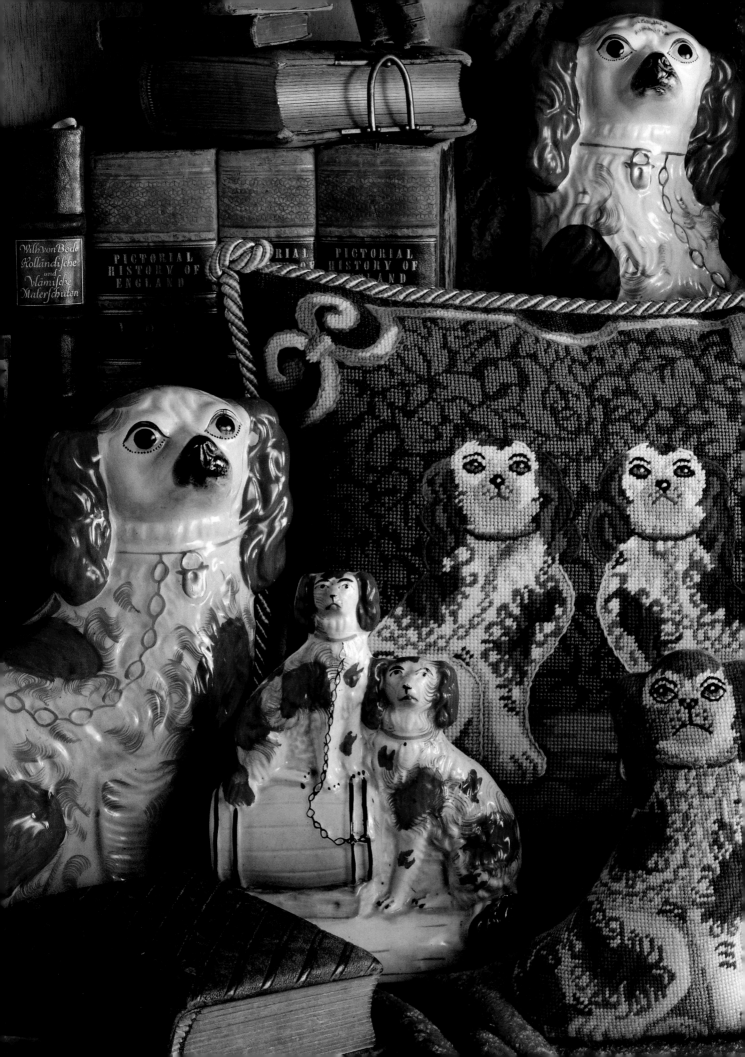

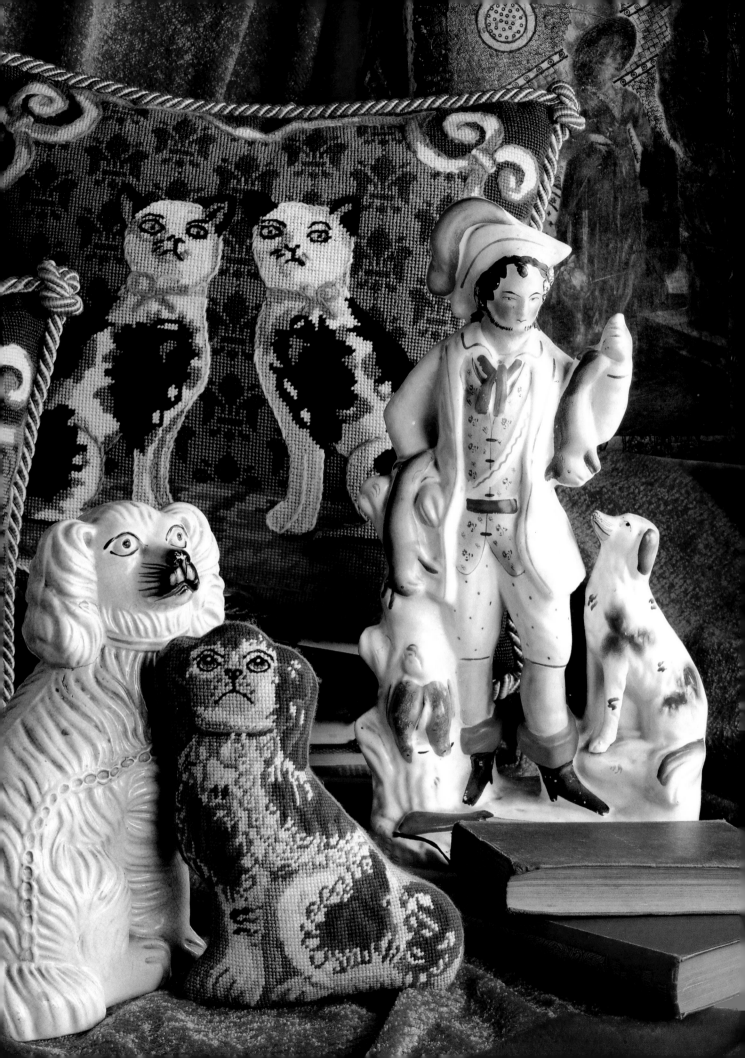

Blue & white

A h, blue and white. So much, made by so many, over such a long time. The most collected and used china, the most loved combination of shades. Blue and white is honest, and its limitations have encouraged huge creativity in design and style.

We whimsically like to imagine collectors needle-pointing this tea cosy for use with a blue and white teapot, standing on a starched white cloth embroidered with bluebells and lily of the valley, eating from a plate of tiny blueberry muffins.

We have several friends who collect blue and white – and who are also the easiest people to buy presents for – and we particularly love the collection we photographed overleaf for its bold scale. Our two cushions disguise themselves very effectively as Spode, and are both worked using tent stitch in five shades of blue, with stem stitch for emphasis and to allow curves to really curve, without broken lines.

The first blue and white design we did was in the dark and distant ages and was one of the very earliest canvases we printed. Over the years we then introduced some Oriental designs in blue and white, which nobody wanted, and some Provençal designs, which nine people wanted – also some blue fuchsias which everyone wanted. It wasn't until Jennifer's collection of blue and white china had covered every available shelf, wall, ledge and cupboard top in her kitchen that she said 'Eureka' and the China Collection began.

Some of these canvases were painted in monotones of pinks and greens but the response was not the same as for the blue and white. We must assume it is the special quality that blue and white has, the reason people give for collecting it: it is never pretentious.

PREVIOUS PAGE *Needlepointed Staffordshire animals, with their dead-pan expressions.*
RIGHT *A Blue and White Tea Cosy. The chart and making instructions are on pages 148-9.*
OVERLEAF *Spode Flower Basket and English China Plate cushions standing among the beautiful Spode originals that inspired these blue and white designs.*

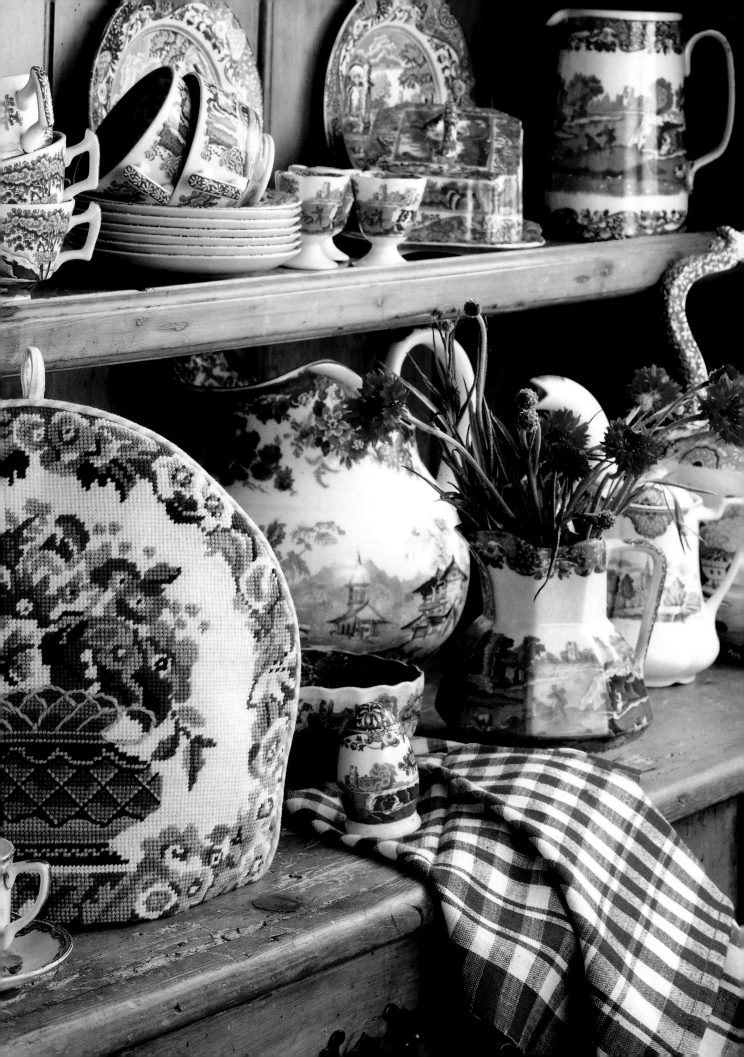

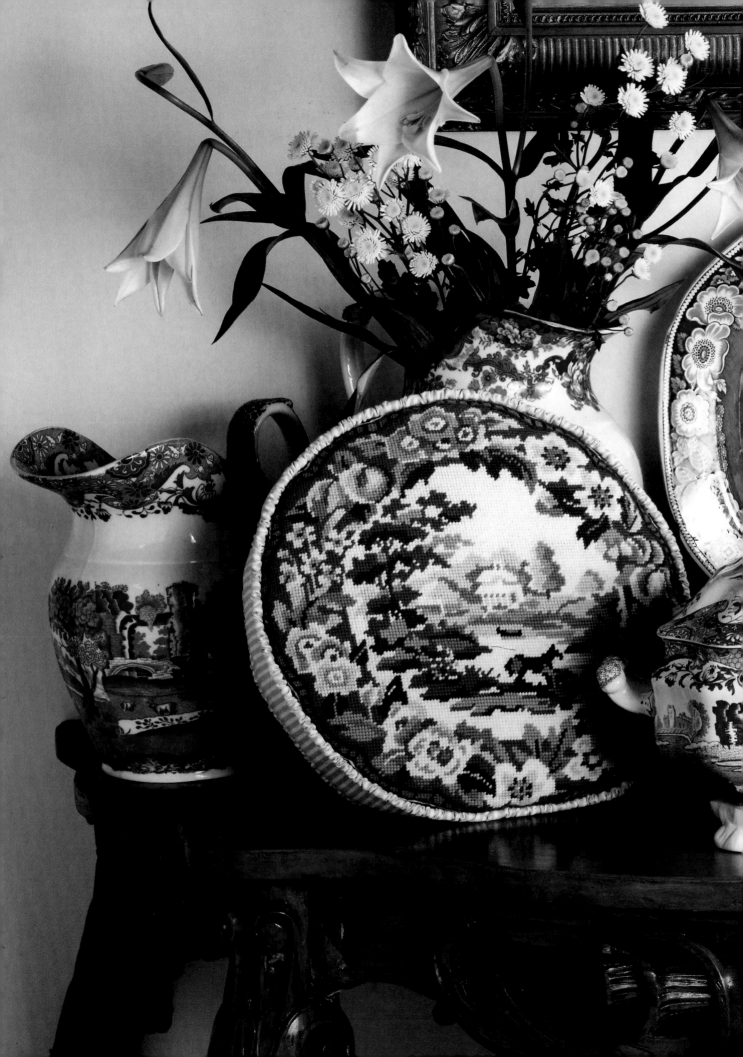

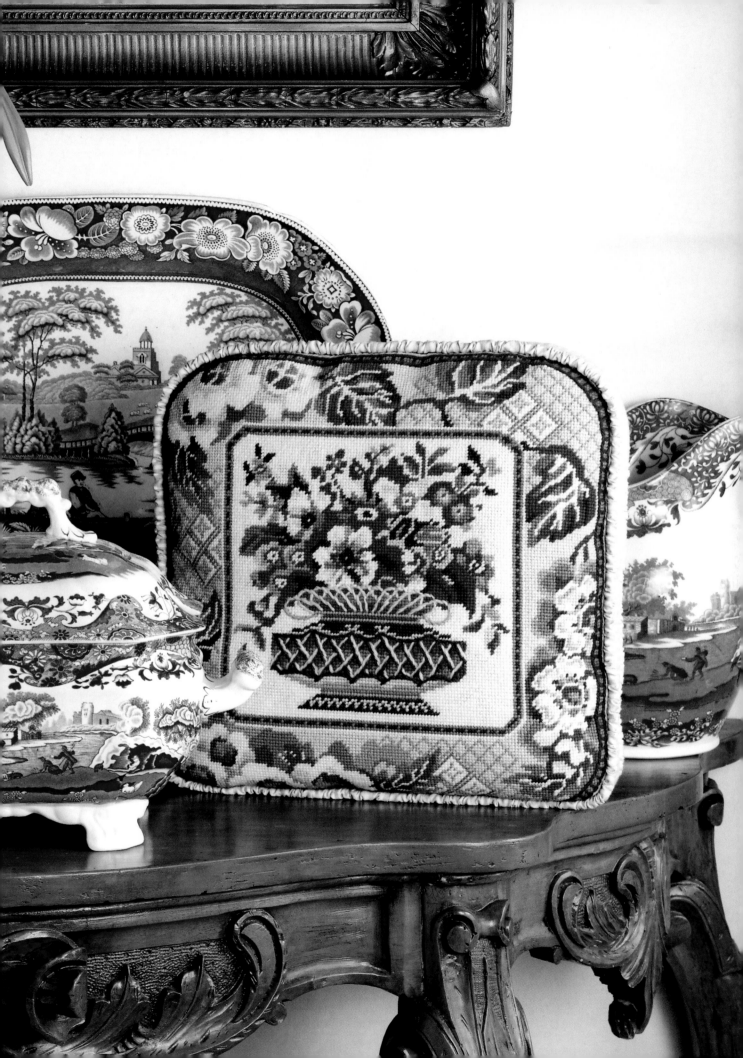

Inspirational blue

SPODE CHINA ADAPTATIONS
Our first blue and white china designs were four small
pictures, two of which are shown on the top shelf of the
dresser opposite. After that we became unstoppable.

There are countless blues making innumerable stunning possibilities. Whether Iznik or Delft, turquoise, cornflower or royal, from Provence or Staffordshire, the combinations are always dazzling and always renewable. Introduce some blue irises or a bowl of massed blue hyacinths to a blue and white room, and watch the dynamics of the existing color scheme alter.

Emperors in China wore blue when they worshipped the sky; to Tibetan monks, blue represents awareness; in East Africa, it means fertility and birth, and lapis lazuli has been the most precious pigment for paint for the last 5,000 years. Then there's Ol' Blue Eyes himself, blue chips, blue moon...the pediment of the Parthenon was painted blue to match the sky, ultramarine means blue from beyond the sea.

Paint your door blue to ward off evil spirits, think of a blue city like Jodhpur, the brilliance of old blue medicine bottles, and Derek Jarman's 'slow blue love of delphinium day'. We use blue as an allusion to happiness, a blue sky is synonymous with sunshine. And, of course, the uniform of the century, that which will turn the inhabitants of our world into one homogeneous mass, that fabric from Nimes: denim.

The great eighteenth-century contribution to blue and white's popularity was the upsurge of porcelain factories and potteries making blue and white china, as well as huge quantities of Chinese imports into Europe and America. Interestingly, the world's most popular design, the Willow Pattern, was not Chinese but made by Thomas Minton, caught up in the enthusiasm for all things Chinese. Two factors that influenced the phenomenal pottery output were Josiah Spode's perfecting blue underglaze painting and the prohibitive tax on tea being reduced, increasing the frequency of tea drinking, and thus the demand for tea-paraphernalia.

All this source material provides marvellous inspiration for needlework. As with toile de Jouy, where we work with tones of the same color, finding five blues can be quite a challenge: they must harmonize without blending too much, contrast but not be too contrasting, otherwise we'll be at navy by the third color. One group of color may not provide a sufficiently wide run of tones, so some mixing and matching has to be done; perhaps a mauvish tinge could work surprisingly well, or an icy blue when the rest are warmer. All you need is the patience to experiment.

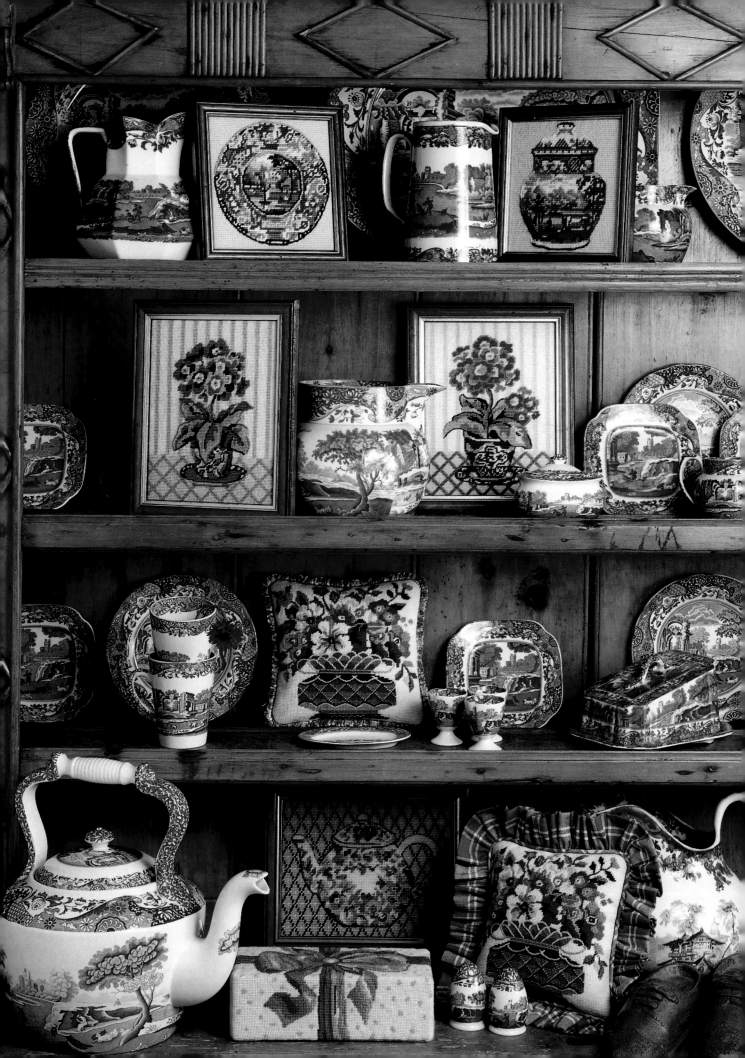

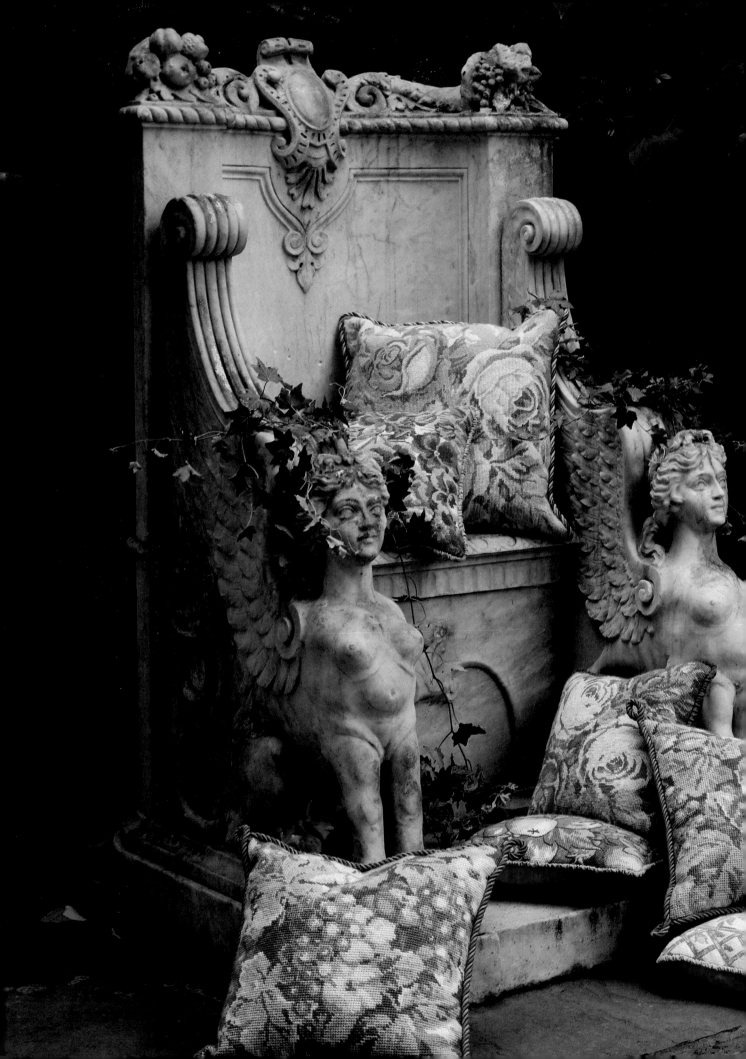

English floral

When we think of English gardens (even slightly Italianate English gardens, as the one shown here), we think of that spontaneous rambliness that relies on little paths covered in columbine and aubrietia, overblown roses cascading, and respect for the waywardness of nature. To us, the perfect English garden would be walled and secretive and within earshot of the church clock, the air quite still except for insects, with a bench beneath a damson tree. There would be an arbor, and trailing walkways, statuary and maybe some gentle water. In spring, catkins will drop to meet the daffodils, and in fall the familiar mellowness pervades everything. A garden is a place where as children we could lose ourselves and in adulthood intentionally do the same thing. For many of us, gardening acts almost as a meditation, and is perhaps the only true link we have with nature in increasingly synthetic lives. Time resists being pushed and we observe rhythms not of our making.

A SELECTION OF SOME OF OUR FAVORITE FLORAL CUSHIONS, EACH STITCHED IN GENTLE GARDEN SHADES.

The English garden

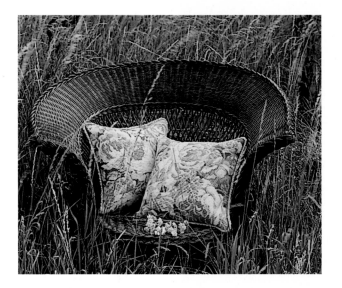

SUMMER ROSES & PANSIES
*Summer Roses (above) and Pansies Cushion and Cottage Tea
Cosy (opposite). The garden settings emphasize the designs'
deliciously summery overtones.*

There is a wonderful house called Little Thakeham in West Sussex. It was designed by Lutyens and has that perfect combination of proportion, brickwork, eccentric chimneys and setting that make it truly beautiful. Lutyens collaborated with Gertrude Jekyll on many projects. He built the houses, she designed magical gardens to soften the architecture, gardens almost cottage-like in their lack of pretension. Little Thakeham's garden seems to exist in a time warp, a place where there are always hot summers, bees, Pimms and the confidence that the weeks following will be exactly the same. The colors of Jekyll's gardens were harmonious, the borders overflowed naturally, blues and mauves and lovely pastels – here gardens were the color of sugared almonds and fondant creams, with sudden flashes of burnt orange, or scarlet. Sometimes she devoted areas to a particular color, or to one strain only. This style of gardening was a far cry from Victorian gardens, which resembled municipal parks, and instead used moderation and a minimum of theatrical extravagance. In short, she

threw away the rule book and what resulted has been copied and copied and is the epitome of what we call the English Garden.

Just as our two homes are different, so are our gardens. One is a true Jekyll-style country garden, climbing, trailing, and blossoming. In all the colors of larkspur, it is very lovely: creams, pinks, blues and mauves; wistaria, lilacs, delphiniums and weeping cherry. The other was a child's secret garden that took 15 years to create. Wild and overgrown, it reached maturity when the children were at the age for secret relationships rather than secret gardens. Now it has been replaced by a tiny town garden full of statuary and stone, and no room for secrets.

Most of us love flowers. Since time immemorial, people have used them for decoration, to beautify and uplift – extravagant ephemera, a proffered apology, weeds picked by an unjudgmental child. Flowers in

OVERLEAF *English Floral Roses. The chart and making instructions are on pages 150-1.*

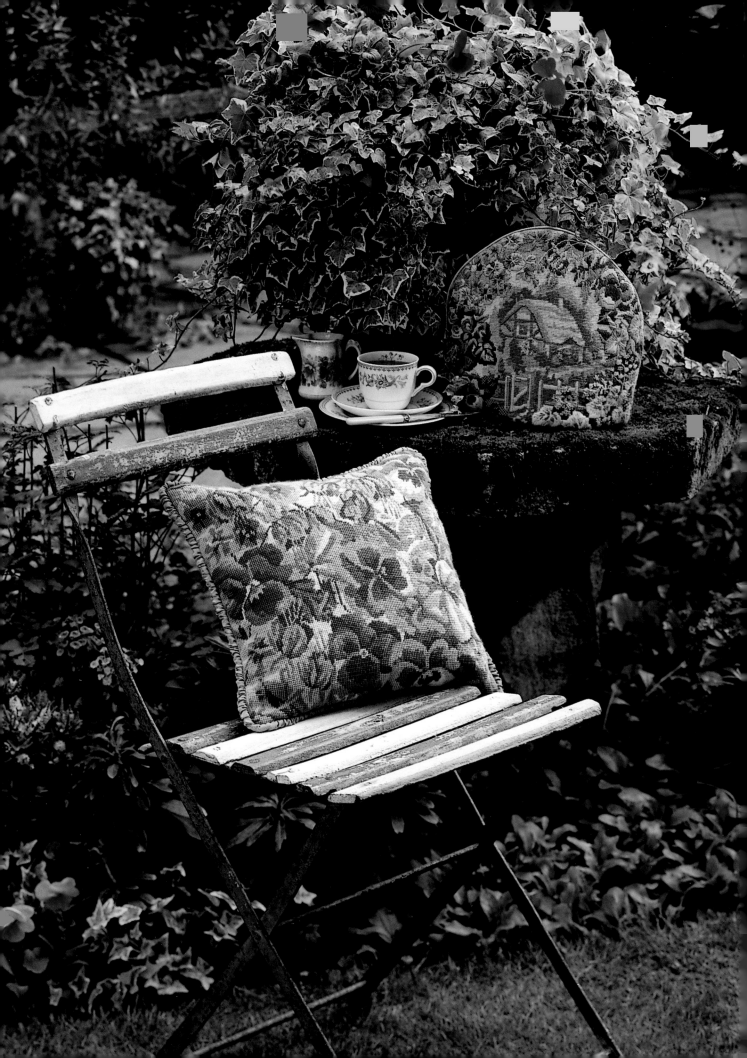

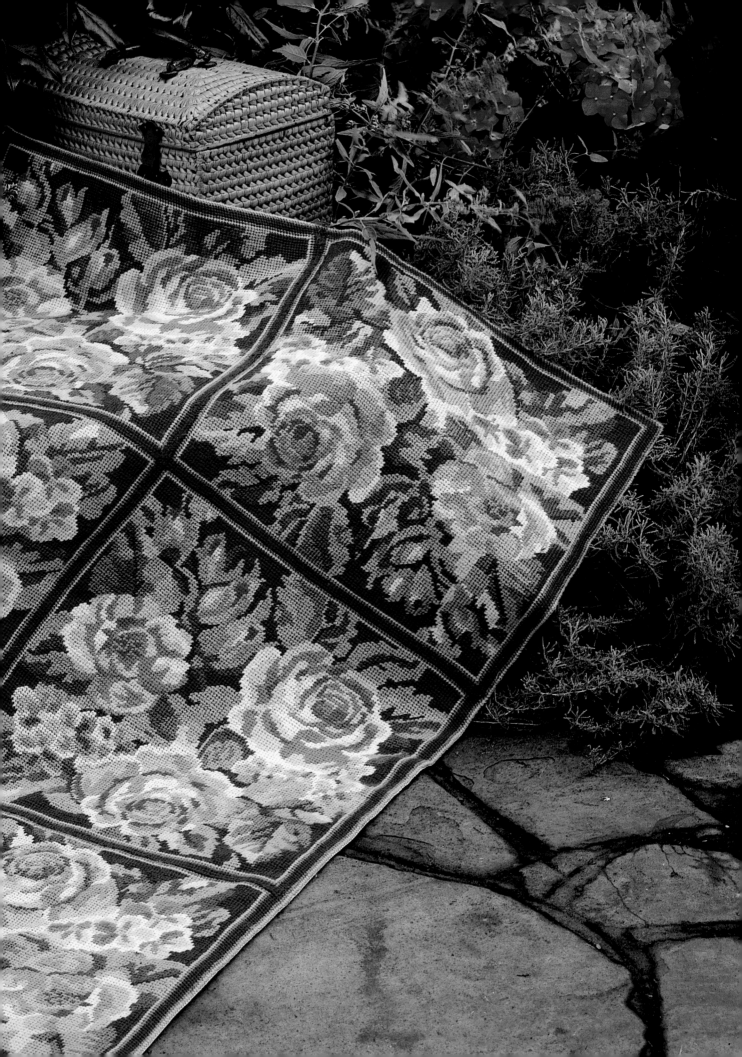

VARIATIONS ON A ROSE
Above: The Pink Rose. Opposite: Wrought Iron Roses; the chart
and making instructions are on pages 152-5.

the house have reached a state of high art, consequently we are more and more conscious of our gardens. However, England is England – the hot hibiscus colors of the Tropics or fucshia and flame of Indian bourgainvillea can be transplanted – but they are somehow wrong in such a green and pleasant land. No matter the influences, or the pattern of British summers becoming longer and hotter, to us the understatement of the English temperament is personified by the hidden and the delicate: bluebells, blossoms blown by the wind, dangling wistaria and laburnum, pale and intoxicating roses.

There is a memory of Tamsin at Waddesdon Manor, the modest Rothschild pile in Buckinghamshire. Waddesdon has a valley of daffodils, a gentle slope sweeping through part of the gardens that around Easter is completely swathed in gold. Perhaps the hill faces north and is cold – whatever, the daffodils seem to open later than anywhere else; and it isn't always easy to time it right. But that year with Tamsin was perfect, and the flowers were at their absolute daffodilness. She must have been about three, and she started running from the top of the hill

and skipped and danced down to the bottom. The sun was beginning to be warm, her hair bubbled behind her, and she looked like a giggling flower fairy among the yellow stars. Having no camera, we had to commit the picture to the inner eye, as did Wordsworth with 'The Daffodils'. Had he had his Nikon with him, he may well have not written the poem. And had this gorgeous image been photographed, it would now be among many others in an album or drawer. Because it wasn't, it can be conjured at will, a perfect image from the detritus of memory.

The colors of our Wrought Iron Roses show the yellows and ashy silver greens so often seen, with flashes of terracotta. The Pansies cushion (see page 81), in muted mauves and greens, with small ocher pansies and hypericum, has the similar herbaceous-border feeling of many successful gardens – subtlety shot with colour.

The English Floral Roses rug (previous pages) consists of six squares in two colorways; the three that are predominantly pink facing one way, the three predominantly yellow facing the other way. Alternatively, one of each edged in braid, make a beautiful pair of

cushions. The beauty of working from a chart is that you can improvize the colors yourself, for example this could look superb in all shades of gray, from charcoal to pastel, or perhaps greens, blues and mauves – still big and overblown, but less pretty.

The chair in the arbor came three years after our Impressionist book, and is a leftover reflex of Monet – as with most addictions, one has to be weaned gently. It was inspired by a late painting he did at Giverny, climbing roses against a hyacinth sky, and is included here, in a walkway of wistaria, for sentimental reasons. At Giverny, the choice of flowers is similar to those grown in Britain – the same northern azaleas, irises and tulips, the roses, nasturtiums and poppies, the overblown dahlias – but it isn't only what is grown, it's the scale of Monet's grand scheme. As something dies, there is another variety ready to replace it in fabulous excess. It's ironic that the epitome of what we think of as the English Garden look should be in France.

The pleasures of stitching
People who are gardeners are often needlepointers, too, though there is nothing to suggest that this applies to Monet. With both, it is important to watch something grow, at its own pace. However, there does come a time when the last stitch is stitched, whereas a garden is never finished, and continues to evolve. Both are an act of hope, whether by the careful planner or those who throw themselves in with both feet, spontaneously stitching at random or stuffing little roots into soil. We believe more than ever that the way we do needlepoint is a personality reading – our approach, our attitude, our methodology, and finally the end result, with a back looking elegant and organized or like a scenic railway (and all points between). We have seen backs that look like fronts and once a front that we both thought was the back, so inventive was the stitching. We repeat what we said in our first book, and every day since, that none of these things matter, that each piece is individual, and needlepoint is to be enjoyed in whatever form that enjoyment takes.

The Monet chair, standing in an arbor of wistaria, inspired by one of his late paintings at Giverny.

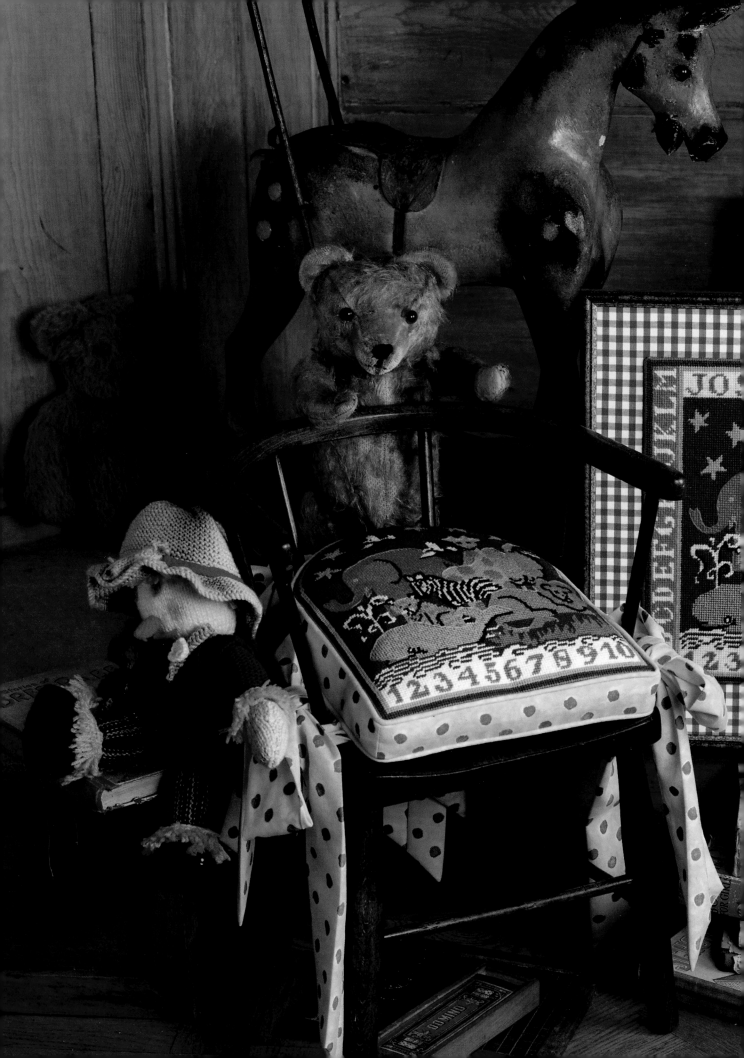

Children's designs

*T*he best thing about doing needlepoint for very small children is that they are so uncritical. They don't say things like, 'I see you've missed some stitches over here on the leg, was that intentional?' or, 'Was this creature blinded in a fight?' They will clasp it in their little arms and love it besottedly, inseparably, as the thing becomes more and more rancid. In this case, a good beating and hanging out in the fresh air works best (don't say it). Our own children still have dozens of stuffed creatures made for them over the years, now stored away, to be brought out for the next generation. Perhaps future great grandchildren will look at the assorted dogs and frogs, not understanding that once people actually made things with their hands, didn't conjure them from holograms.

The picture opposite has been adapted from the Noah's Ark chair. We like its limited palette and the amount of discussion-value there is in the design. It could made a charming birth or birthday sampler.

NOAH'S ARK SAMPLER. THE CHART AND MAKING INSTRUCTIONS ARE ON PAGES 156-7.

Dolls & animals

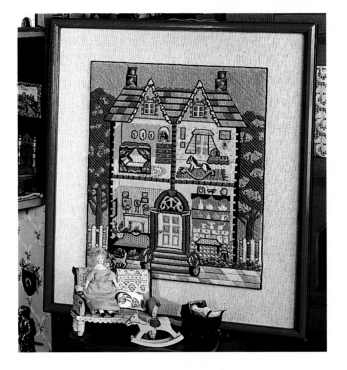

CHILDREN'S TOYS
Above is our favourite children's picture, we wish we'd worked
it twice the size to allow for such details as a baby in the cradle
and spiders in the attic. Opposite is Koalas; the chart and
making instructions are on pages 158-60.

The Koalas, right, obviously read the rule book and hug each other as Koalas are supposed to do and they can have any message, or color, used on the ball (see page 158-9). Either stuff them as shown, or fill in the background for a picture or cushion.

The Doll's House Picture, above, is our all-time favorite picture for children. Our only regret is that it isn't twice the size, or worked on a much smaller gauge canvas than the 14-holes-to-the-inch we stitched it on. It would have given us the ideal opportunity to put in much more detail such as an attic with spiders, a cellar with spiders, a baby in the cradle, that sort of thing.

The designs shown in this section are really to be made for children by adults, but we are always encouraging young people to try needlepoint. When you think of the samplers worked by nine-year-olds in Victorian times, and Asian children whose fingers at that same age were becoming too big to weave carpets, child lace-makers in Venice who could also only work a few years before their sight became irreparably damaged, it is obvious that we underestimate the abilities of our children. We love to hear parents give enthusiastic encouragement to children in our shop.

The seeds of such abilities are often better if sewn (!) early, so that they become part of life, like an appreciation of music. Why shouldn't children be taught to cook, look at paintings, see serious theater at a young age? Sometimes it is dangerous to wait too long, when they may not be able to squeeze in time for parental input, and may never acquire the tools that are so enriching in later life.

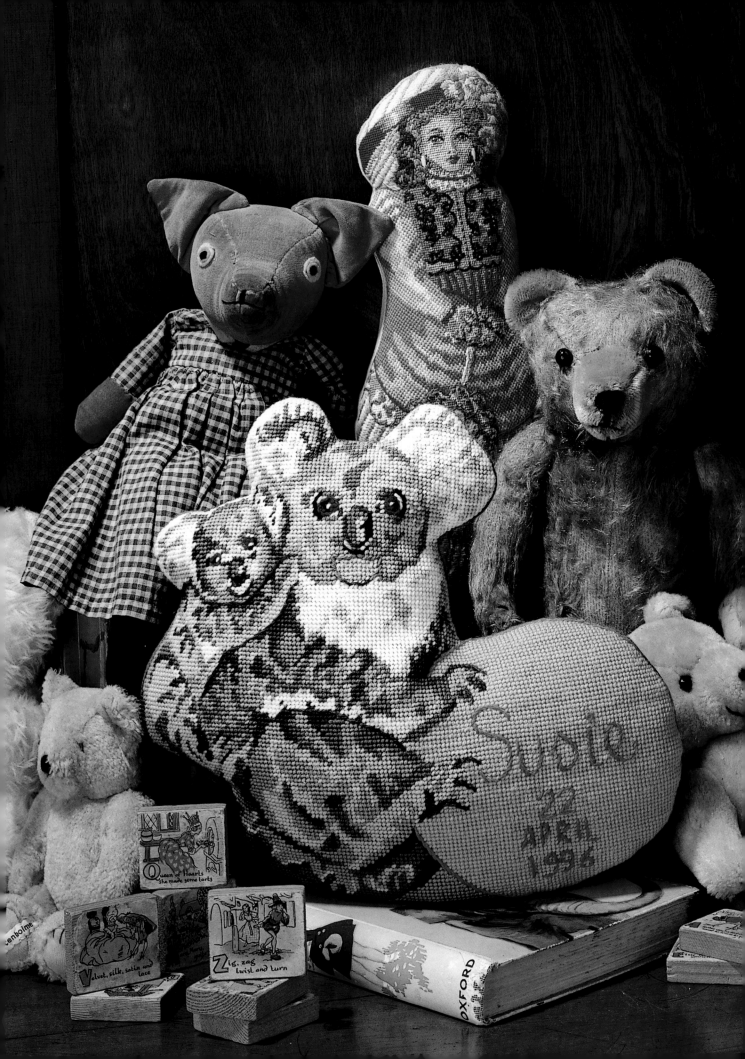

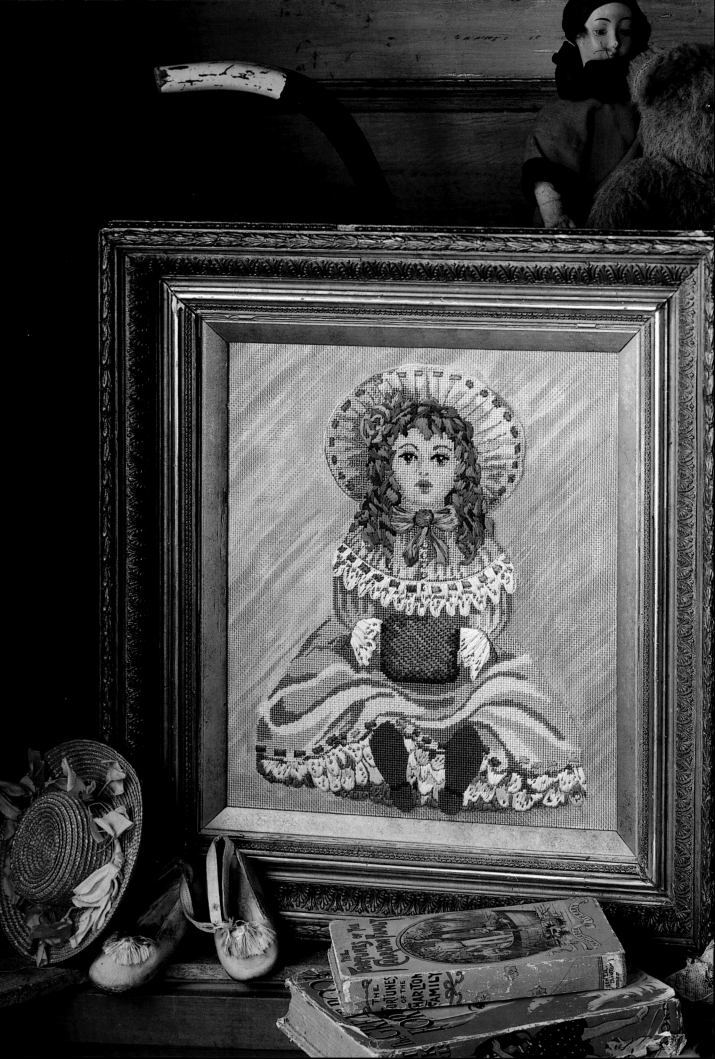

So, we should encourage our children to sew; not as the mind-numbing experience it was for many of us, but to learn the satisfaction of creating and experimenting, with definitely no mention of the word 'perfectionist' (because therein lies madness).

Stitching is such a journey. For the methodical, it can be as rewarding as building with Legos, making beautiful yarns and patterns work fascinatingly. For the child for whom there are no boundaries, it can be like a box of paints, a key to limitless adventures. Alison used to love sewing, and we kept her samples in the shop to show what a young person was capable of, but then she discovered The Horse (see page 96) and was lost to the cause. Tamsin knits serpentine scarves and huge angora garments, likes doing kilims and stitched our Sahara project for this book. She enjoys it because the end is always such a surprise. She remembers when little being fascinated that colored woollen spaghetti could be transformed into needlepoint pictures, and wanting to try it herself. She also has an early school memory of sewing being Grim, Hateful and Boring, which many of us share. In the late fifties at Dame Henrietta Barnett's establishment we shut the needlework teacher in a cupboard (which was to be just about the last thing we did do there). Let's hope things have changed and that inspired skills are being taught; abilities that will enable young people to professionally shorten the arms of a departing lover's tuxedo, or appliqué over burns in an heirloom tablecloth. In short, we must encourage our children to stitch – and certainly their own name tapes from the age of four!

This needlepoint (left) took a nineteenth-century French doll as its inspiration, with her gorgeous rosebud mouth, painted eyelashes and muff (the muff saves the anguish of trying to work fingers on 14-gauge canvas). She is the kind of picture most little girls would like to have through childhood, and then keep in adulthood, rather than a nursery picture that has a fairly limited life – rabbits blowing bubbles would not sit happily with a Grateful Dead poster.

Doll picture with the background left unworked, inspired by a nineteenth-century French doll.

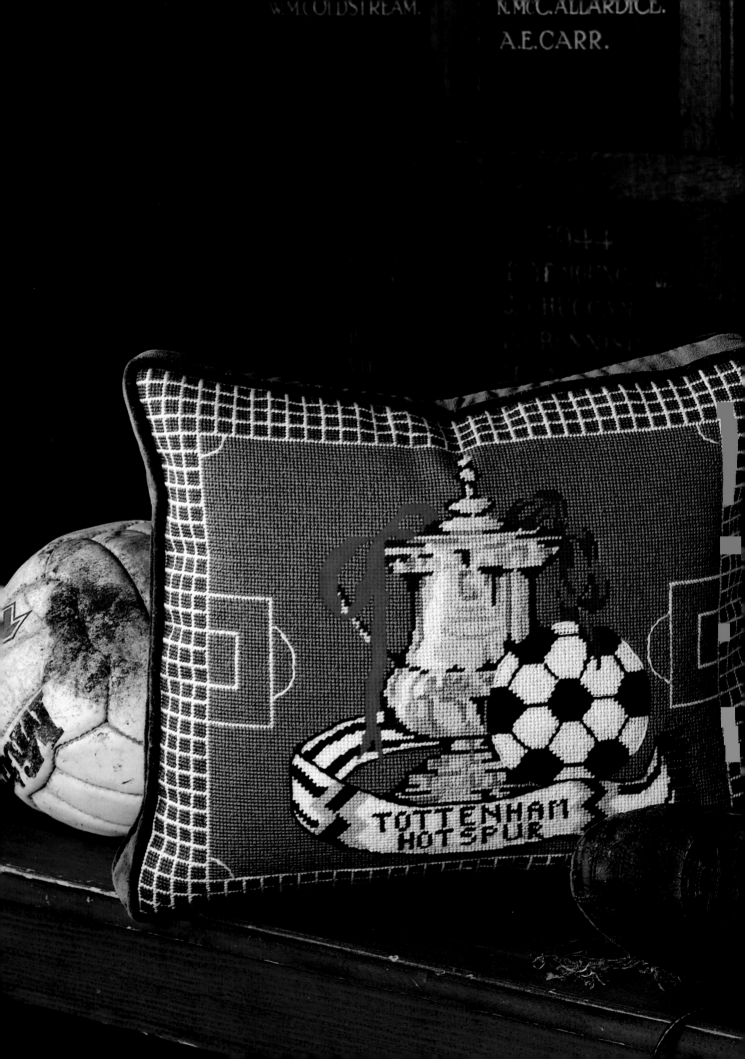

This sporting life

*M*ore than an interest, sports can reach *heights of passion, not to say obsession. Indeed, we know one poetry-reading opera-lover who weekly becomes a screaming hooligan. In coherent moments he will compare Pavarotti's Otello to a breathtakingly fluid pass between Barmby and Klinsman in a game against Blackburn Rovers at White Hart Lane. Living with such an enigma answers imponderables such as why fans have three scarves (one to wear, one for the left window of the car, one for the right), and why the closet is inadequate to accommodate precious paraphernalia (insignia caps, shirts, ties, fixtures lists, a signed soccerball, the lucky underwear). Furthermore, one learns that behind the glazed eye of post-coital serenity, he is reliving that second goal against his least favorite team.*

A SOCCER CUSHION. THE CHART AND MAKING INSTRUCTIONS ARE ON PAGES 161-4. THE CUSHION CAN BE ADAPTED TO ANY TEAM AND DETAILS FOR CHANGING THE COLORS AND WORDING ARE ALSO GIVEN ON PAGE 164.

Sporting passions

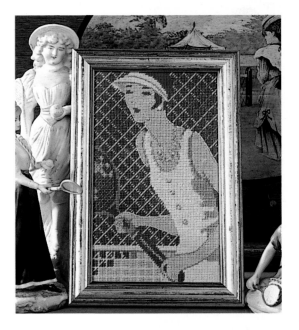

RACQUETS, BATS AND BALLS
*Above and opposite: Genteel tennis and a series of sports
pictures with a twenties atmosphere, worked mainly in tent
stitch with three-dimensional leaf borders. Perhaps that period
was more gracious for playing games than today!*

The Hunt, shown overleaf, is designed to sit happily in any drawing room, town or country, and would look most handsome if framed. If the horse in question is not a chestnut, take a photograph of him along with this book to an Anchor stockist and substitute the relevant shades, keeping them close to each other so they blend.

We have customers who ride, whose input resulted in this design, but the great shaker and mover has to be Alison J. Berman, who has spent the last ten years, since she was five, mucking out, grooming, being careful not to underfeed or overfeed, picking hooves, combing manes, plaiting tails, toting that barge and lifting that bale. She has been unfaithful to Timmie with Pip, then unfaithful to Pip with Livvie, finally finding Pepper who she loves beyond all reason. All her money goes on Pepper, be it a numnah to keep him warm, a brow band, mane comb, dandy brush for

his legs, body brush for his body, face brush for his face; taking him to the farrier for a bit of foot filing, or to have his teeth rasped, his injections renewed or buying apple-flavored horsey-treats (for apple-flavored horseys). Her mother is resigned to fumigating house and car, and realizes that the stables are preferable to (a) Alison spending hours coaxing her hair into multicolored spikes and (b) having unknown assignations at unknown destinations.

Tennis has an advantage. Enthusiasts are a little more restrained, there is less shouting, less manure for a start. Cricket and golf ditto. But there is definitely the gleam in the eye and all signs of the obsessive. Such sports inspire passion even in those not given to passion, though as far as golf goes, to us the 'ineffec-

OVERLEAF: *The Hunt. The chart and making instructions are on pages 165-7.*

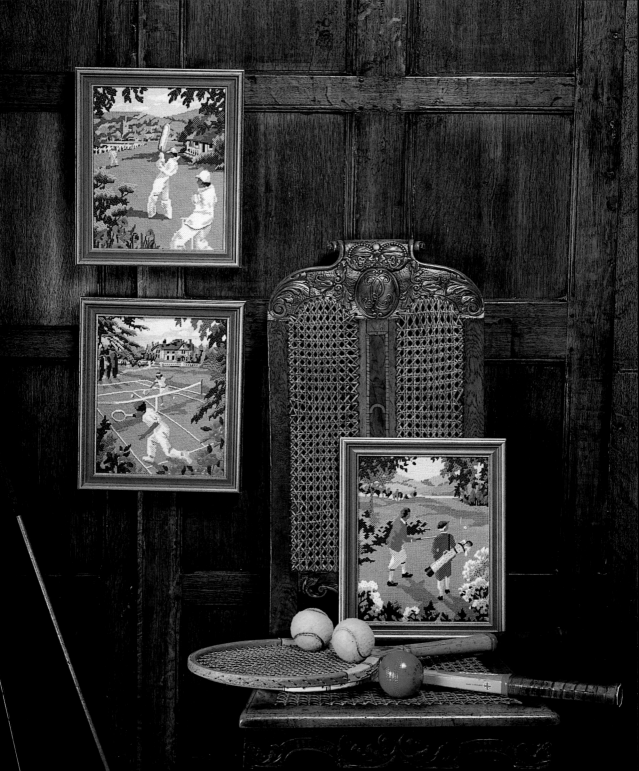

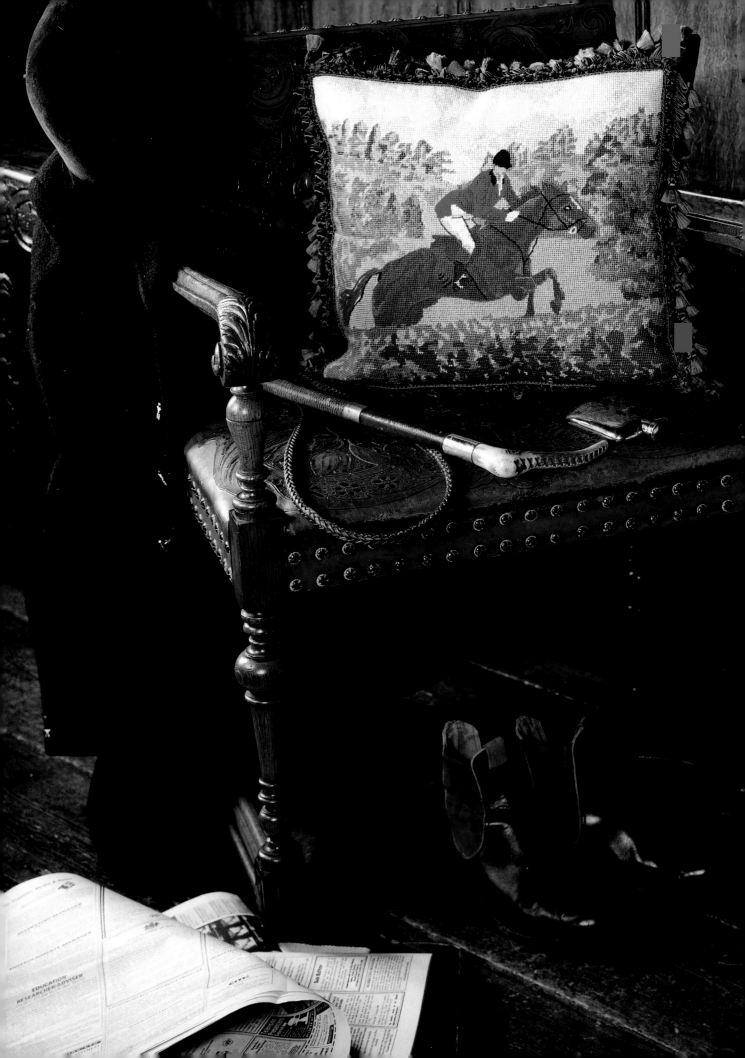

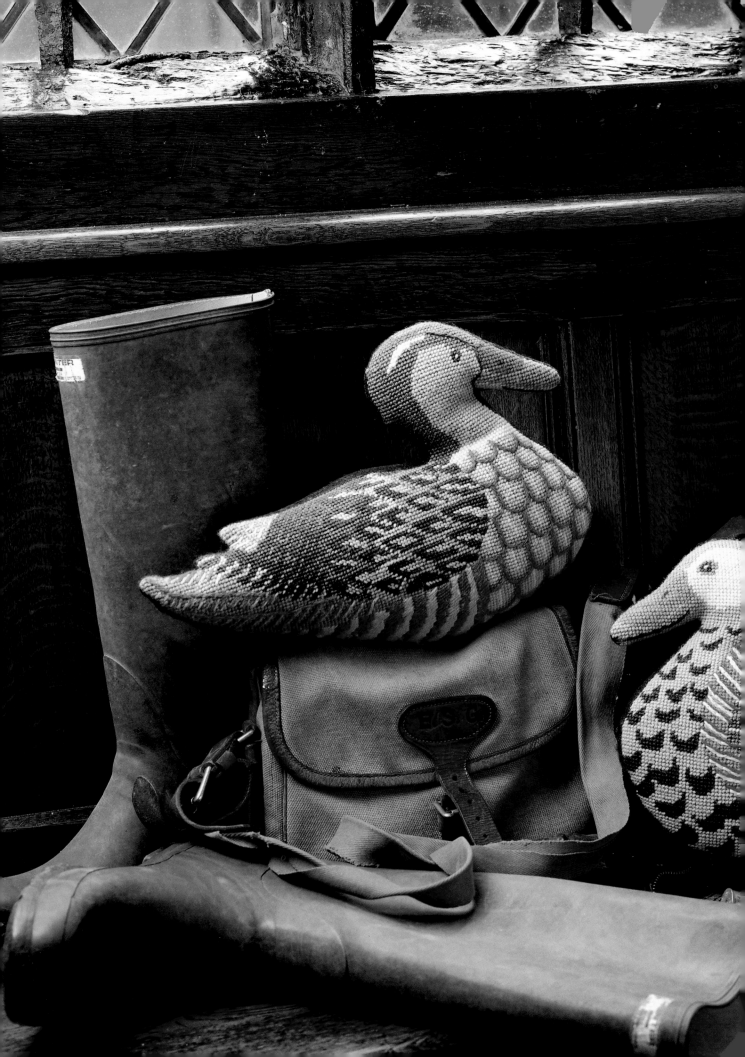

tual endeavor to put an insignificant pellet into an obscure hole with inadequate weapons' just about sums it up. But what do we uninitiated know? Perhaps there isn't enough needlepoint attached to golf. We'd like to see a bit more of the situation where players are backed up to the first tee because someone is finishing a really satisfying piece of stitching while waiting her turn on the green at the 18th hole.

Stuffed needlepoint creatures are so enjoyable to stitch – there is no background for a start. We began with stuffed cats, and called them Perfect Pets, maintenance-free animals who neither chewed nor pooped, and then went on to frogs and dogs and elephants and teddies. Ducks are a marvelous subject for needlepoint, from the English ducks that are so familiar, to gorgeous ornamental Oriental ducks. Their colors are fantastic, so you can be as inventive as you like with yarn shades. Interesting to us is the fact that the sexual game is inverted. It is the males who are usually beautiful, because they take the need to attract a mate very seriously. The drab female paddles behind, free of the corsetry associated with the predatory female and the nightmare of squeezing a webbed foot into an elegant shoe. But that's another sport altogether.

Decoy Ducks. Ducks such as this would look superb among the trophies.

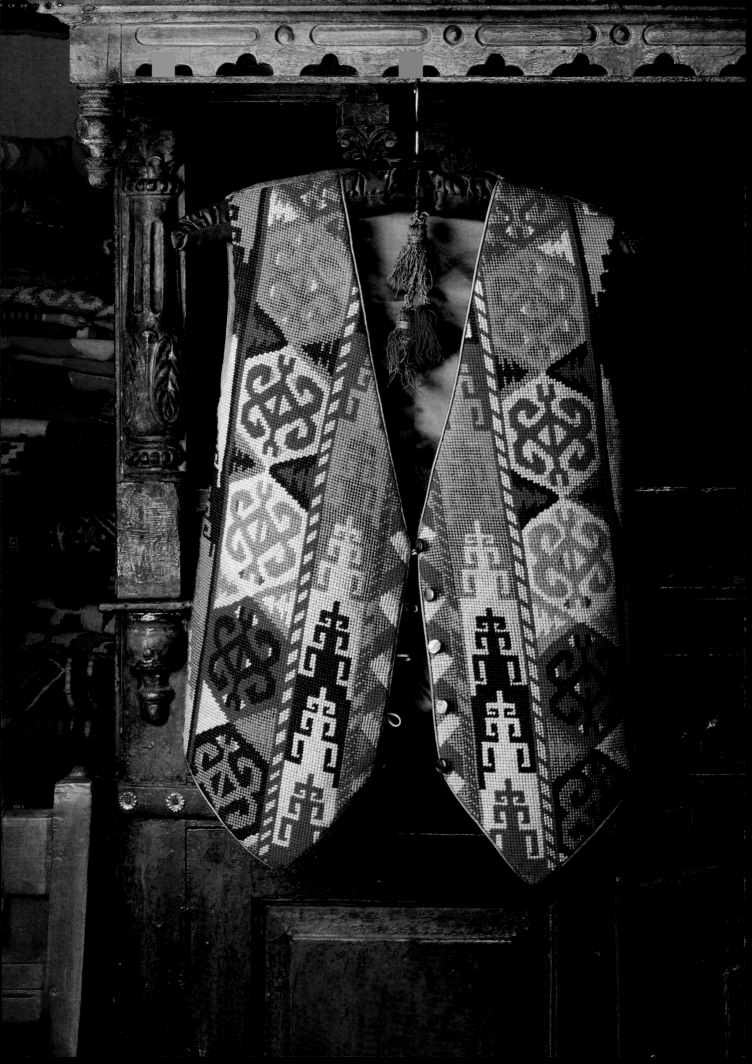

Kilims

The secret language of beliefs, as shown in kilim motifs, is handed down from mother to daughter, ancestral stories being superseded by more recent superstitions. The motifs act as symbolic talismen, representing birth, or the desire for a child; the intention to marry; harmonious relationships, and fertility symbols and amulets. Birds have most meaning because they represent power, as well as being the messengers of love and joy; and vultures, as we know, mean death. And everywhere the tree of life, symbolizing immortality.

From an early age, a young girl will prepare for marriage, and weave kilims for rugs and bags, embroider clothing, make fine underwear. All her hopes and aspirations for life would be woven into the kilim motifs.

The symbols we have used for our projects include star motifs, for happiness; scorpion motifs, to protect ourselves from scorpions (which certainly works for us in Mill Hill), and the ram's horn. In weaving this particular motif, the woman is hoping her husband will be strong in every aspect. What can we add, except that it might be prudent to also slip some ginseng into his cocoa.

KILIM VEST. THE CHART AND MAKING INSTRUCTIONS ARE ON PAGES 171-5.

Tribal motifs

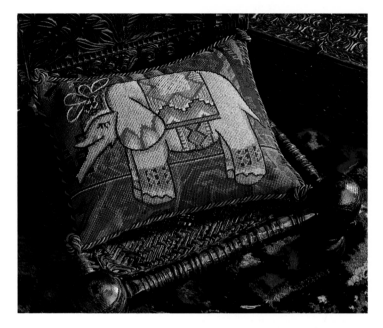

KILIM DESIGNS
*Above is our Kilim Elephant. Opposite are the Buokhara
Cushion and a rug that has been made by joining together six
stitched cushion canvases, as described on pages 186-8.*

Kilims are made for needlepoint. Thank you, Ana-
tolian Turks; weaving your magic in the twelfth
century, you had no idea what you were starting. The
scale of the designs is perfect for stitching on canvas,
geometric yet not, rich and intricate, something won-
derful about a design that has been wrought in yarn
for hundreds of years. The source supply is almost
infinite. The first kilim we designed was a carpet bag
based on a saddle bag from Turkestan, and thereafter,
through scribbling in showrooms, stealing motifs
from friends' carpets, we created something hybrid.
Think of England with its Wiltons and polite florals
where carpets meant a way of covering floorboards
and were a far cry from the dyeing and grinding and
spinning and weaving in gorgeous celebration of
nomadic heritage. They wove the same patterns that
their mothers and grandmothers wove, for until
recently the weaving was the domain of the women,
with patterns passed down through the generations.

We look at the motifs through a needlepoint eye –
angles, shapes and colors – and put them on 7-gauge
canvas, which requires a double thickness of tapestry
wool to be used, blending and mixing the shades to
give a slightly woven and textured effect to imitate the
visual roughness of the original. Try adding garden
twine, coarse or smooth string, frayed fine ribbon; not
always easy to thread the needle or pull through the
holes but the effects can be sensational.

Kilims are for people who want to create some-
thing but don't do needlepoint, whose itch to stitch is
thwarted by belief that they *can't*, suffer poor eyesight
or have a short interest span. Kilims can be done as a
passenger in a bumpy car, while speaking on the
phone, while waiting in a queue. If television is chew-
ing gum for the eyes, kilims are chewing gum for the

OVERLEAF *A selection of our Kilim-inspired cushions edged
with a splendid choice of cords and tassels.*

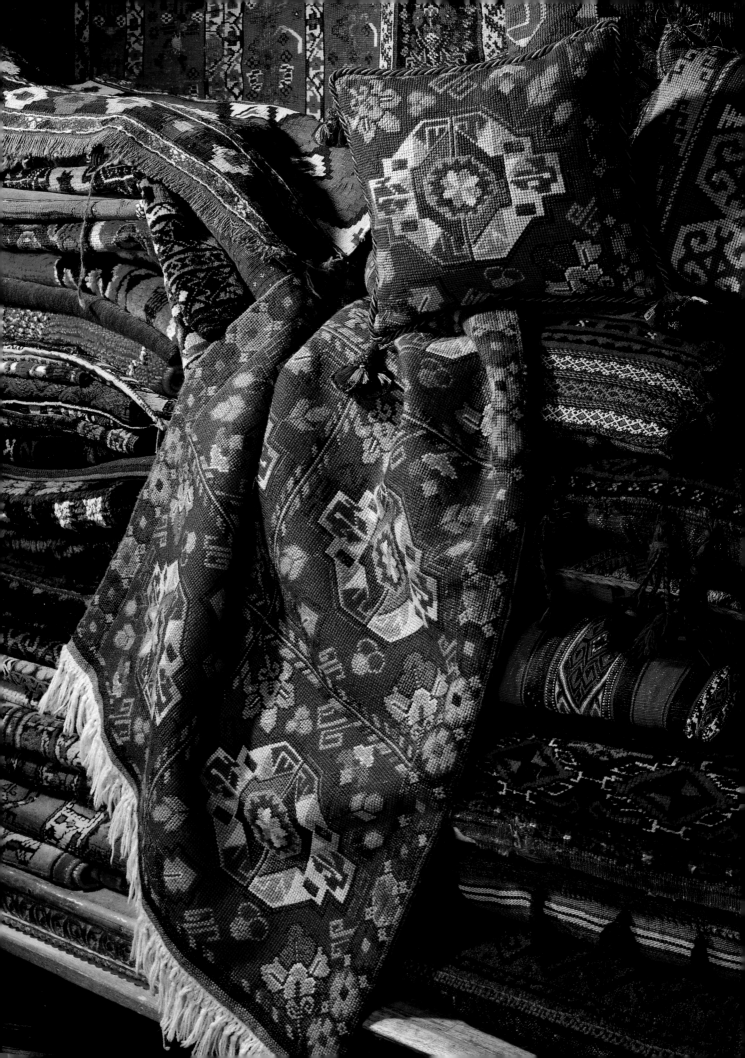

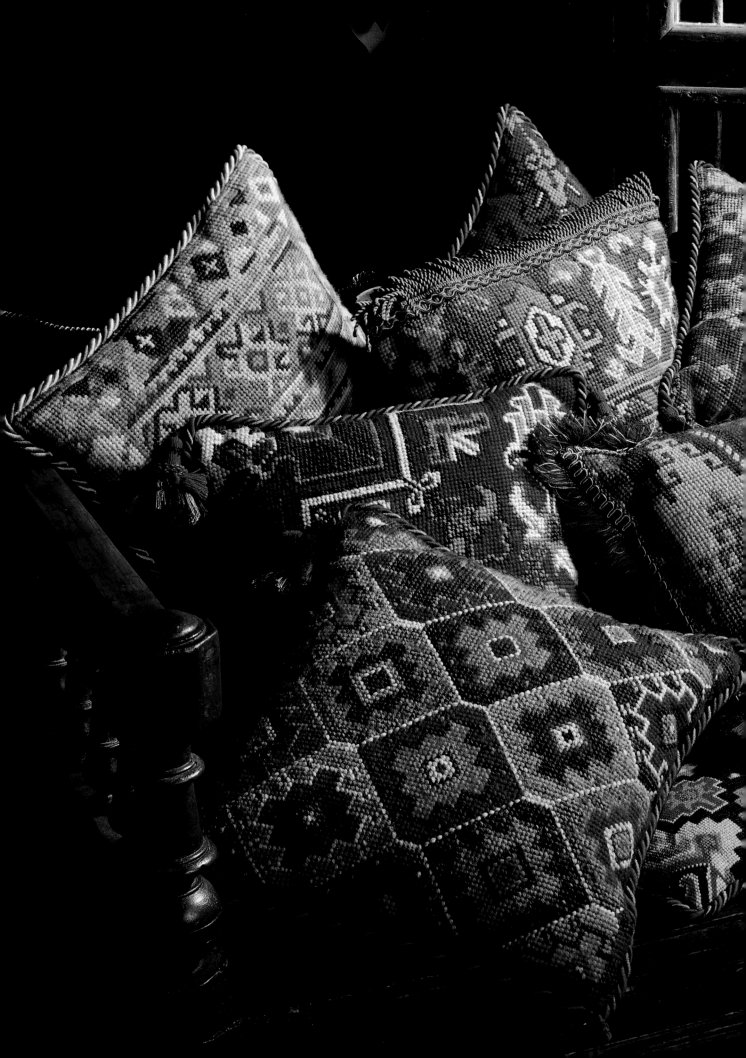

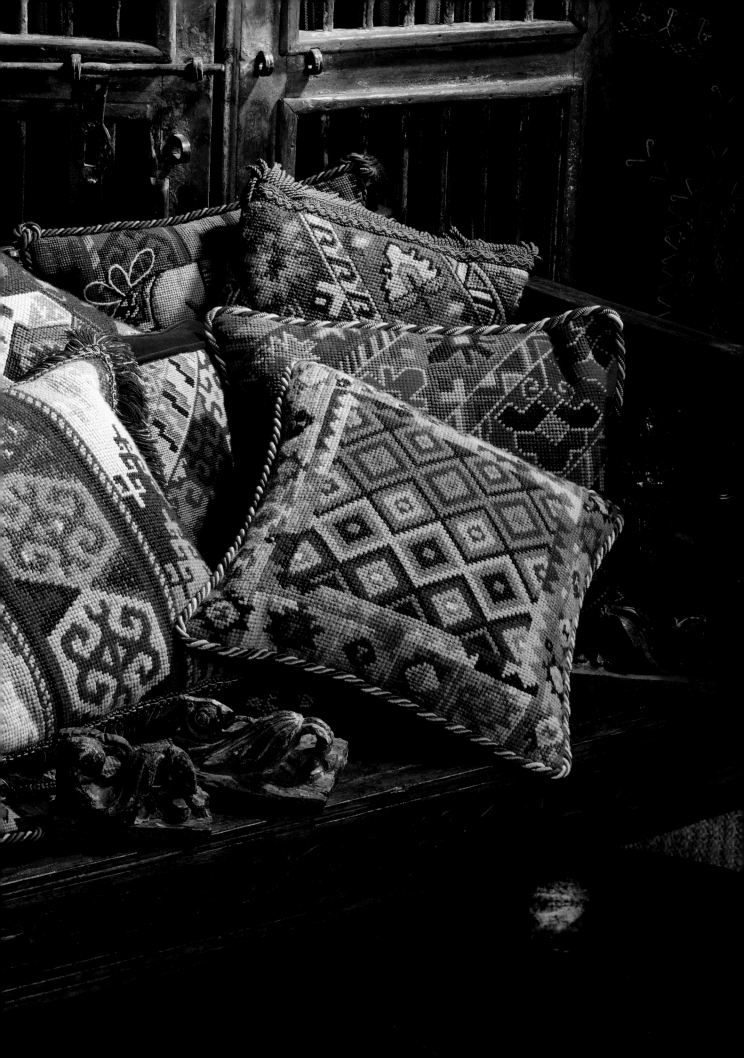

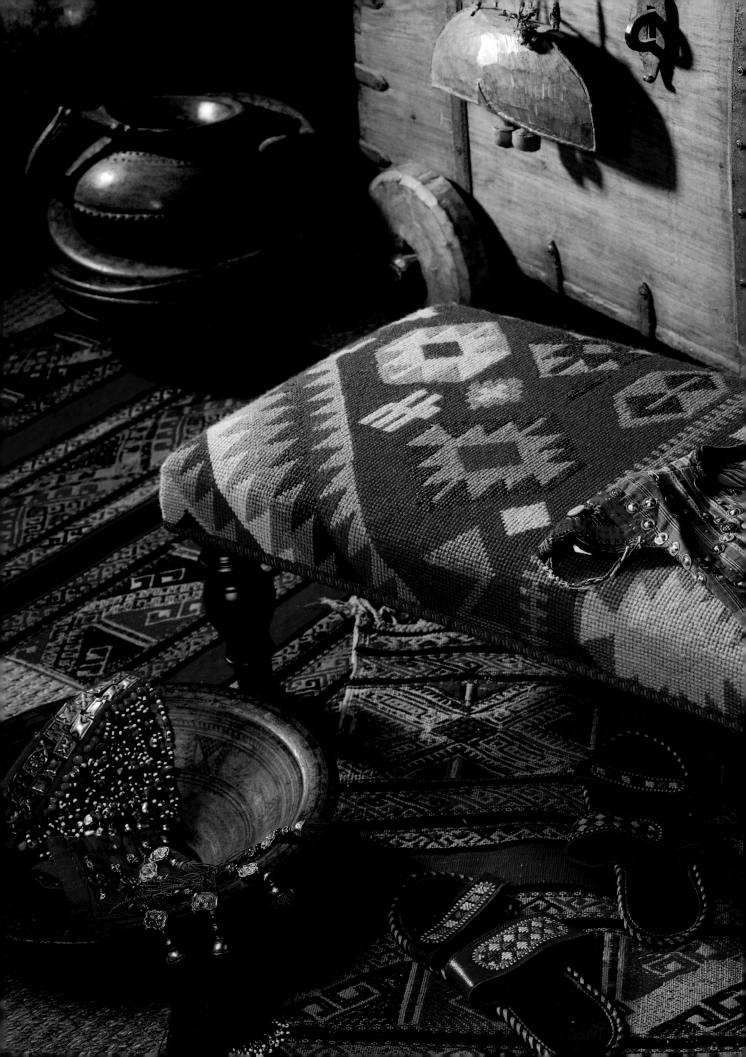

hands. In our shop, we recommend them as beginner's kits because they grow so encouragingly fast and make such an impact. If there are any mistakes, this can add to their charm – in fact, irregularities in the stitching seem to improve their look hugely (perfectionists please ignore this remark). Although we cannot claim they help mood swings, chronic fatigue, fear of public speaking, jealousy, infidelity or arachnophobia, kilims are invaluable when it comes to panic attacks and general mid-life crises.

One friend has several not-quite-finished kilims, always wanting to leave a little bit to delay the pleasure of completion – and because she works on a frame only has the excitement of seeing the whole design when she unrolls it. She finds it extraordinary that someone who has never considered herself good at sewing can produce something that looks so wonderful. Perhaps this echoes the sentiments of many. She also says that it makes watching television a guilt-free exercise, because there's so much to show for the time.

The trick to mixing the colors is that they must be virtually the same tone, even if the shade is different. Take the blues, for example: use one blue and one gray, and it works because the tones are very close. The aim is a subtle movement in the color (not Donegal tweed), and the effect is slightly blurred and has a softness that stops it looking new.

The waistcoat shown on page 102 seems to look great on small women and big men, it can look casual with jeans and formal with a suit, and the more it's worn, the more it will soften and mould itself to the body. Because we wanted it to have a finer design than the cushions, we used 10-gauge canvas and one thread of tapestry wool. If you wanted to use the colour mixing technique, you could substitute fine crewel wool for the tapestry wool and use combinations of strands.

Kilim stool. The chart and making instructions are on pages 168-70.

Design nostalgia

A *s we approach the millennium, current style frequently looks back with nostalgia. At the turn of the last century, William Morris was looking back longingly to the pre-industrial age, and a few years later Vanessa Bell and Duncan Grant were wanting to shake off the mannered Victorian mores and return to a philosophy of free expression. They were all looking for something that would give their work emotional truth.*

William Morris was influential in forming a loosely-knit group of architects and artists who became the Arts and Crafts Movement; Bell and Grant wanted to reach the imagination through color and shape, paring away representations of nature and all they considered unessential, formed the Omega Workshop, and were a vital part of what was to become the Bloomsbury Group. All were to produce some of the most vivid looks in the last century.

THE BLUE VASE. THE CHART AND MAKING INSTRUCTIONS ARE ON PAGES 176-8.

The Blue Vase chair

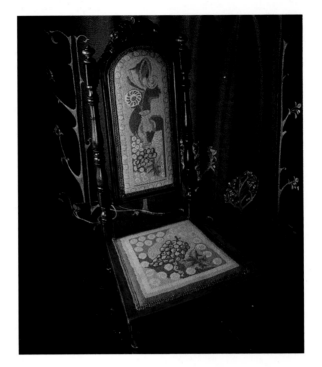

BLOOMSBURY AND ARTS AND CRAFTS
*Above: The Blue Vase design on this chair was inspired by a
needlepoint wallhanging designed by Duncan Grant and worked
by his mother Ethel. Opposite is a cushion and bellpull in the
Arts and Crafts style.*

For Duncan Grant and Vanessa Bell, sister of Virginia Woolf, and a medley of others well-known and less well-known, Bloomsbury life revolved around Charleston Farmhouse in Sussex.

Charleston epitomizes one of those glorious inbred follies that the British do so well; for further reading, Melinda Coss has done a superb book on the house, its occupants and the abundant needlepoint there. Unfortunately, it isn't possible to wander around Charleston alone, it is necessary to be escorted, instructed and moved on, perhaps lest visitors find themselves slipping through a time-warp. Some of the rooms are pleasantly haunted as if someone has just gone out to fetch some tea. Almost every likely and unlikely surface is painted, blobbed, squiggled. The effect is not nightmare, but exhilarating, and so

vibrant that paint still seems to be wet on the coal scuttle, mantelpiece and chair legs.

We worked the chair just for fun, because we loved it, and were so excited by the time-weary colours that we made the picture as a project. The colors are so harmonious that the eye gently moves around the piece with no effort; in fact, everything at Charleston seems to be viewed through a tinted filter. The colors are deliberately, deliciously faded (and it is harder than it looks to achieve institution-wall, semolina-pudding ivory, which dulls the background into just the right period!).

OVERLEAF *Four small Arts and Crafts panels with the distinctive outlining typical of the period. The charts and making instructions are on pages 179-81.*

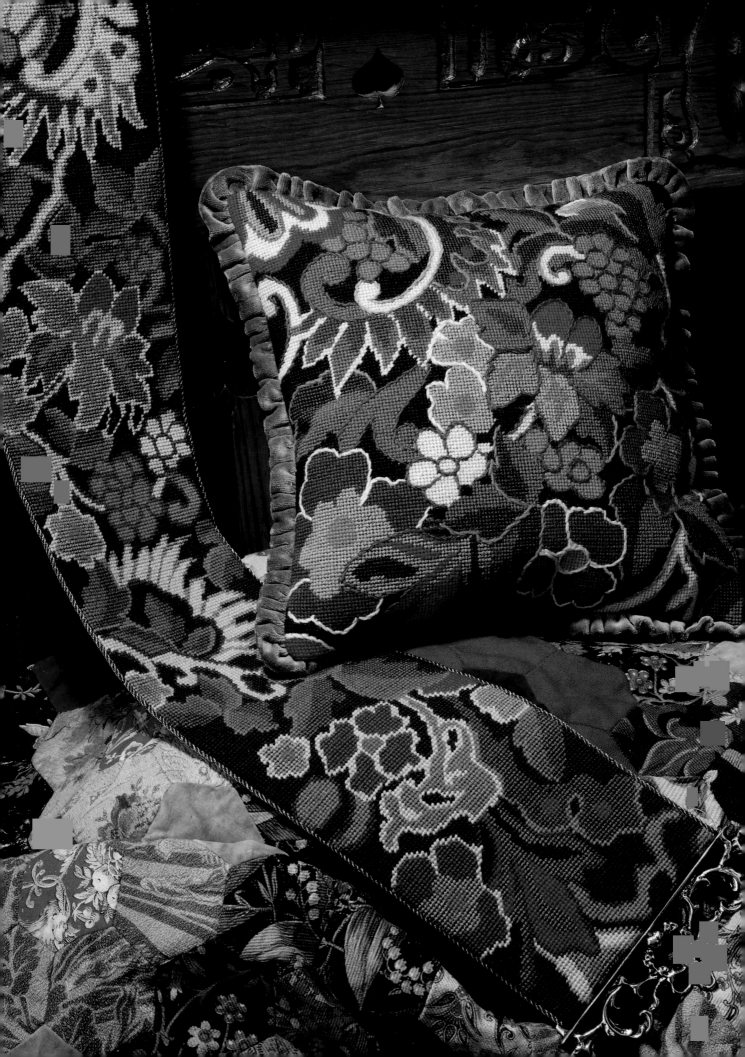

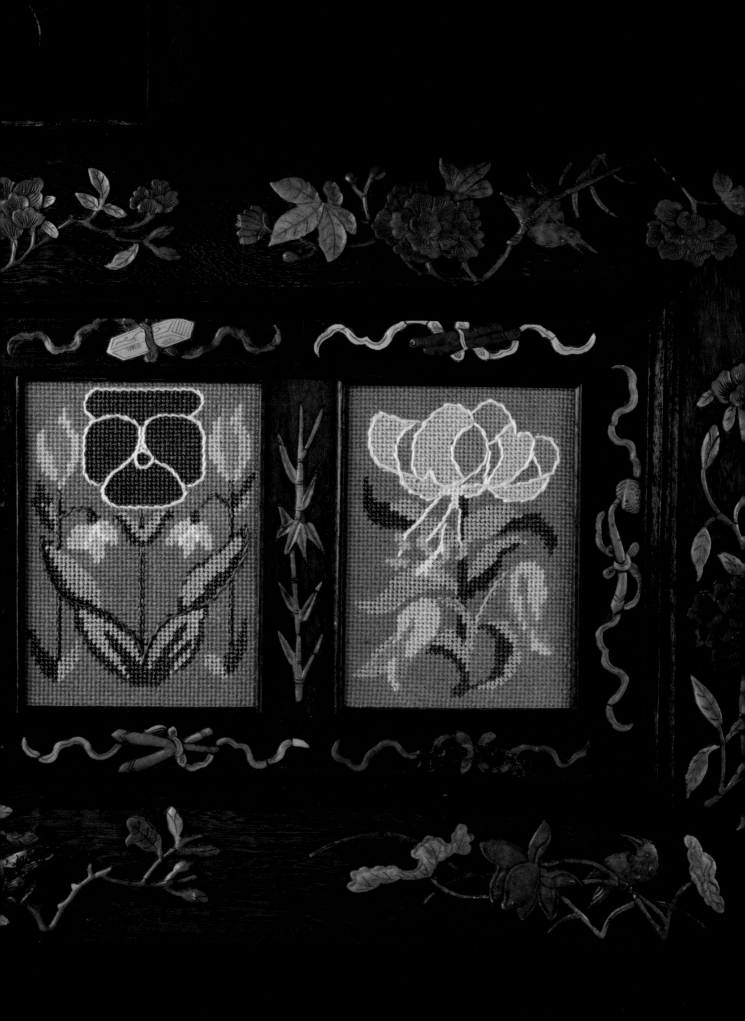

The artist-craftsman

POPPIES AND BUTTERCUPS
Above and opposite: Typical of the period's two-
dimensional designs with their swirling, stylized patterns,
the distinctive outlining on these designs is worked first
in stem stitch.

Arts and Crafts has the verve of Art Nouveau but has less flamboyance and more home-spun worthiness. The flower panels on the previous page were inspired by designs created at the turn of the century. The distinctive feature of this look is the contrasting outlining, emphasized here with stem stitch.

The panels are worked in stranded cotton on 14-gauge canvas, but they could be worked on a larger gauge canvas using wool, perhaps sewing them together with rows of stripes, or panels of blobs as in The Blue Vase picture. They typify the style that the Arts and Crafts movement achieved, wonderfully simple and so distinctive. We particularly like the wooden piece that they are in, with its tiny animals. You can see similar creatures worked into plaster panels at Liberty in London's Regent Street, and for those of us who miss not having lizards crawling up our walls, this could be a charming decorative idea to keep in mind for those free moments between needlepoint projects.

William Morris's nostalgia was for the age of the artist-craftsman, before the industrial age – artisans who made objects of beauty with honesty and integrity, and respect for aesthetics. He idealistically wrote: 'Have nothing in your houses that you do not know to be useful, or believe to be beautiful'. This new style was Country House Severe, but with innovative informality, and followed on from Victorian enthusiasms for excessive clutter. The Arts and Crafts exponents found this clutter pretentious, although their desire to sweep away useless ornamentation, frills and fringes, left their rooms looking frighteningly empty to the uninitiated eye.

The group opposed machine manufacture, but their designs were eventually mass produced, which made them less prohibitively expensive, and allowed their philosophy to reach many more people. Liberty produced their fabrics, and that glorious emporium in Regent Street remains not only the last interesting store in London, but a homage to the movement, from its gorgeous decor, to the Arts and Crafts furniture and (much reproduced) treasures in the textile departments.

Charts & information

*I*n the following section you will find instructions for making the projects shown in this book. Those who have worked from charts won't need to be told how absorbing this can be and how wonderfully rewarding it is to see a pattern grow across blank canvas. Charts also mean that we can show detailed geometric designs, usually only possible with hand-painted canvases. As charts are versatile, the designs can also be adapted to any size and we explain how a chart shown as a cushion could be scaled up to a footstool or carpet.

For new needlepointers, we show the stitches in a simple diagram form and explain the methods of working. The charts are printed in color to make them pleasurable to use and are followed by instructions for stretching and making up the completed canvas.

Shells

Featured in Shells and butterflies on pages 12-13

Finished size of design
14in square

Yarns

Key	Anchor Tapisserie Wool		Skeins
A	8004	White	6
B	8328	Terracotta	3
C	9618	Dusty pink	2
D	8326	Pale terracotta	2
E	8894	Turquoise	1
F	8872	Pale turquoise	3
G	9524	Orange	2
H	9506	Apricot	3
I	8132	Yellow	3
J	9522	Peach	3
K	9672	Heather	3
L	9592	Mushroom	8

Canvas
12-gauge white mono deluxe
Size: 18in square

Other materials
Tapestry needle, size 20
Ruler or tape measure
Masking tape for binding the canvas
Sharp scissors for cutting the canvas
Embroidery scissors
Sharp HB pencil or fine permanent
marker in suitable color
Eraser

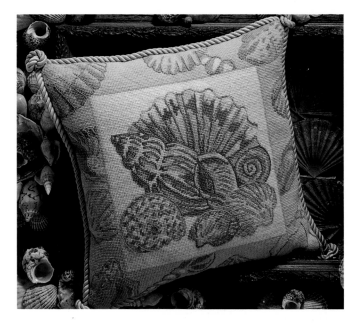

Following the chart
Cut the canvas to size and bind the
edges with masking tape. The design
does not have to be marked out on the
canvas; just follow the color chart
opposite. Remember that the squares
represent the canvas intersections, not
the holes. Each square represents one
TENT stitch.

The chart is divided into units of 10
squares by 10 squares to make it easier
to follow. Before beginning to stitch, it
may be helpful to mark out your canvas
in similar units with an HB pencil or
permanent marker in a suitable color.
At the same time, mark the top of the
canvas so that if you turn the canvas
while stitching, you will still know
where the top is.

The colors on the chart are shown
stronger than the actual yarn colors to
make them easier to see. The
corresponding yarns are given in the
color key.

Stitches used
TENT stitch (1), STEM stitch (2)
(optional). For stitch instructions, see
page 182.

Stitching the design
The whole thread is used throughout,
except for STEM stitch – see below.

Begin with TENT stitch in any area
you wish. It may be easiest to start at
the top right-hand corner 1½-2in in
from the corner, working horizontally
from one block of color to another. We
have used STEM stitch to outline and
highlight the shells. Please refer to the
color photograph and the chart for the
positioning of the STEM stitch. It will
probably be easier to outline at the
end. If you find there are spaces once
you have worked the STEM stitch 'fill
in' with TENT stitches in the relevant
colors. However, if you work the whole
design in TENT stitch, go to the nearest
square.

For a finer look for STEM stitch, we
have split the thread and used only two
strands, but this is optional. To split the
wool in two, hold one end of the
thread with your teeth and, beginning
in the middle, split the thread with your
hands, pulling gently and slowly apart.

Making-up instructions
When the design has been sewn, the
needlepoint may need to be stretched
back into shape (see page 183). Then
make it up into a cushion as shown on
pages 184-6. We suggest you use the
corded cushion with knots that is
shown on page 184.

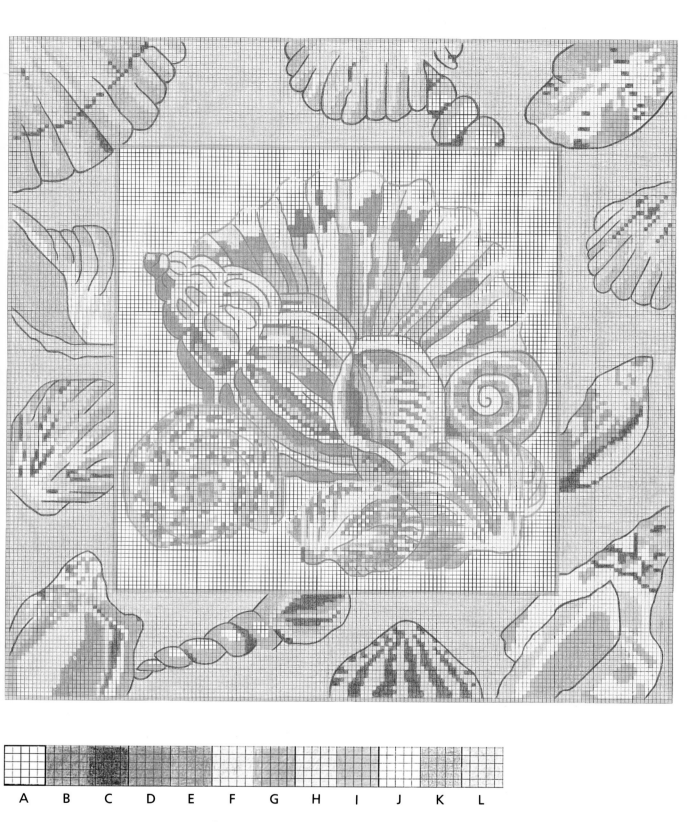

A B C D E F G H I J K L

Butterflies

Featured in Shells and butterflies on pages 12-13

Finished size of design

14in square

Yarns

Key	Anchor Tapisserie Wool		Skeins
A	8004	White	8
B	8328	Terracotta	2
C	8326	Pale terracotta	5
D	9618	Dusky pink	2
E	8894	Turquoise	3
F	8872	Pale turquoise	3
G	9524	Orange	2
H	8132	Yellow	3
I	9506	Apricot	2
J	9522	Peach	5
K	9592	Mushroom	8
	REVERSED TENT stitch		·

Canvas

12-gauge white mono deluxe
Size: 18in square

Other materials

Tapestry needle, size 20
Ruler or tape measure
Masking tape for binding the canvas
Sharp scissors for cutting the canvas
Embroidery scissors
Sharp HB pencil or fine permanent
marker in suitable color
Eraser

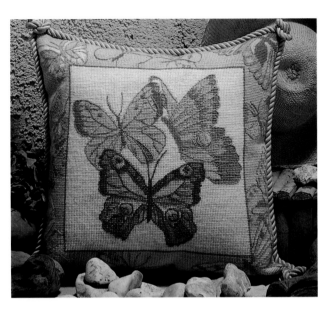

Following the chart

Cut the canvas to size and bind the edges with masking tape. The design does not have to be marked out on the canvas; just follow the color chart opposite. Remember that the squares represent the canvas intersections, not the holes. Each square represents one TENT stitch.

The chart is divided into units of 10 squares by 10 squares to make it easier to follow. Before beginning to stitch, it may be helpful to mark out your canvas in similar units with an HB pencil or permanent marker in a suitable color. Mark the top of the canvas so that if you turn the canvas while stitching, you will still know where the top is.

The colors on the chart are shown stronger than the actual yarn colors to make them easier to see. The corresponding yarns are given in the color key.

Stitches used

TENT stitch (1), REVERSED TENT stitch (1a), STEM stitch (2) (optional). For stitch instructions, see page 182.

Stitching the design

The whole thread is used throughout, except for STEM stitch – see below.

Begin with TENT stitch in any area you wish. It may be easiest to start at the top right-hand corner 1½-2in in from the corner, working horizontally from one block of color to another. We have used STEM stitch to outline and highlight the butterflies. Please refer to the color photograph and the chart for the positioning of the STEM stitch. It will probably be easier to outline at the end. If you find there are spaces once you have worked the STEM stitch 'fill in' with TENT stitches in the relevant colors. However, if you work the whole design in TENT stitch, go to the nearest square. The bodies of several of the butterflies facing to the left are worked in REVERSED TENT stitch to give an unbroken line, but this is optional – see symbols on the chart.

For a finer look for STEM stitch, we have split the thread and used only two strands, but this is optional. To split the wool in two, hold one end of the thread with your teeth and, beginning in the middle, split the thread with your hands, pulling gently and slowly apart.

Making-up instructions

When the design has been sewn, the needlepoint may need to be stretched into shape (see page 183). Then make it up into a cushion as shown on pages 184-6. We suggest you use the corded cushion with knots on page 184.

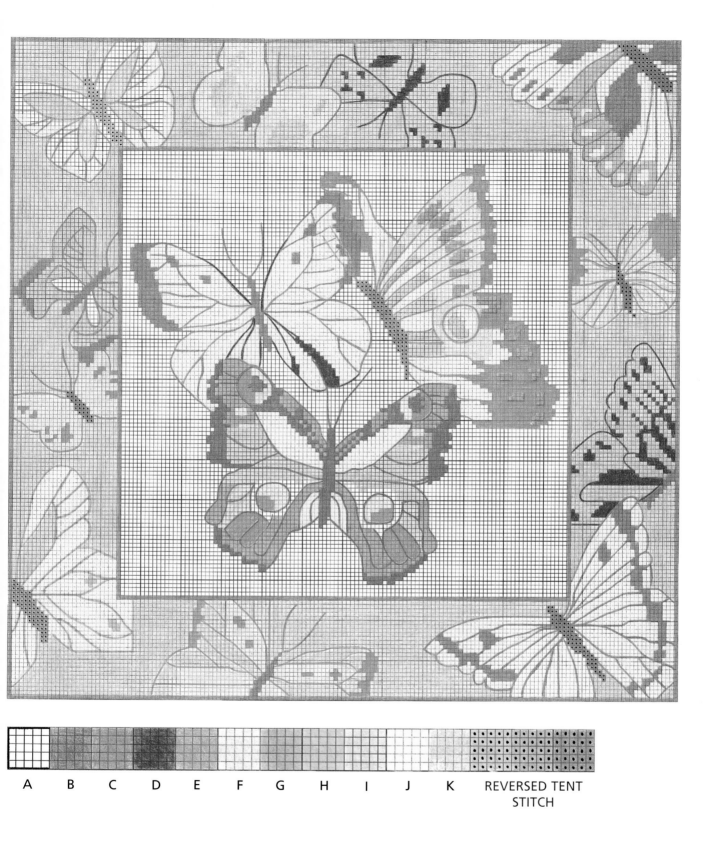

A B C D E F G H I J K REVERSED TENT
STITCH

Pastoral scene

*For yarn quantities and stitching
instructions, see overleaf*

A B C D E

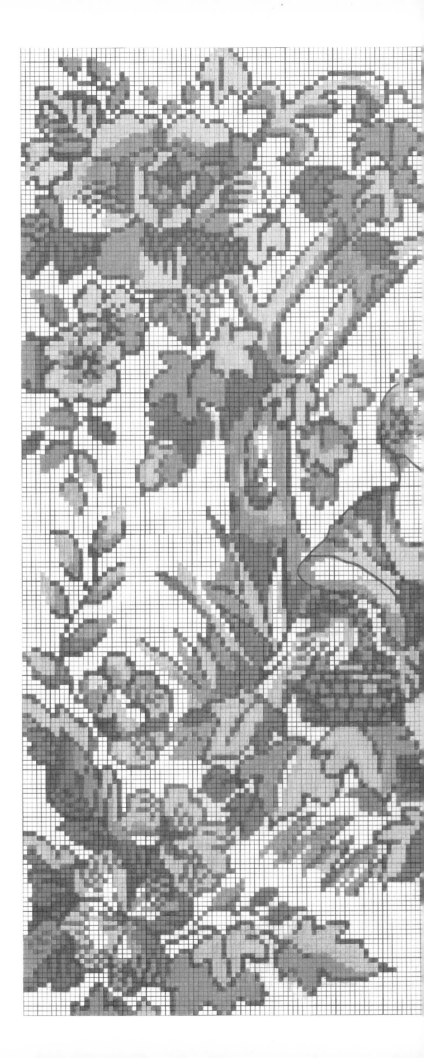

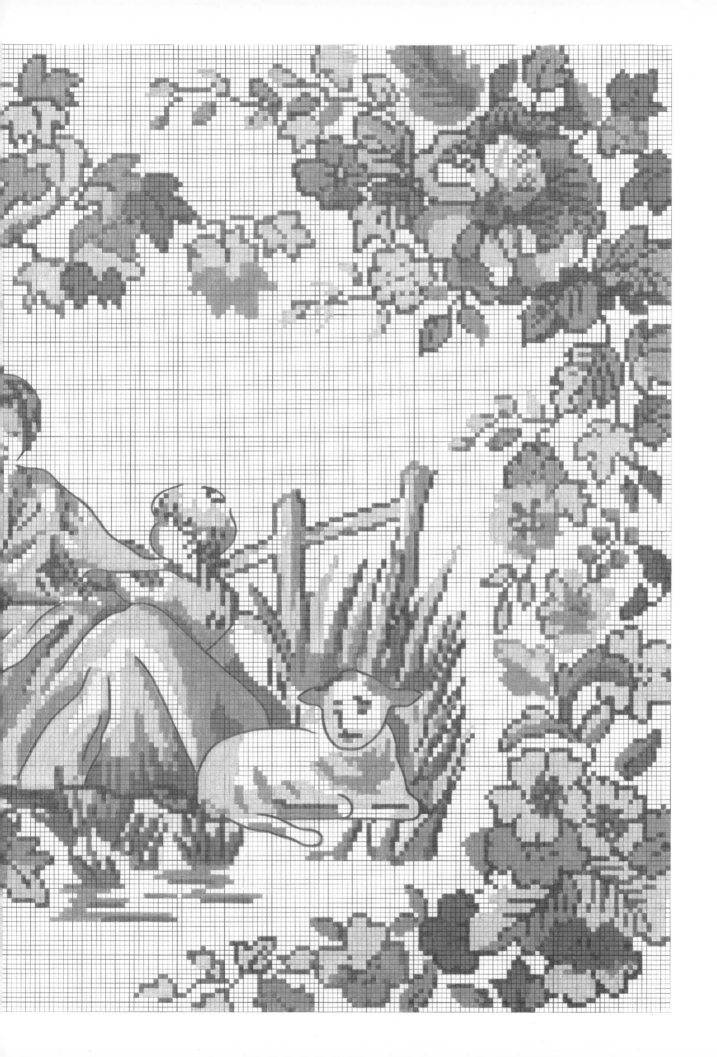

Pastoral scene
Featured in Antique textiles on page 18

Finished size of design
16½ x 14½in

Yarns

Key	Anchor Stranded Cotton Skeins		
A	926	Ecru	20
B	1021	Sugar pink	10
C	1022	Mid-pink	10
D	1024	Dark pink	8
E	1025	Red	11

Canvas
14-gauge white mono deluxe
Size: 20½ x 18½in

Other materials
Tapestry needle, size 20
Ruler or tape measure
Masking tape for binding the canvas
Sharp scissors for cutting the canvas
Embroidery scissors
Sharp HB pencil or fine permanent
marker in suitable color
Eraser

Chart
See previous page

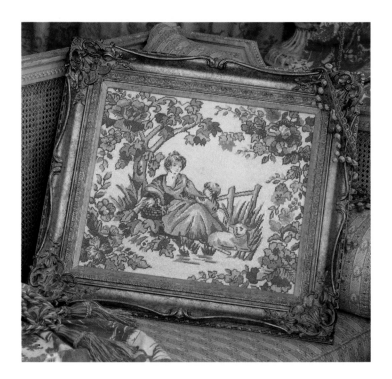

Following the chart
Cut the canvas to size and bind the edges with masking tape. The design does not have to be marked out on the canvas; just follow the color chart on the previous page. Remember that the squares represent the canvas intersections, not the holes. Each square represents one TENT stitch.

The chart is divided into units of 10 squares by 10 squares to make it easier to follow. Before beginning to stitch, it may be helpful to mark out your canvas in similar units with an HB pencil or permanent marker in a suitable color. At the same time, mark the top of the canvas so that if you turn the canvas while stitching, you will still know where the top is.

The colors on the chart are shown stronger than the actual yarn colors to make them easier to see. The corresponding yarns are given in the color key.

Stitches used
TENT stitch (1), STEM stitch (2) (optional). For stitch instructions, see page 182.

Stitching the design
The whole thread (six strands) has been used except for the lips, eyes and nose, when three strands have been used.

Begin with TENT stitch in any area you wish. It may be easiest to start at the top right-hand corner 1½-2in in from the corner, working horizontally from one block of color to another. We have used STEM stitch to outline part of the figures. Please refer to the color photograph and the chart for the positioning of the STEM stitch. If you find there are spaces once you have worked the STEM stitch, 'fill in' with TENT stitches in the relevant colors. It will probably be easier to outline at the end. However, if you decide to work the whole design in TENT stitch, go to the nearest square.

Making-up instructions
Many needlepointers feel experienced enough to stretch and make up their needlework designs into cushions, but we always feel that a needlepoint picture should be framed by a professional, who has experience at stretching and framing needlepoint.

Abundance of fruit
Featured in Fabulous fruit on page 32

Finished size of design

16 x 14in

Yarns

Key	Anchor Tapisserie Wool		Skeins
A	8004	White	1
B	9532	Apricot	1
C	8058	Dark yellow	3
D	8140	Orange	2
E	8398	Shocking pink	2
F	8440	Dark pink	2
G	8200	Red	2
H	8402	Plum	4
I	8550	Dark mauve	2
J	8546	Pale mauve	3
K	9002	Eau de nil green	3
L	8878	Dark turquoise	3
M	9174	Olive	3
N	9180	Bottle green	3
	Anchor stranded cotton		
O	297	Bright yellow	11

Canvas

12-gauge white mono deluxe
Size: 20 x 18in

Other materials

Tapestry needle, size 20
Ruler or tape measure
Masking tape for binding the canvas
Sharp scissors for cutting the canvas
Embroidery scissors
Sharp HB pencil or fine permanent
marker in suitable color
Eraser

Chart

See overleaf

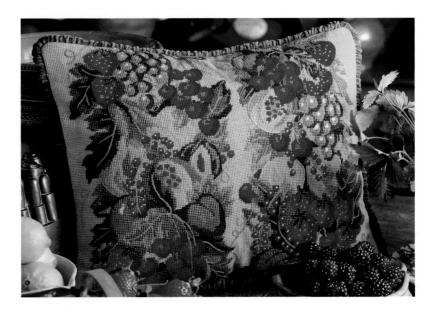

Following the chart

Cut the canvas to size and bind the edges with masking tape. The design does not have to be marked out on the canvas; just follow the color chart overleaf. Remember that the squares represent the canvas intersections, not the holes. Each square represents one TENT stitch.

The chart is divided into units of 10 squares by 10 squares to make it easier to follow. Before beginning to stitch, it may be helpful to mark out your canvas in similar units with an HB pencil or permanent marker in a suitable color. Mark the top of the canvas so that if you turn the canvas while stitching, you will still know where the top is.

The colors on the chart are shown stronger than the actual yarn colors to make them easier to see. The corresponding yarns are given in the color key.

Stitches used

TENT stitch (1), STEM stitch (2) (optional). For stitch instructions, see page 182.

Stitching the design

The whole thread of tapestry wool is used except for STEM stitch – see below. The whole thread of stranded cotton (6 strands) is used throughout.

Begin with TENT stitch in any area you wish. It may be easiest to start at the top right-hand corner 1½-2in in from the corner, working horizontally from one block of color to another. We have used STEM stitch to outline all the fruit except for the redcurrants. The stems and veins on the leaves are also in STEM stitch. Please refer to the color photograph and the chart for the positioning of the STEM stitch. It will probably be easier to outline at the end. If you find there are spaces once you have worked the STEM stitch, 'fill in' with TENT stitches in the relevant colors. However, if you work the whole design in TENT stitch, go to the nearest square.

For a finer look for STEM stitch, we have split the thread and used only two strands, but this is optional. To split the wool in two, hold one end of the thread with your teeth and, beginning in the middle, split the thread with your hands, pulling gently apart.

Making-up instructions

When the design has been sewn, the needlepoint may need to be stretched into shape (see page 183). Then make it up into a cushion as shown on pages 184-6. We suggest you use the cushion with ruched piping on page 185.

Abundance of fruit

For yarn quantities and stitching
instructions, see previous page

A
B
C
D
E
F
G
H
I
J
K
L
M
N
O

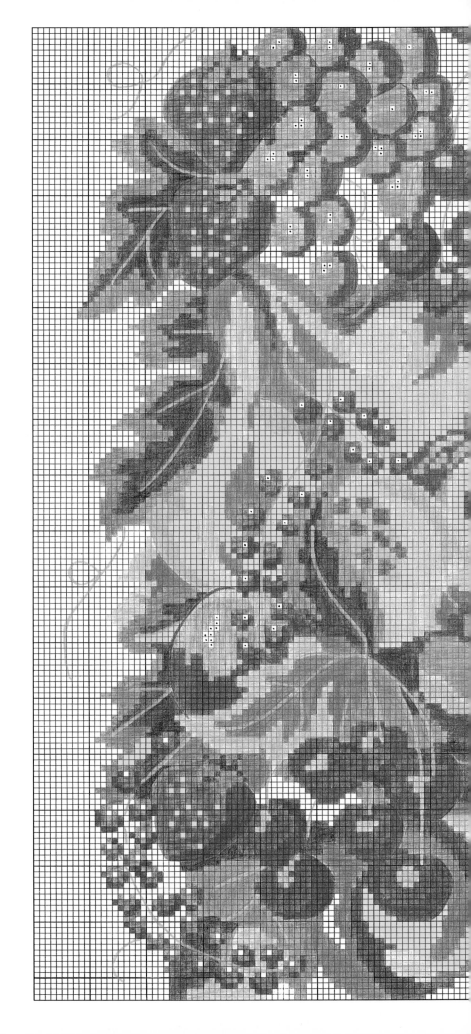

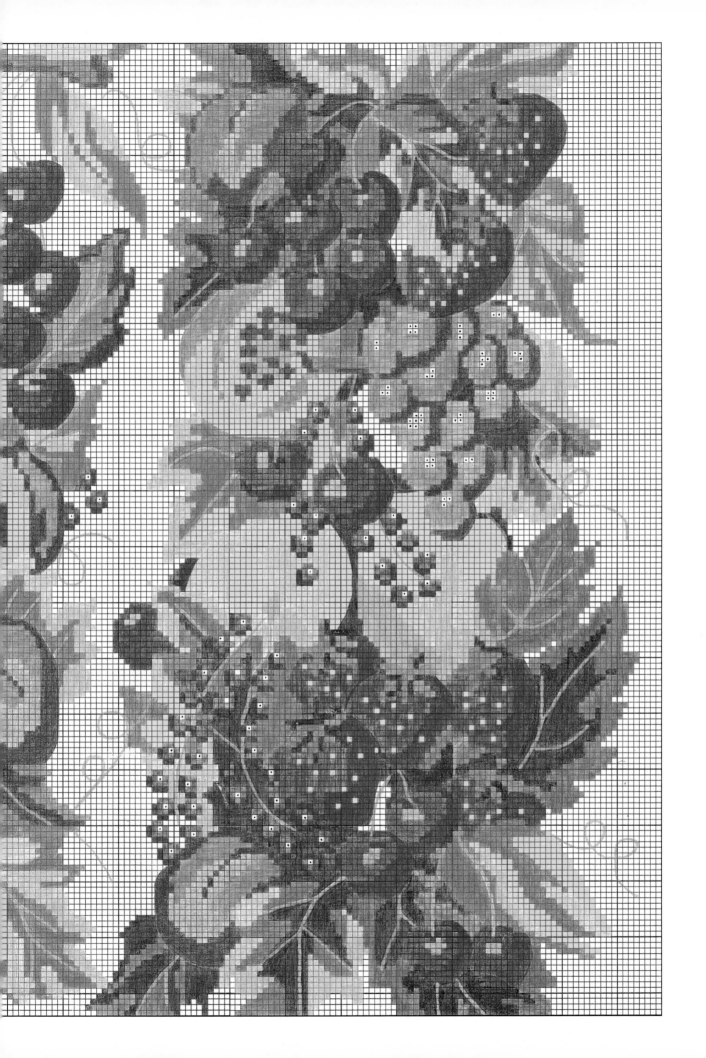

Tartan Christmas decorations
Featured in Tartan patterns on page 40

Finished size of designs
Tartan stocking: approximately 5 x 6in
Tartan box: approximately 5in square
Tartan candle: approximately 5in
diameter

Yarns
All three Tartan designs together

Key	Anchor Tapisserie Wool		Skeins
A	8034	Cream	1
B	8132	Pale yellow	1
C	8136	Dark yellow	2
D	8200	Red	2
E	8194	Orange	1
F	8876	Pale green	1
G	8900	Jade	1
H	8882	Dark green	3
I	9792	Pale gray	1
J	9800	Black	1
K	8636	Navy	3

Tartan stocking

Key	Anchor Tapisserie Wool		Skeins
C	8136	Dark yellow	1
D	8200	Red	1
F	8876	Pale green	1
G	8900	Jade	1
I	9792	Pale gray	1
J	9800	Black	1
K	8636	Navy	1

Tartan box

Key	Anchor Tapisserie Wool		Skeins
A	8034	Cream	1
B	8132	Pale yellow	1
C	8136	Dark yellow	1
D	8200	Red	1
H	8882	Dark green	2
K	8636	Navy	1

Tartan candle

Key	Anchor Tapisserie Wool		Skeins	
A	8034	Cream	1	
C	8136	Dark yellow	1	
D	8200	Red	1	
E	8194	Orange	1	
H	8882	Dark green	2	
K	8636	Navy	1	

Canvas
12-gauge white mono deluxe

Size
Stocking: 9 x 10in
Box: 9in square
Candle: 9in square
For all three decorations stitched

together: 27 x 10in

Other materials
Tapestry needle, size 20
Ruler or tape measure
Masking tape for binding the canvas
Sharp scissors for cutting the canvas
Embroidery scissors
Sharp HB pencil or fine permanent
marker in suitable color
Eraser

Following the charts
Cut the canvas to size and bind the
edges with masking tape. The design
does not have to be marked out on the
canvas; just follow the color charts
opposite. Remember that the squares
represent the canvas intersections, not
the holes. Each square represents one
TENT stitch.

　　The charts are divided into units of
10 squares by 10 squares to make
them easier to follow. Before beginning
to stitch, it may be helpful to mark out
your canvas in similar units with an HB
pencil or permanent marker in a
suitable color. Mark the top of the

canvas so that if you turn the canvas
while stitching, you will still know
where the top is.

　　The colors on the charts are shown
stronger than the actual yarn colors to
make them easier to see. The
corresponding yarns are given in the
color keys.

Stitches used
TENT stitch (1), STEM stitch (2)
(optional). For stitch instructions, see
page 182.

Stitching the design
The whole thread is used throughout,
except for the outlining on the candle –
see below.

　　Begin in any area you wish. It may
be easiest to start at the top right-hand
corner 1½-2in in from the corner,
working horizontally from one block of
color to another. We have used STEM
stitch to outline the flame on the
candle. Please refer to the color
photograph and the chart for the
positioning of the STEM stitch. It will
probably be easier to outline at the
end. If you find there are spaces once
you have worked the STEM stitch, 'fill
in' with TENT stitches in the relevant
colors. However, if you work the whole
design in TENT stitch, go to the nearest
square.

　　For a finer look for STEM stitch, we
have split the thread and used only two
strands, but this is optional. To split the
wool in two, hold one end of the
thread with your teeth and, beginning
in the middle, split the thread with your
hands, pulling gently and slowly apart.

Making-up instructions
When the design has been sewn, the
needlepoint may need to be stretched
back into shape (see page 183). Then
make it up into decorations as shown
on page 188.

A

B

C

D

E

F

G

H

I

J

K

Sahara

Featured in Tribal designs on page 46

Finished size of design

15½in square

Yarns

Key	Anchor Tapisserie Wool	Skeins
A	8052/9322 Beige	4 of each colour
B	8040 Custard	6
C	8024 Ocher	6
D	9058 Pale green	6
E	9260 Leaf green	4
F	9620 Plum	7
G	9394/9452 Brown	3 of each colour
H	9648 Dark brown	6

Canvas

7-gauge cream interlocked rug canvas
Size: 19½in square

Other materials

Tapestry needle, size 16
Ruler or tape measure
Masking tape for binding the canvas
Sharp scissors for cutting the canvas
Embroidery scissors
Sharp HB pencil or fine permanent
marker in suitable color
Eraser

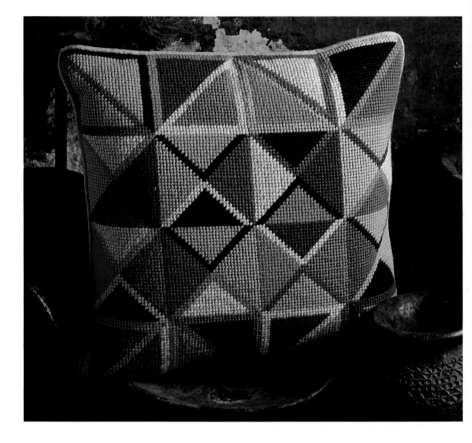

Following the chart

Cut the canvas to size and bind the edges with masking tape. The design does not have to be marked out on the canvas; just follow the color chart opposite. Remember that the squares represent the canvas intersections, not the holes. Each square represents one TENT stitch.

The chart is divided into units of 10 squares by 10 squares to make it easier to follow. Before beginning to stitch, it may be helpful to mark out your canvas in similar units with an HB pencil or permanent marker in a suitable color. At the same time, mark the top of the canvas so that if you turn the canvas while stitching, you will still know where the top is.

The colors on the chart are shown stronger than the actual yarn colors to make them easier to see. The corresponding yarns are given in the color key.

Stitches used

TENT stitch (1) is used throughout. For stitch instructions, see page 182.

Stitching the design

The thread has been used double throughout. Thread two threads of the same color into the needle at the same time except for A (8052/9322) Beige and G (9394/9452) Brown, when one thread of each color should be threaded into the needle. This will give a handwoven shaded effect.

Begin in any area you wish. It may be easiest to start at the top right-hand corner 1½-2in in from the corner, working horizontally from one block of color to another.

Making-up instructions

When the design has been sewn, the needlepoint may need to be stretched back into shape (see page 183). Then make it up into a cushion as shown on pages 184-6. We suggest you use the simple piped cushion on page 184.

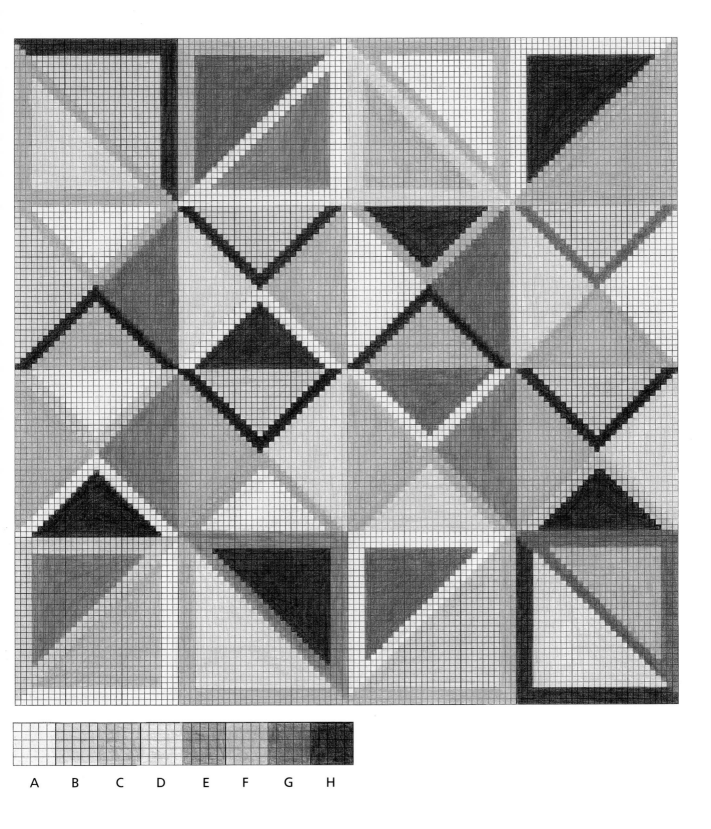

A B C D E F G H

The charts

India

For yarn quantities and stitching instructions, see overleaf

A
B
C
D
E
F
G
H
I
J

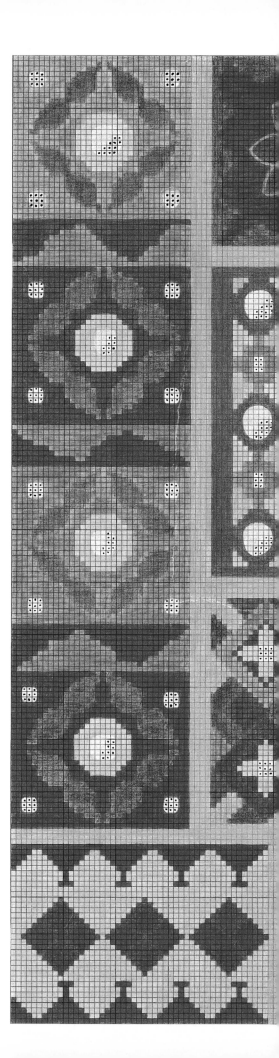

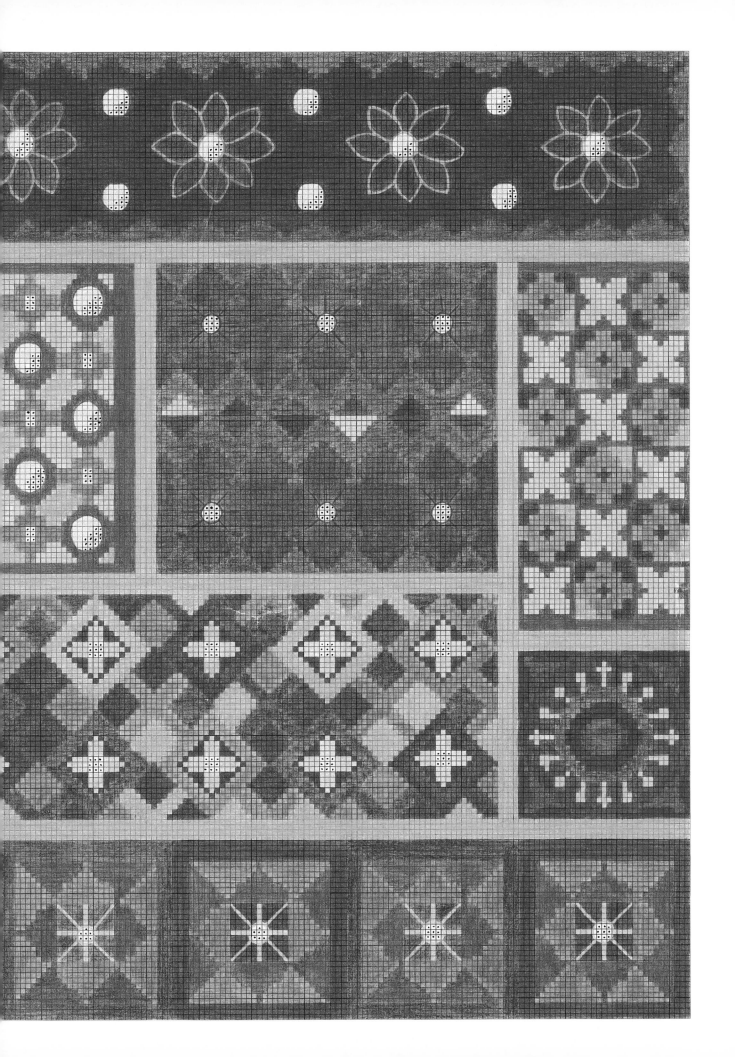

India

Featured in Tribal designs on pages 50-1

Finished size of design

15in square

Yarns

Key	Anchor Tapisserie Wool		Skeins
A	9618	Dusky pink	3
B	8400	Rose pink	4
C	9512	Terracotta	4
D	8204	Red	3
E	8220	Crimson	6
F	9566	Chocolate brown	3
G	8510	Mauve	6
H	9658	Taupe	5
	Anchor Stranded Cotton		
I	233	Elephant gray	2
	Mez Ophir		
J	0301	Silver	1 spool

Mix the Mez Ophir 0301 Silver with Anchor Stranded Cotton 233 Elephant gray.

Canvas

12-gauge white mono deluxe
Size: 19in square

Other materials

Tapestry needle, size 20
Ruler or tape measure
Masking tape for binding the canvas
Sharp scissors for cutting the canvas
Embroidery scissors
Sharp HB pencil or fine permanent marker in suitable color
Eraser

Chart

See previous page

Following the chart

Cut the canvas to size and bind the edges with masking tape. The design does not have to be marked out on the canvas; just follow the color chart on the previous page. Remember that the squares represent the canvas intersections, not the holes. Each square represents one TENT stitch.

The chart is divided into units of 10 squares by 10 squares to make it easier to follow. Before beginning to stitch, it may be helpful to mark out your canvas in similar units with an HB pencil or permanent marker in a suitable color. Mark the top of the canvas so that if you turn the canvas while stitching, you will still know where the top is.

The colors on the chart are shown stronger than the actual yarn colors to make them easier to see. The corresponding yarns are given in the color key.

Stitches used

TENT stitch (1), STEM stitch (2) (optional). For stitch instructions, see page 182.

Stitching the design

The whole thread of tapestry wool is used throughout except for STEM stich – see below. The whole thread of stranded cotton (6 strands) is used throughout. One strand of silver thread is used throughout.

Begin with TENT stitch in any area you wish. It may be easiest to start at the top right-hand corner 1½-2in in from the corner, working horizontally from one block of color to another. We have used STEM stitch to outline the silver motifs. Please refer to the color photograph and the chart for the positioning of the STEM stitch. It is impossible to show all the outlining on the circles on the chart if the color outlined is the same as the background. You can see where they are by the shape on the chart and also by referring to the color photograph. It will probably be easier to outline at the end. If you find there are spaces once

you have worked the STEM stitch, 'fill in' with TENT stitches in the relevant colors. However, if you work the whole design in TENT stitch, go to the nearest square.

Some areas have been stitched using a combination of silver thread and Anchor stranded cotton – see the chart for the position. Stitch the stranded cotton first, then the silver thread on top. Do not stitch the two different yarns together.

For a finer look for STEM stitch, we have split the thread and used only two strands, but this is optional. To split the wool in two, hold one end of the thread with your teeth and, beginning in the middle, split the thread with your hands, pulling gently and slowly apart.

Making-up instructions

When the design has been sewn, the needlepoint may need to be stretched back into shape (see page 183). Then make it up into a cushion as shown on pages 184-6. We suggest you use the corded cushion with knots that is shown on page 184.

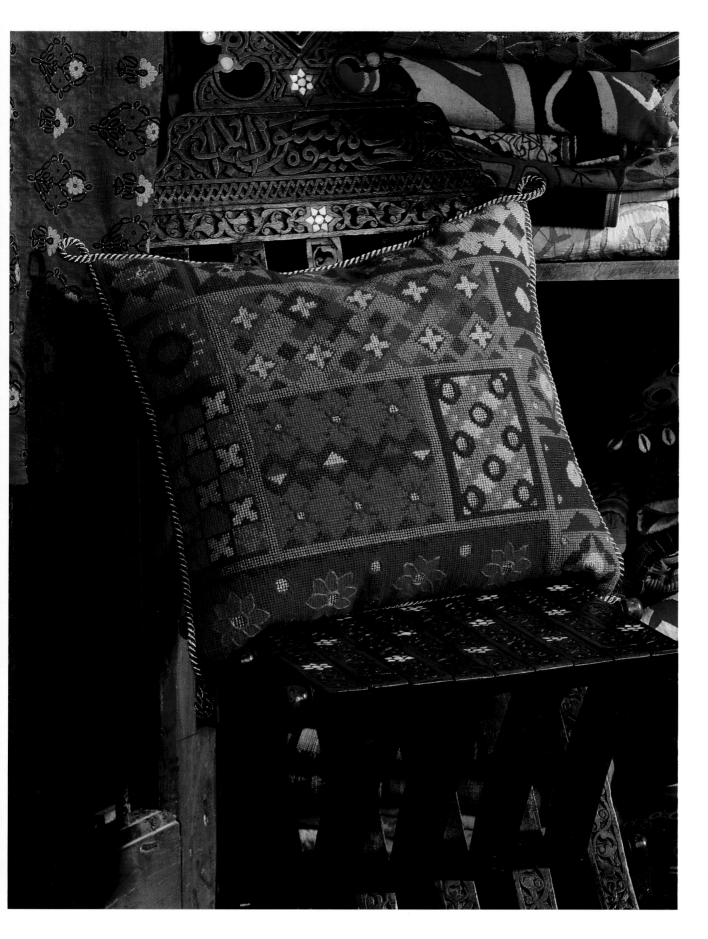

Victorian garlands

For yarn quantities and stitching instructions, see overleaf

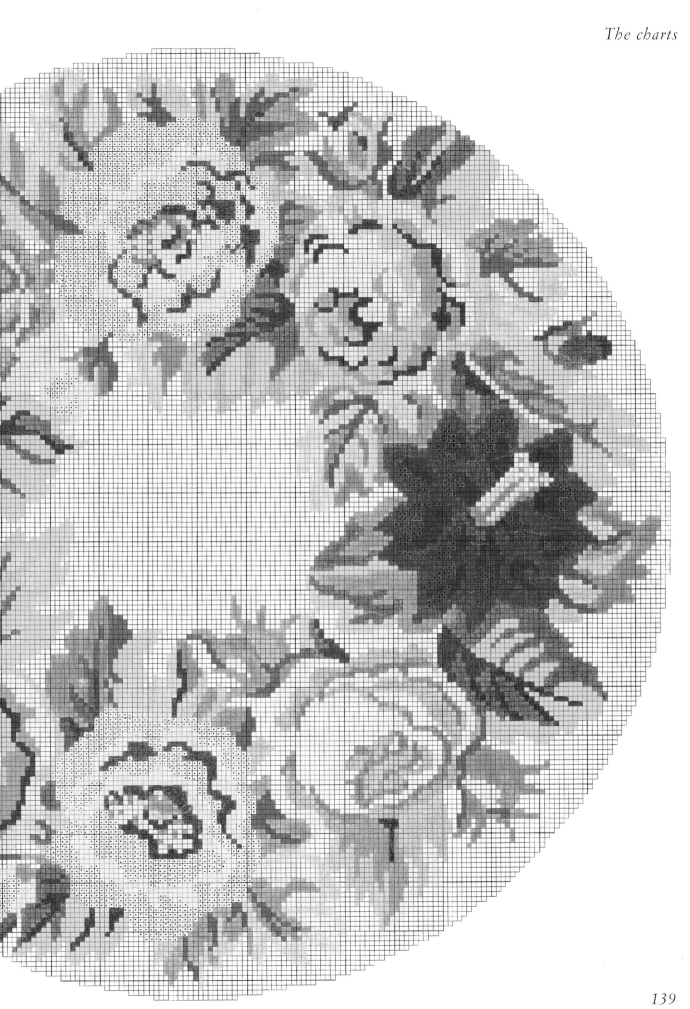

Victorian garlands
Featured in Victoriana on page 57

Finished size of design
19in diameter

Yarns

Key	Anchor Tapisserie Wool		Skeins
A	8296	Flesh	2
B	9618	Dusky pink	2
C	8346	Rose	2
D	8352	Wine	2
E	8216	Light red	3
F	8218	Dark red	1
G	9554	Pale orange	2
H	8192	Dark orange	2
I	9772	Silver gray	4
J	9774	Gray	1
K	9678	Grape	1
L	9058	Pale green	3
M	9176	Apple green	3
N	8876	Light turquoise	2
O	8882	Dark turquoise	2
P	9180	Dark green	2
Q	9384	Honey	2
R	9448	Cinnamon	1
S	8042	Gold	2
T	9286	Light olive	2
U	9290	Dark olive	3
V	8428	Aubergine	1
W	9648	Dark brown	1
Suggested background			
X	9648	Dark brown	9

Canvas
10-gauge white mono deluxe
Size: 23in square

Other materials
Tapestry needle, size 18
Ruler or tape measure
Masking tape for binding the canvas
Sharp scissors for cutting the canvas
Embroidery scissors
Sharp HB pencil or fine permanent marker in suitable color
Eraser

Chart
See previous page

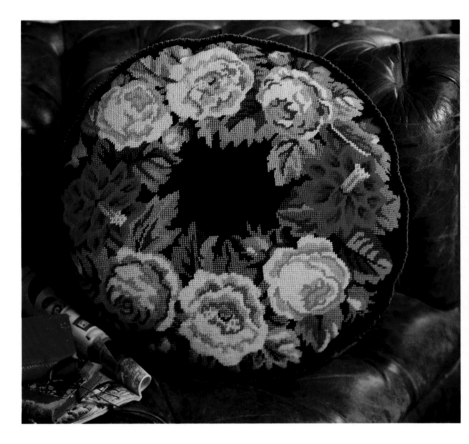

Following the chart
Cut the canvas to size and bind the edges with masking tape. The design does not have to be marked out on the canvas; just follow the color chart on the previous page. Remember that the squares represent the canvas intersections, not the holes. Each square represents one TENT stitch.

The chart is divided into units of 10 squares by 10 squares to make it easier to follow. Before beginning to stitch, it may be helpful to mark out your canvas in similar units with an HB pencil or permanent marker in a suitable color. At the same time, mark the top of the canvas so that if you turn the canvas while stitching, you will still know where the top is.

The colors on the chart are shown stronger than the actual yarn colors to make them easier to see. The corresponding yarns are given in the color key.

Stitches used
TENT stitch (1) is used throughout. For stitch instructions, see page 182.

Stitching the design
The whole thread is used throughout. Begin in any area you wish. It may be easiest to start at the top right-hand corner 1½-2in from the corner, working horizontally from one block of color to another.

Making-up instructions
When the design has been sewn, the needlepoint may need to be stretched back into shape (see page 183). Then make it up into a cushion as shown on pages 184-6. We suggest you use the boxed ruched cushion on page 186.

Imari plate

Featured in Porcelain & pottery on page 62

Finished size of design

14½in diameter

Yarns

Key	Anchor Tapisserie Wool	Skeins
A	8004 White	6
B	9386 Beige	1
C	8132 Yellow	1
D	8022 Ocher	4
E	8328 Pale terracotta	1
F	8238 Red	5
G	9162 Apple green	1
H	9078 Pine green	2
I	8628 Pale blue	1
J	8632 Bright blue	4
K	8742 Navy	1
	REVERSED TENT stitch	⊡

Canvas

12-gauge white mono deluxe
Size: 18½in square

Other materials

Tapestry needle, size 20
Ruler or tape measure
Masking tape for binding the canvas
Sharp scissors for cutting the canvas
Embroidery scissors
Sharp HB pencil or fine permanent
marker in suitable color
Eraser

Chart

See overleaf

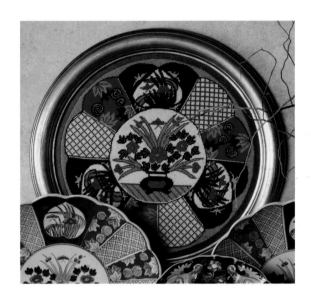

Following the chart

Cut the canvas to size and bind the edges with masking tape. The design does not have to be marked out on the canvas; just follow the color chart overleaf. Remember that the squares represent the canvas intersections, not the holes. Each square represents one TENT stitch.

The chart is divided into units of 10 squares by 10 squares to make it easier to follow. Before beginning to stitch, it may be helpful to mark out your canvas in similar units with an HB pencil or permanent marker in a suitable color. Mark the top of the canvas so that if you turn the canvas while stitching, you will still know where the top is.

The colors on the chart are shown stronger than the actual yarn colors to make them easier to see. The corresponding yarns are given in the color key.

Stitches used

TENT stitch (1), REVERSED TENT stitch (1a), STEM stitch (2) (optional). For stitch instructions, see the general information on page 182.

Stitching the design

The whole thread of tapestry wool is used throughout, except for STEM stitch – see below.

Begin with TENT stitch in any area you wish. It may be easiest to start at the top right-hand corner 1½-2in in from the corner, working horizontally from one block of color to another. We have used STEM stitch to outline various areas. Please refer to the photograph and the chart for the positioning. It will probably be easier to outline at the end. If you find there are spaces once you have worked the STEM stitch, 'fill in' with TENT stitches in the relevant colors. However, if you work the whole design in TENT stitch, go to the nearest square.

For a finer look for STEM stitch, we have split the thread and used only two strands, but this is optional. To split the wool in two, hold one end of the thread with your teeth and, beginning in the middle, split the thread with your hands, pulling gently and slowly apart.

The symbols on the chart show the areas where REVERSED TENT stitch ⊡ has been used.

Making-up instructions

Many needlepointers feel experienced enough to stretch and make up their needlework designs into cushions, but we always feel that a needlepoint picture should be framed by a professional, who has experience at stretching and framing needlepoint.

Imari plate

For yarn quantities and stitching instructions, see previous page

A
B
C
D
E
F
G
H
I
J
K

REVERSED
TENT
STITCH

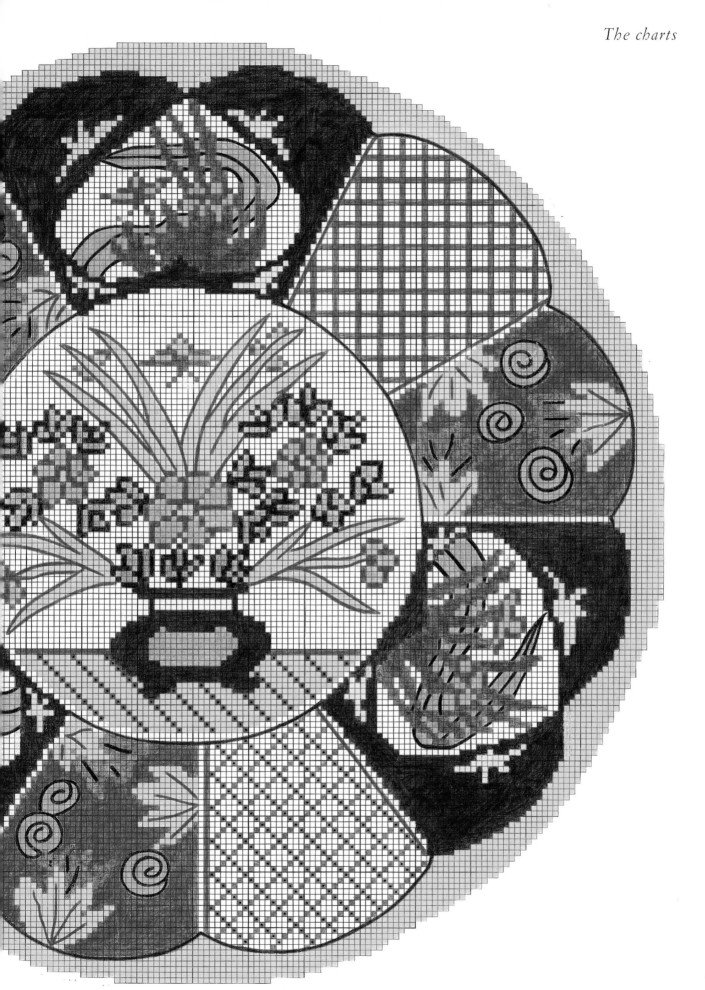

Clarice Cliff wallhanging
Featured in Porcelain & pottery on page 65

Finished size of design
15 x 24in

Yarns

Key	Anchor Tapisserie Wool		Skeins
A	8014	Pale yellow	7
B	8118	Bright yellow	5
C	8134	Custard	1
D	9368	Fawn	2
E	9322	Beige	6
F	8982	Pale mint green	2
G	8964	Turquoise	2
H	8984	Dark mint green	8
I	8970	Emerald	3
J	9534	Dull orange	7
K	8166	Bright orange	2
L	8196	Vermilion	3
M	8198	Pillar box red	3
N	8240	Rust	4
O	8544	Pale lavender	4
P	8546	Dark lavender	1
Q	8608	Violet	3
R	8610	Dark violet	2
S	8742	Navy	1
T	8412	Pale pink	2
U	8414	Dark pink	2

Canvas
10-gauge white mono deluxe
Size: 19 x 28in

Other materials
Tapestry needle, size 18
Ruler or tape measure
Masking tape for binding the canvas
Sharp scissors for cutting the canvas
Embroidery scissors
Sharp HB pencil or fine permanent
marker in suitable color
Eraser

Chart
See overleaf

Following the chart
Cut the canvas to size and bind the edges with masking tape. The design does not have to be marked out on the canvas; just follow the color chart overleaf. Remember that the squares represent the canvas intersections, not the holes. Each square represents one TENT stitch.

The chart is divided into units of 10 squares by 10 squares to make it easier to follow. Before beginning to stitch, it may be helpful to mark out your canvas in similar units with an HB pencil or permanent marker in a suitable color. Mark the top of the canvas so that if you turn the canvas while stitching, you will still know where the top is.

The colors on the chart are shown stronger than the actual yarn colors to make them easier to see. The corresponding yarns are given in the color key.

Stitches used
TENT stitch (1), STEM stitch (2) (optional). For stitch instructions, see page 182.

Stitching the design
The whole thread is used, except for SOME of the outlining – see below.

You will see that in some places, two shades of the same color have been used. For example, the lavender colored tree, top left. This is to imitate the streaky brush strokes so typical of Clarice Cliff china and need not be followed exactly from the chart, but can be done in a random way.

Begin with TENT stitch in any area you wish. It may be easiest to start at the top right-hand corner 1½-2in in from the corner, working horizontally from one block of color to another. We have used STEM stitch to outline and highlight the picture. Please refer to the color photograph and the chart for the positioning of the STEM stitch. It will probably be easier to outline at the end. If you find there are spaces once you have worked the STEM stitch, 'fill in' with TENT stitches in the relevant colors.

In some areas we have used STEM stitch simply to give an unbroken flow and in this case it is impossible to show the outlining on the chart as the outlining is in the same color as the TENT stitch, so it is imperative for you to refer to the color photograph. The areas where this occurs in this way are as follows: all the tree trunks, branches and the smoke. In these areas of STEM stitch, we have split the thread and used only two strands. To split the wool in two, hold one end of the thread with your teeth and, beginning in the middle, split the thread with your hands, pulling gently and slowly apart.

When STEM stitch outlining is in a contrast color, and this you can see clearly on the chart, use the full thickness of wool.

If the whole design is worked in TENT stitch, go to the nearest square.

Making-up instructions
When the design has been sewn, the needlepoint may need to be stretched back into shape (see page 183). Then make it up into a wallhanging as shown on page 188. However, should you want to turn this into a picture, we feel that it should be framed by a professional, who has experience at stretching and framing needlepoint.

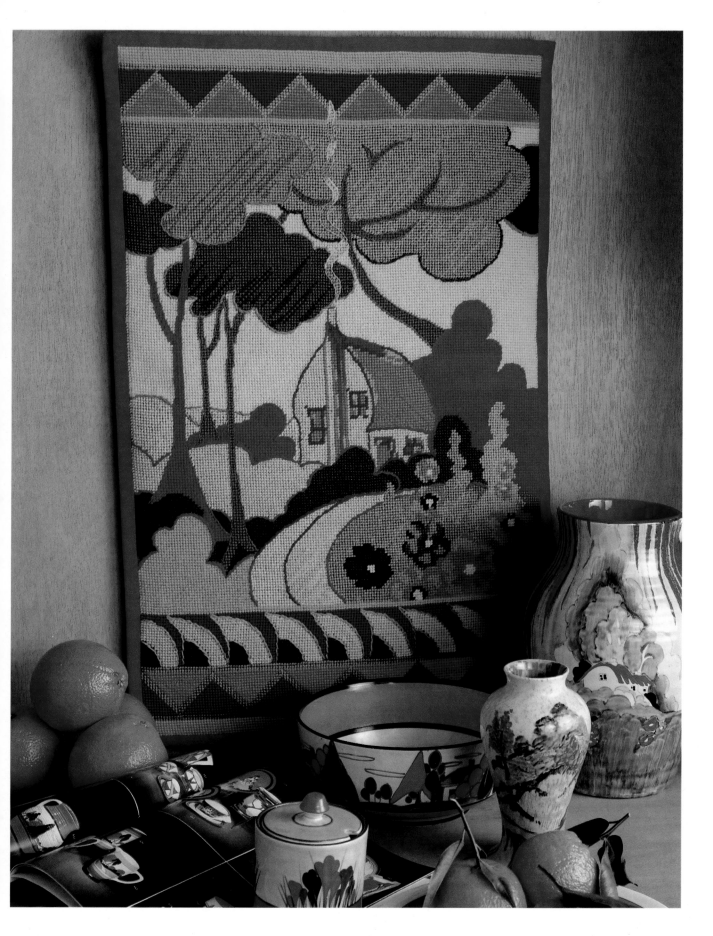

Clarice Cliff wallhanging

For yarn quantities and stitching instructions, see previous page

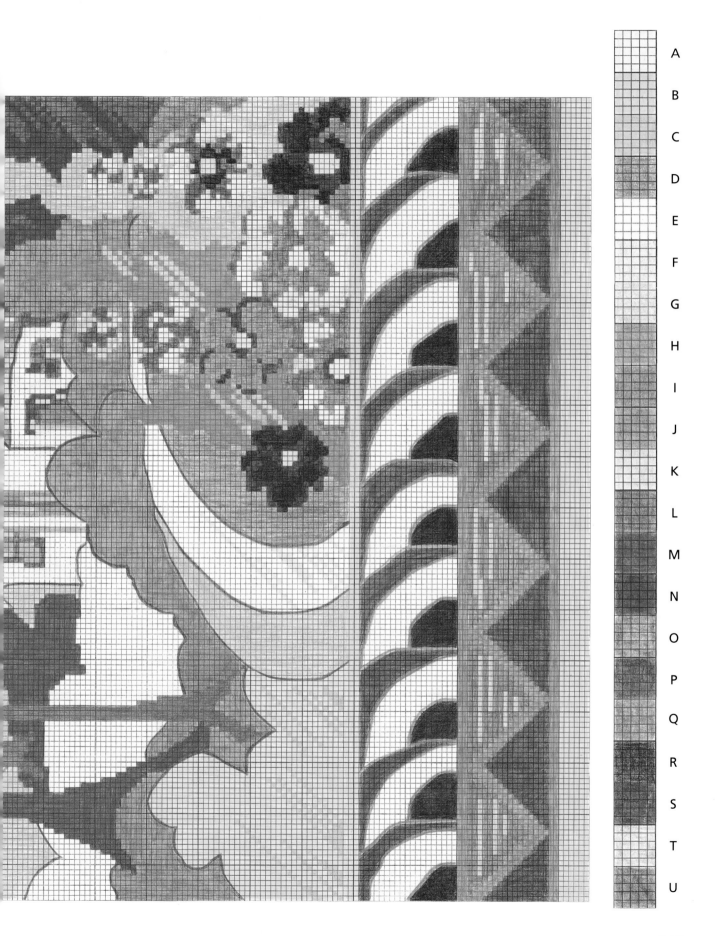

A
B
C
D
E
F
G
H
I
J
K
L
M
N
O
P
Q
R
S
T
U

Blue & white tea cosy

Featured in Porcelain & pottery on pages 72-3

Finished size of design

12 x 10½in

Yarns

Key	Anchor Tapisserie Wool		Skeins
A	8000	White	7
B	8624	Pastel blue	3
C	8686	Pale blue	3
D	8644	Mid-blue	3
E	8690	Royal blue	4
F	8634	Navy	2
		REVERSED TENT stitch	⊡

Canvas

12-gauge white mono deluxe
Size: 16 x 14½in

Other materials

Tapestry needle, size 20
Ruler or tape measure
Masking tape for binding the canvas
Sharp scissors for cutting the canvas
Embroidery scissors
Sharp HB pencil or fine permanent
marker in suitable color
Eraser

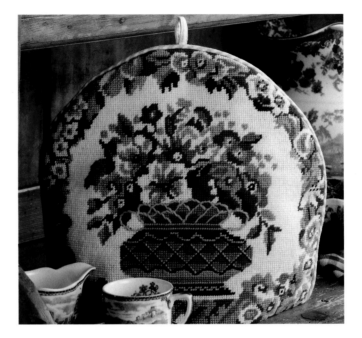

Following the chart

Cut the canvas to size and bind the edges with masking tape. The design does not have to be marked out on the canvas; just follow the color chart opposite. Remember that the squares represent the canvas intersections, not the holes. Each square represents one TENT stitch.

The chart is divided into units of 10 squares by 10 squares to make it easier to follow. Before beginning to stitch, it may be helpful to mark out your canvas in similar units with an HB pencil or permanent marker in a suitable color. Mark the top of the canvas so that if you turn the canvas while stitching, you will still know where the top is.

The colors on the chart are shown stronger than the actual yarn colors to make them easier to see. The corresponding yarns are given in the color key.

Stitches used

TENT stitch (1) is used throughout, REVERSED TENT stitch (1a) (optional), STEM stitch (2) (optional). For stitch instructions, see page 182.

Stitching the design

The whole thread is used throughout.

Begin with TENT stitch in any area you wish. It may be easiest to start at the top right-hand corner 1½-2in in from the corner, working horizontally from one block of color to another. We have used STEM stitch and some REVERSED TENT stitch, but if you prefer, the whole design can be stitched in TENT stitch. If you decide to use STEM stitch, please refer to the color photograph and the chart for the positioning.

The flower border and the flowers in the basket are all worked in TENT stitch. The lattice work at the top of the vase and the curves on the vase are outlined in STEM stitch. It will probably be easier to outline at the end. If you find there are spaces once you have worked the STEM stitch, 'fill in' with TENT stitches in the relevant colors. The trellis in the center is worked in TENT stitch and REVERSED TENT stitch to give an unbroken line.

Making-up instructions

When the design has been sewn, the needlepoint may need to be stretched back into shape (see page 183). Then make it up into a tea cosy as shown on page 189.

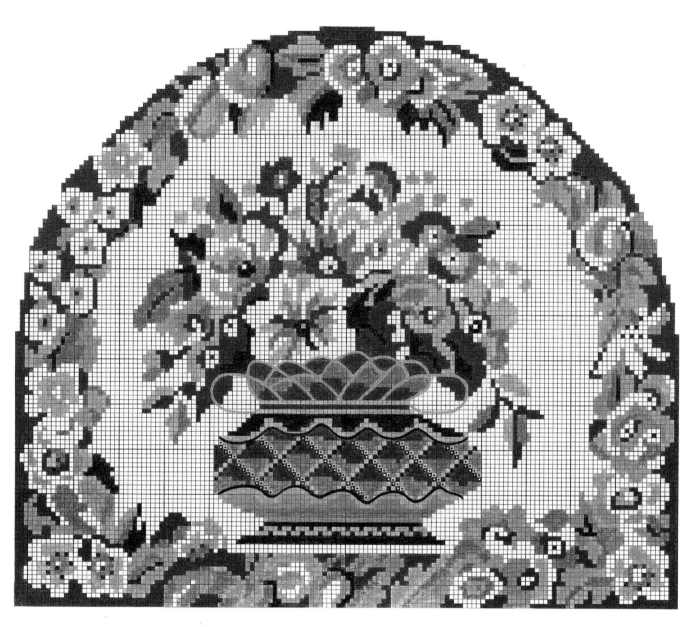

A　　B　　C　　D　　E　　F　　REVERSED
TENT STITCH

English floral roses

Featured in English floral on pages 82-3

Finished size of each square

16in square

Sew one for a cushion or six for a carpet. If you decide to make a carpet, we suggest you stitch three of each colorway and follow our instructions on pages 186-8 for joining the squares, stitching the border, and finally making up into a carpet

Carpet stitchers

There are two things that must be noted if you are going to sew squares together for a carpet:

1 Each design should be worked with the canvas THE SAME WAY UP. This is because the holes of the 7-gauge canvas are slightly oblong and unless the canvases correspond they will not join comfortably. The easiest way to ensure this is to ALWAYS keep the selvedge on the right (or left, if you are left-handed). The canvases are worked in two colorways laid alternately but always the same way up – this is vital for the reason given above.

2 You MUST work on a frame or you will find that the distortion of TENT stitch over six squares will be extremely difficult to overcome.

Yarns

Yellow rose colorway

Key	Anchor Tapisserie Wool		Skeins
A	8036	Cream	4
B	8056	Yellow	5
C	8060	Ocher	4
D	8062	Cinnamon	1
E	8392	Pastel pink	2
F	8364	Pale pink	4
G	8414	Mid-pink	4
H	8420	Dark pink	2
I	9074	Almond green	5
J	9258	Pale green	6
K	9262	Dark green	4
L	9314	Olive*	8
M	8878	Turquoise	3
N	8582	Lavender	2
O	8522	Pale mauve	4
P	8546	Mid-mauve	4
Q	8548	Dark mauve	1

* Background

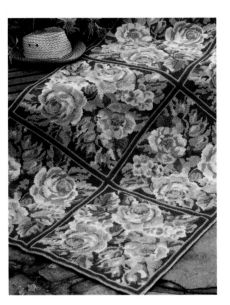

Pink rose colorway

Key	Anchor Tapisserie Wool		Skeins
A	8392	Pastel pink	4
B	8364	Pale pink	5
C	8414	Mid-pink	4
D	8420	Dark pink	1
E	8582	Lavender	2
F	8522	Pale mauve	4
G	8546	Mid-mauve	4
H	8548	Dark pink	2
I	9074	Almond green	5
J	9258	Pale green	6
K	9262	Dark green	4
L	9314	Olive*	8
M	8878	Turquoise	3
N	8036	Cream	2
O	8056	Yellow	4
P	8060	Ocher	4
Q	8062	Cinnamon	1

* Background

Canvas

7-gauge interlocked cream rug canvas
Size: 20in square

Other materials

Tapestry needle, size 16
Ruler or tape measure
Masking tape for binding the canvas
Sharp scissors for cutting the canvas
Embroidery scissors
Sharp HB pencil or fine permanent marker in suitable color
Eraser

Following the chart

Cut the canvas to size and bind the edges with masking tape. The design does not have to be marked out on the canvas; just follow the color chart opposite. Remember that the squares represent the canvas intersections, not the holes. Each square represents one TENT stitch.

The chart is divided into units of 10 squares by 10 squares to make it easier to follow. Before beginning to stitch, it may be helpful to mark out your canvas in similar units with an HB pencil or permanent marker in a suitable color. Mark the top of the canvas so that if you turn the canvas while stitching, you will still know where the top is.

The colors on the chart are shown stronger than the actual yarn colors to make them easier to see. The corresponding yarns are given in the color key.

We have only shown the chart for the yellow rose colorway. For the pink rose colorway, simply substitute the colors on the second colorway.

Stitches used

TENT stitch (1) is used throughout. For stitch instructions, see page 182.

Stitching the design

The thread has been used double. Put two threads of the same color into the needle at the same time. Then begin in any area you wish. It may be easiest to start at the top right-hand corner 1½-2in in from the corner, working horizontally from one block of color to another.

Making-up instructions

When the design has been sewn, the needlepoint may need to be stretched back into shape (see page 183). Then make it up into a cushion of your choice (see pages 184-6), or if making a carpet, follow the joining instructions on pages 186-8.

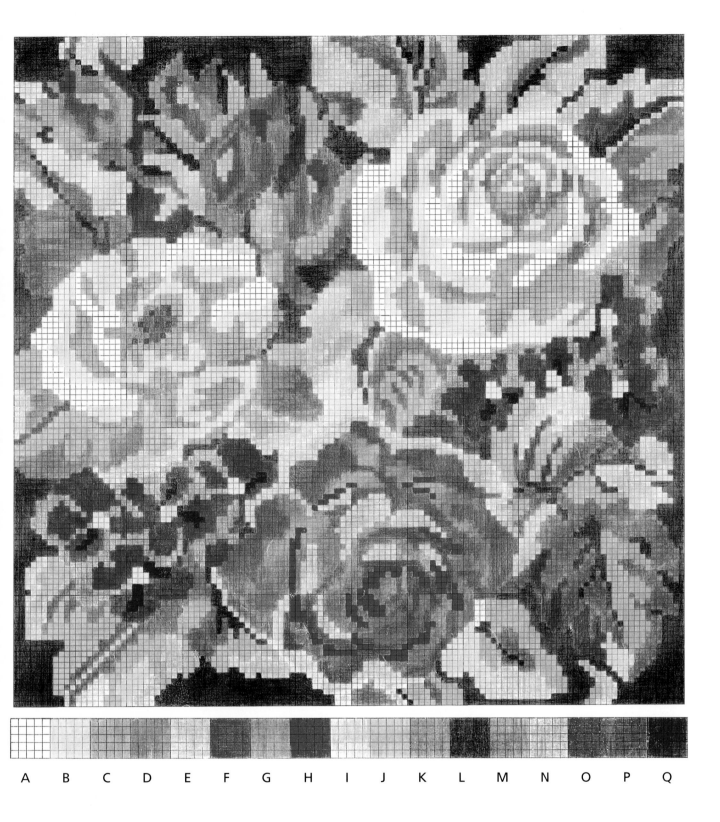

A B C D E F G H I J K L M N O P Q

Wrought iron roses

For yarn quantities and stitching instructions, see overleaf

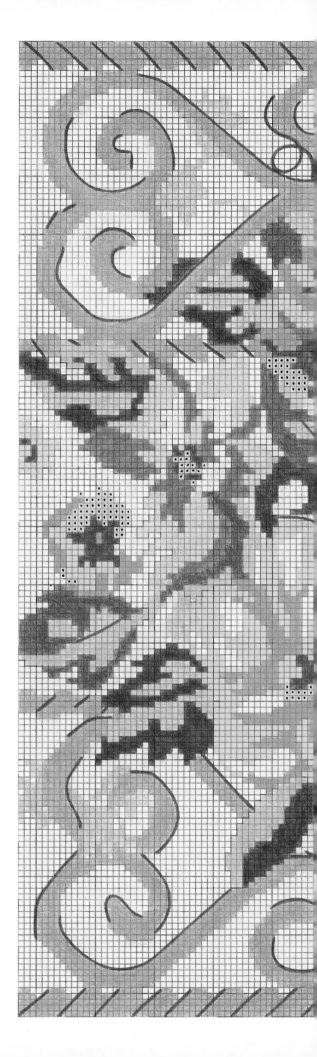

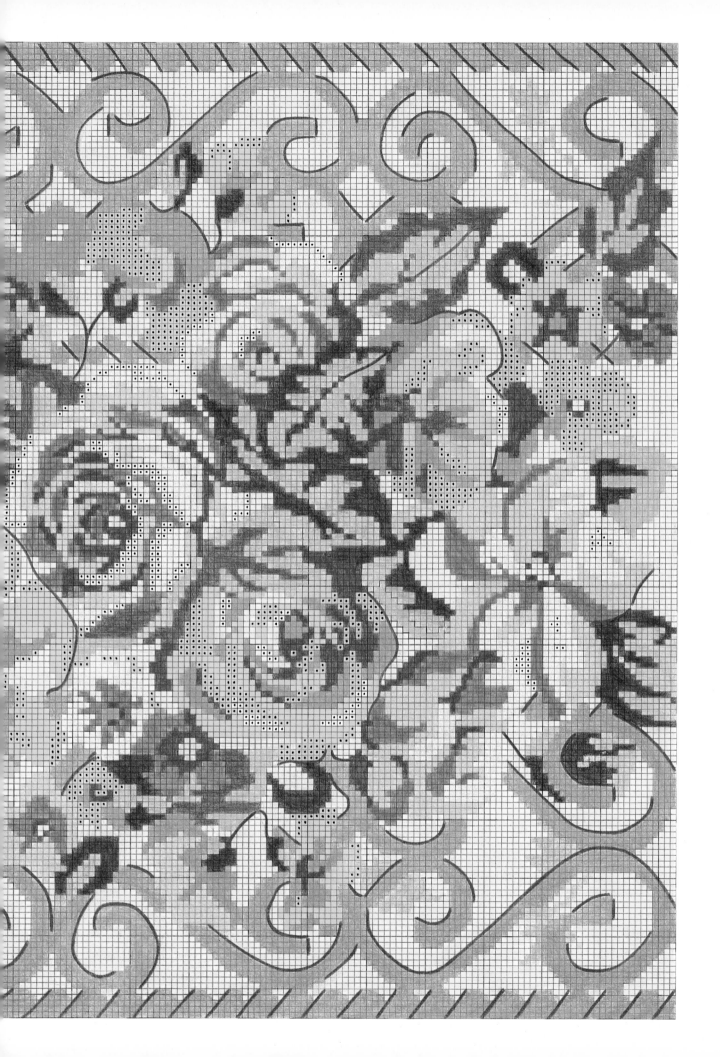

Wrought iron roses
Featured in English floral on page 84

Finished size of design
14in square

Yarns

Key	Anchor Tapisserie Wool		Skeins
A	8002	White	1
B	9774	Pale gray	6
C	8038	Yellow	2
D	8040	Light gold	2
E	8042	Dark gold	2
F	9592	Peach	2
G	9508	Salmon	3
H	9536	Burnt orange	2
I	9074	Almond green	2
J	9066	Sage green	2
K	8896	Pale turquoise	2
L	8900	Dark turquoise	3
M	9600	Terracotta	2
N	8012	Pale yellow	7

Canvas
12-gauge white mono deluxe
Size: 18in square

Other materials
Tapestry needle, size 20
Ruler or tape measure
Masking tape for binding the canvas
Sharp scissors for cutting the canvas
Embroidery scissors
Sharp HB pencil or fine permanent
marker in suitable color
Eraser

Chart
See previous page

Following the chart
Cut the canvas to size and bind the edges with masking tape. The design does not have to be marked out on the canvas; just follow the color chart on the previous page. Remember that the squares represent the canvas intersections, not the holes. Each square represents one TENT stitch.

The chart is divided into units of 10 squares by 10 squares to make it easier to follow. Before beginning to stitch, it may be helpful to mark out your canvas in similar units with an HB pencil or permanent marker in a suitable color. Mark the top of the canvas so that if you turn the canvas while stitching, you will still know where the top is.

The colors on the chart are shown stronger than the actual yarn colors to make them easier to see. The corresponding yarns are given in the color key.

Stitches used
TENT stitch (1), STEM stitch (2) (optional). For stitch instructions, see page 182.

Stitching the design
Begin with TENT stitch in any area you wish. It may be easiest to start at the top right-hand corner 1½-2in in from the corner, working horizontally from one block of color to another. We have used STEM stitch to outline the wrought iron and to highlight the flowers and leaves. Please refer to the color photograph and the chart for the positioning of the STEM stitch. It will probably be easier to outline at the end. It is impossible to show on the chart the white outlining on the central peach roses, so please refer to the photograph. *The roses are outlined in white wool.* If you find there are spaces once you have worked the STEM stitch, fill in with TENT stitches in the relevant colors. However, if you work the whole design in TENT stitch go to the nearest square.

For a finer look for STEM stitch, we have split the thread and used only two strands, but this is optional. To split the wool in two, hold one end of the thread with your teeth and, beginning in the middle, split the thread with your hands, pulling gently and slowly apart.

Making-up instructions
When the design has been sewn, the needlepoint may need to be stretched back into shape (see page 183). Then make it up into a cushion as shown on pages 184-6. We suggest you use the cushion with ruched piping that is shown on page 185.

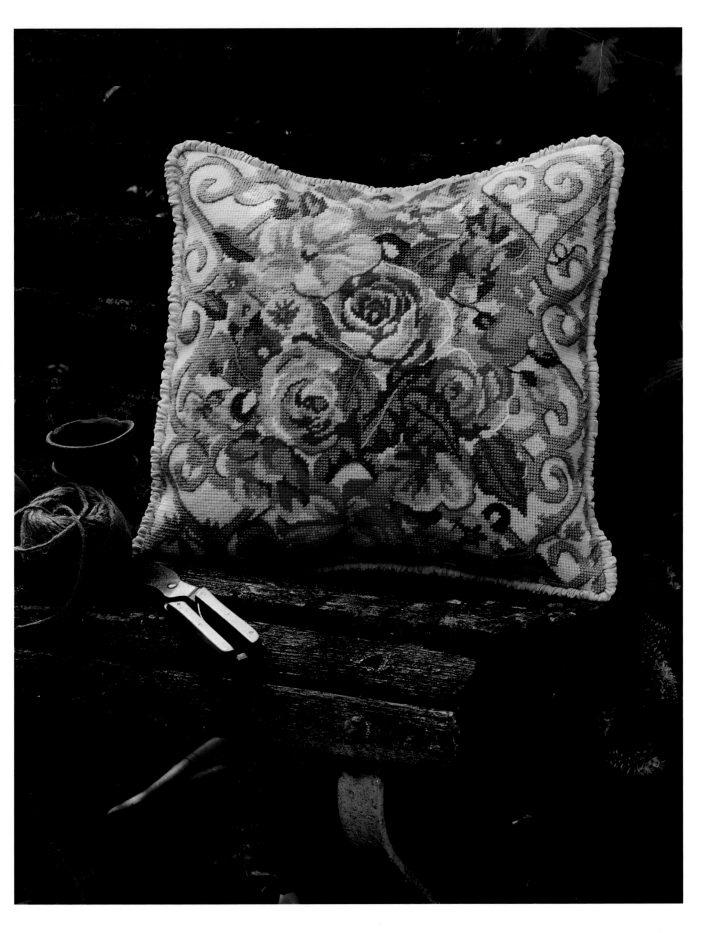

Noah's ark sampler

Featured in Children's designs on pages 88-9

Finished size of design

12in square

Yarns

Key	Anchor Tapisserie Wool		Skeins
A	8002	White	5
B*	8416	Pink	4
C	9558	Orange	3
D	8120	Yellow	3
E	9424	Beige	2
F	8896	Turquoise	2
G	8690	Royal blue	7
H	9666	Dark brown	1

* This colour can be substituted with 8686 Blue (3 skeins) if you stitch the picture for a boy. You will then need only 2 skeins of 8416 Pink for the elephant and the reeds.

Canvas

12-gauge white mono deluxe
Size: 16in square

Other materials

Tapestry needle, size 20
Ruler or tape measure
Masking tape for binding the canvas
Sharp scissors for cutting the canvas
Embroidery scissors
Sharp HB pencil or fine permanent marker in suitable color
Eraser

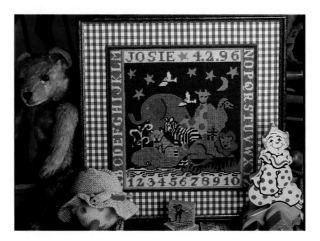

Following the chart

Cut the canvas to size and bind the edges with masking tape. The design does not have to be marked out on the canvas; just follow the color chart opposite. Remember that the squares represent the canvas intersections, not the holes. Each square represents one TENT stitch.

The chart is divided into units of 10 squares by 10 squares to make it easier to follow. Before beginning to stitch, it may be helpful to mark out your canvas in similar units with an HB pencil or permanent marker in a suitable color. Mark the top of the canvas so that if you turn the canvas while stitching, you will still know where the top is.

The colors on the chart are shown stronger than the yarn colors to make them easier to see. The corresponding yarns are given in the color key.

Stitches used

TENT stitch (1), STEM stitch (2) (optional). For stitch instructions, see page 182.

Stitching the design

The whole thread is used throughout, except for STEM stitch – see below.

Begin with TENT stitch in any area you wish. It may be easiest to start at the top right-hand corner 1½-2in in from the corner, working horizontally from one block of color to another. We have used STEM stitch to outline and

highlight the animals. Please refer to the color photograph and the chart for the positioning of the STEM stitch. It will probably be easier to outline at the end. If you find there are spaces once you have worked the STEM stitch, 'fill in' with TENT stitches in the relevant colors. However, if you work the whole design in TENT stitch, go to the nearest square.

For a finer look for STEM stitch, we have split the thread and used only two strands, but this is optional. To split the wool in two, hold one end of the thread with your teeth and, beginning in the middle, split the thread with your hands, pulling gently and slowly apart.

When stitching the border, we suggest turning the design through 90 degrees to sew the alphabet panel on either side. This will give the letters a uniform look.

Personalizing

To plan your name and date, take a photocopy of the blank chart and simply copy the numbers and letters of your choice from the numbers and alphabet around the design.

Making-up instructions

Many needlepointers feel experienced enough to stretch and make up their needlework designs into cushions, but we always feel that a needlepoint picture should be framed by a professional, who has experience at stretching and framing needlepoint.

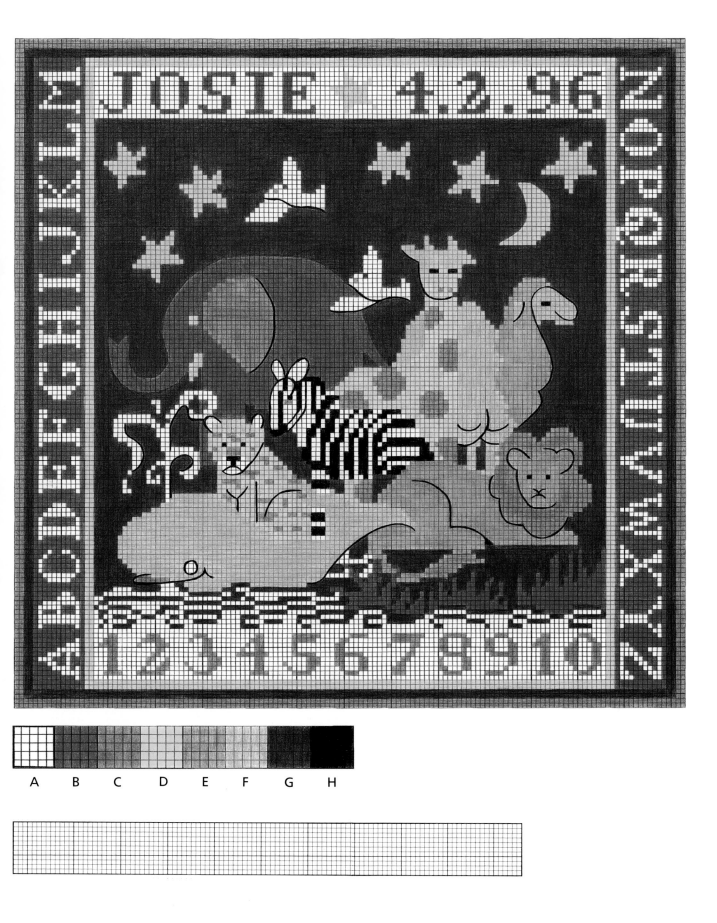

The charts

Koalas
For yarn quantities and stitching instructions, see overleaf

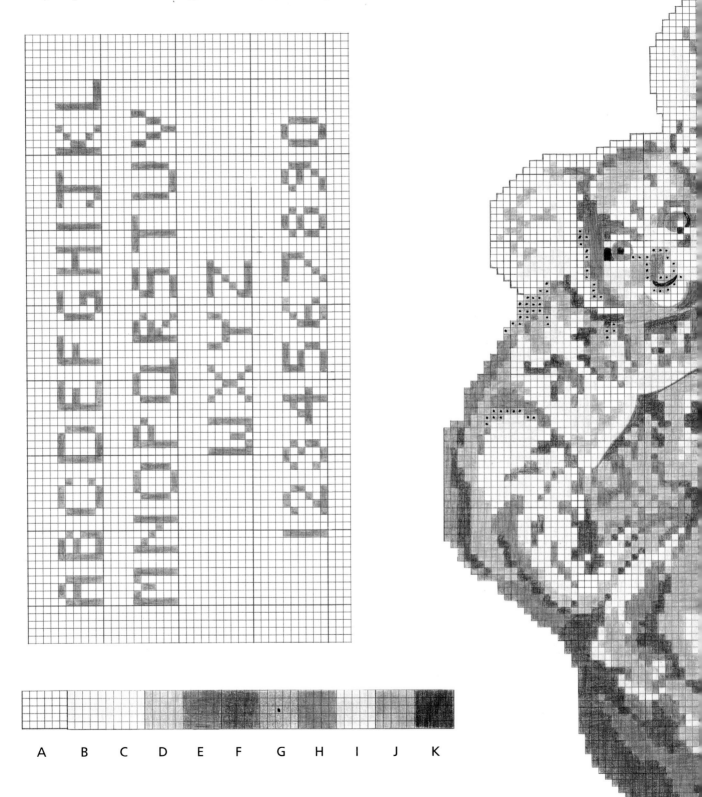

A B C D E F G H I J K

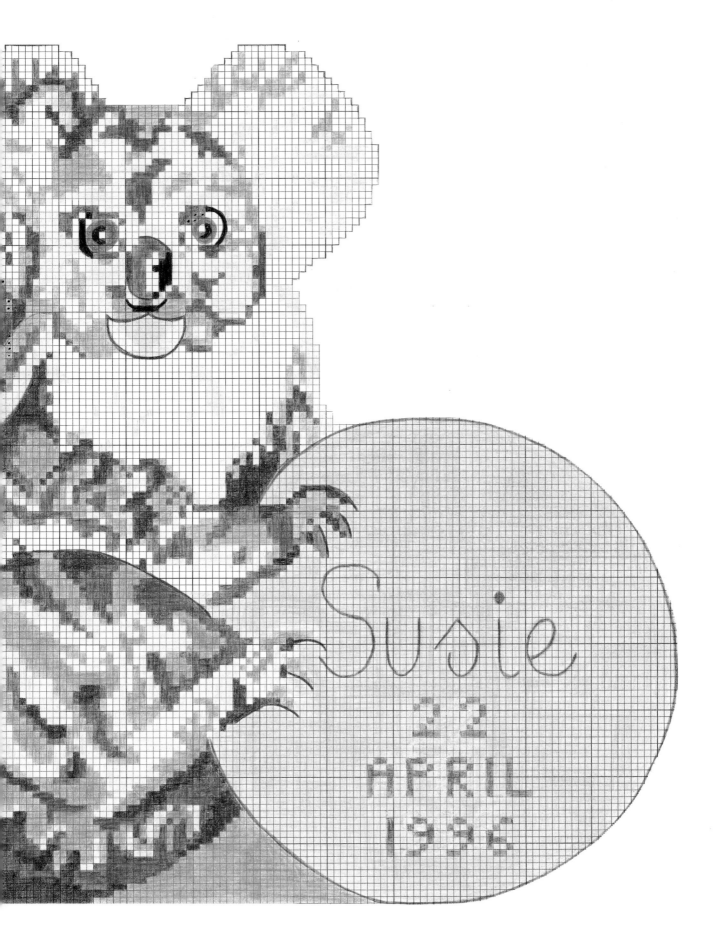

Koalas

Featured in Children's designs on page 91

Finished size of design

14½ x 12½in

Yarns

Key	Anchor Tapisserie Wool		Skeins
A	8000	White	3
B	8252	Peach	1
C	8704	Silver gray	3
D	8706	Gray	4
E	8718	Airforce	3
F	8720	Gunmetal	2
G	9796	Charcoal	1
H	8264	Chestnut	1
I	8432	Sugar pink	5
J	8416	Dark pink	1
K	9800	Black	1

Canvas

10-gauge white mono deluxe
Size: 18½ x 16½in

Other materials

Tapestry needle, size 18
Ruler or tape measure
Masking tape for binding the canvas
Sharp scissors for cutting the canvas
Embroidery scissors
Sharp HB pencil or fine permanent
marker in suitable color
Eraser

Chart

See previous page

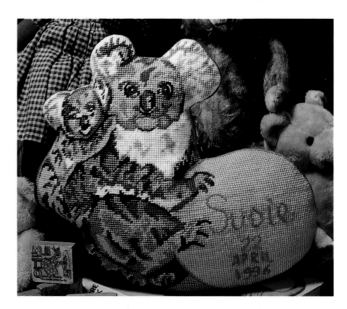

Following the chart

Cut the canvas to size and bind the edges with masking tape. The design does not have to be marked out on the canvas; just follow the color chart on the previous page. Remember that the squares represent the canvas intersections, not the holes. Each square represents one TENT stitch.

The chart is divided into units of 10 squares by 10 squares to make it easier to follow. Before beginning to stitch, it may be helpful to mark out your canvas in similar units with an HB pencil or permanent marker in a suitable color. Mark the top of the canvas so that if you turn the canvas while stitching, you will still know where the top is.

The colors on the chart are shown stronger than the actual yarn colors to make them easier to see. The corresponding yarns are given in the color key.

Stitches used

TENT stitch (1), STEM stitch (2) (optional). For stitch instructions, see page 182.

Stitching the design

The whole thread is used throughout. Begin with TENT stitch in any area you wish. It may be easiest to start at the top right-hand corner 1½-2in in from the corner, working horizontally from one block of color to another. We have used STEM stitch to outline the following areas: mouths, noses, eyes, necks, bodies, claws, outline of the pink circle and the name. Please refer to the color photograph and the chart for the positioning of the STEM stitch. It will probably be easier to outline at the end. If you find there are spaces once you have worked the STEM stitch, 'fill in' with TENT stitches in the relevant colors. However, if you work the whole design in TENT stitch, go to the nearest square.

Before you begin to stitch, decide on the name and date you want. Write your chosen name onto the canvas using a permanent marker in your own handwriting. Use the letter/number chart on the previous page for the date. It may be a good idea to plan it on graph paper first. You can also use the alphabet chart for the name if you prefer.

Making-up instructions

When the design has been sewn, the needlepoint may need to be stretched back into shape (see page 183). Then make it up into a cushion as shown on page 189.

Soccer cushion
Featured in This sporting life on pages 94-5

Finished size of design
16½ x 14in

Yarns

Key	Anchor Tapisserie Wool		Skeins
A	8000	White	9
B	9020	Dark green	8
C	9018	Grass green	10
D	8692	Dark blue	1
E	8644	Pale blue	1
F	8202	Red	1
G	8214	Orange	1
H	9790	Mid-gray	1
I	9786	Light gray	1
J	9782	Pale gray	2
K	9800	Black	1
L	9796	Charcoal	1
M	8636*	Navy	1
N	8056*	Yellow	1

* These colors can be changed according to your team's colors.

Canvas
12-gauge white mono deluxe
Size: 20 x 18in

Other materials
Tapestry needle, size 20
Ruler or tape measure
Masking tape for binding the canvas
Sharp scissors for cutting the canvas
Embroidery scissors
Sharp HB pencil or fine permanent marker in suitable color
Eraser

Chart
See overleaf, and for suggested scarf variations, see page 164.

Following the chart
Cut the canvas to size and bind the edges with masking tape. The design does not have to be marked out on the canvas; just follow the color chart overleaf. Remember that the squares represent the canvas intersections, not the holes. Each square represents one TENT stitch.

The chart is divided into units of 10 squares by 10 squares to make it easier to follow. Before beginning to stitch, it may be helpful to mark out your canvas in similar units with an HB pencil or permanent marker in a suitable color. Mark the top of the canvas so that if you turn the canvas while stitching, you will still know where the top is.

The colors on the chart are shown stronger than the actual yarn colors to make them easier to see. The corresponding yarns are given in the color key.

Stitches used
TENT stitch (1), STEM stitch (2) (optional). For stitch instructions, see page 182.

Stitching the design
The whole thread is used throughout, except for STEM stitch – see below.

Begin with TENT stitch in any area you wish. The football pitch has been stitched using 9018 Grass green wool and the border is in 9020 Dark green wool. It may be easiest to start at the top right-hand corner 1½-2in in from the corner, working horizontally from

one block of color to another. We have used STEM stitch to outline the scarf and for the fringe. We have also used it for the soocerball and the corners of the pitch and the penalty area. Please refer to the color photograph and the chart for the positioning of the STEM stitch. It will probably be easier to outline at the end. If you find there are spaces once you have worked the STEM stitch, 'fill in' with TENT stitches in the relevant colors. However, if you work the whole design in TENT stitch, go to the nearest square.

For a finer look for STEM stitch, we have split the thread and used only two strands, but this is optional. To split the wool in two, hold one end of the thread with your teeth and, beginning in the middle, split the thread with your hands, pulling gently apart.

As you will see, we have plotted the area for the scarf on a separate piece of graph paper. We suggest you photocopy this graph paper and work out your own scarf using symbols or colored pencils. We have given some examples for various soccer teams on page 164, but if your special team isn't there don't be offended, simply choose your team's colors from the Anchor range and plan your scarf accordingly. We have simplified the Tottenham Hotspur scarf and the other examples we have shown. All you need is the name, a chevron or stripe, or a simplification of the shield – whatever is characteristic of the soccer team's colors. We have angled the chevron on the left to follow the curve of the scarf. Follow our alphabet for the name. Watch the spaces between the letters, ensuring thay are even.

Making-up instructions
When the design has been sewn, the needlepoint may need to be stretched back into shape (see page 183). Then make it up into a cushion as shown on pages 184-6. We suggest you use the square boxed cushion with piping on page 185.

Soccer cushion

*For yarn quantities and stitching instructions,
see previous page*

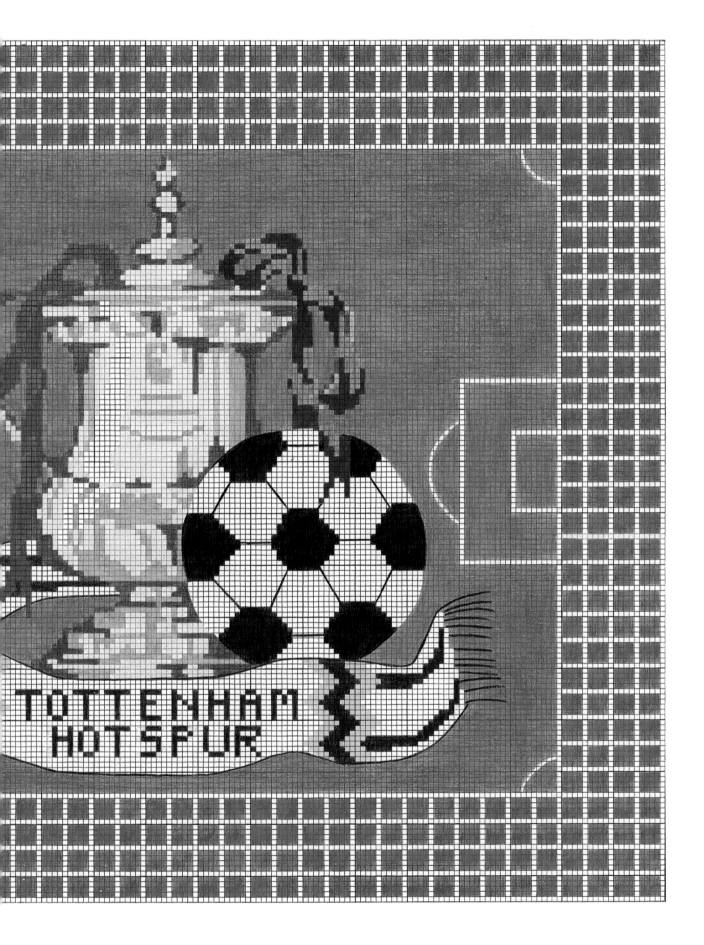

The hunt

For yarn quantities and stitching instructions,
see previous page

A
B
C
D
E
F
G
H
I
J
K
L
M
N
O
P
Q
R

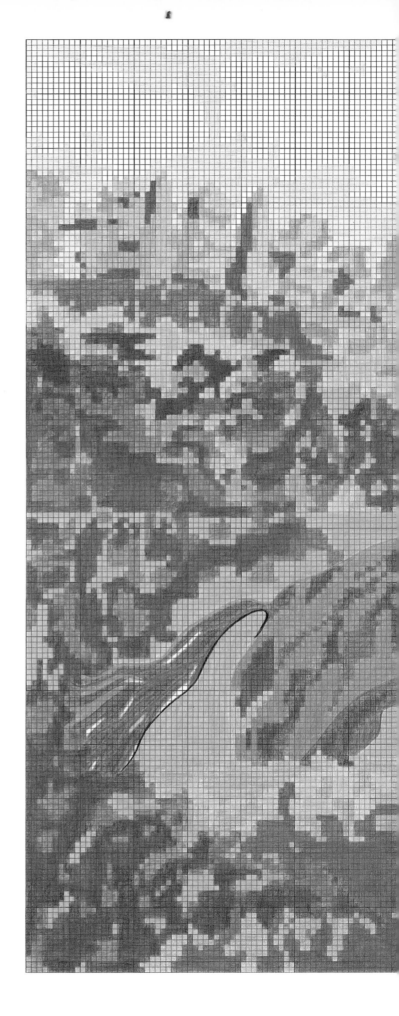

The hunt

Featured in This sporting life on pages 98-9

Finished size of design

16 x 14in

Yarns

Key	Anchor Tapisserie Wool		Skeins
A	8002	White	4
B	9784	Pale gray	1
C	9486	Beige	1
D	9492	Pale chestnut	1
E	9450	Mid-chestnut	2
F	9494	Dark chestnut	2
G	9394	Brown	2
H	9666	Dark brown	1
I	8202	Red	1
J	8350	Burgundy	1
K	8874	Pale turquoise	3
L	8876	Mid-turquoise	5
M	8880	Dark turquoise	4
N	9172	Pale green	4
O	9258	Mid-green	3
P	9260	Dark green	3
Q	8812	Pale blue	4
R	9796	Dark gray	1

Canvas

12-gauge white mono deluxe
Size: 20 x 18in

Other materials

Tapestry needle, size 20
Ruler or tape measure
Masking tape for binding the canvas
Sharp scissors for cutting the canvas
Embroidery scissors
Sharp HB pencil or fine permanent
marker in suitable color
Eraser

Chart

See overleaf

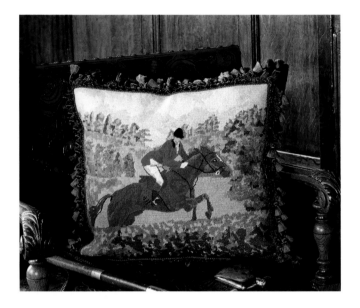

Following the chart

Cut the canvas to size and bind the edges with masking tape. The design does not have to be marked out on the canvas; just follow the color chart overleaf. Remember that the squares represent the canvas intersections, not the holes. Each square represents one TENT stitch.

The chart is divided into units of 10 squares by 10 squares to make it easier to follow. Before beginning to stitch, it may be helpful to mark out your canvas in similar units with an HB pencil or permanent marker in a suitable color. At the same time, mark the top of the canvas so that if you turn the canvas while stitching, you will still know where the top is.

The colours on the chart are shown stronger than the actual yarn colors to make them easier to see. The corresponding yarns are given in the color key.

Stitches used

TENT stitch (1), STEM stitch (2) (optional). For stitch instructions, see page 182.

Stitching the design

The whole thread of tapestry wool is used throughout, except for STEM stitch – see below.

Begin in any area you wish. It may be easiest to start at the top right-hand corner 1½-2in in from the corner, working horizontally from one block of color to another. We used STEM stitch to outline and highlight the horse and the rider. STEM stitch has also been used on the whole of the horse's tail. Please refer to the color photograph and the chart for the positioning of the STEM stitch. It will probably be easier to outline at the end. If you find there are spaces once you have worked the STEM stitch, 'fill in' with TENT stitches in the relevant colors. However, if you work the whole design in TENT stitch, go to the nearest square.

For a finer look for STEM stitch, we have split the thread and used only two strands, but this is optional. To split the wool in two, hold one end of the thread with your teeth and, beginning in the middle, split the thread with your hands, pulling gently and slowly apart.

Making-up instructions

When the design has been sewn, the needlepoint may need to be stretched back into shape (see page 183). Then make it up into a cushion (see pages 184-6). We suggest you use the fringed cushion with border that appears on page 186.

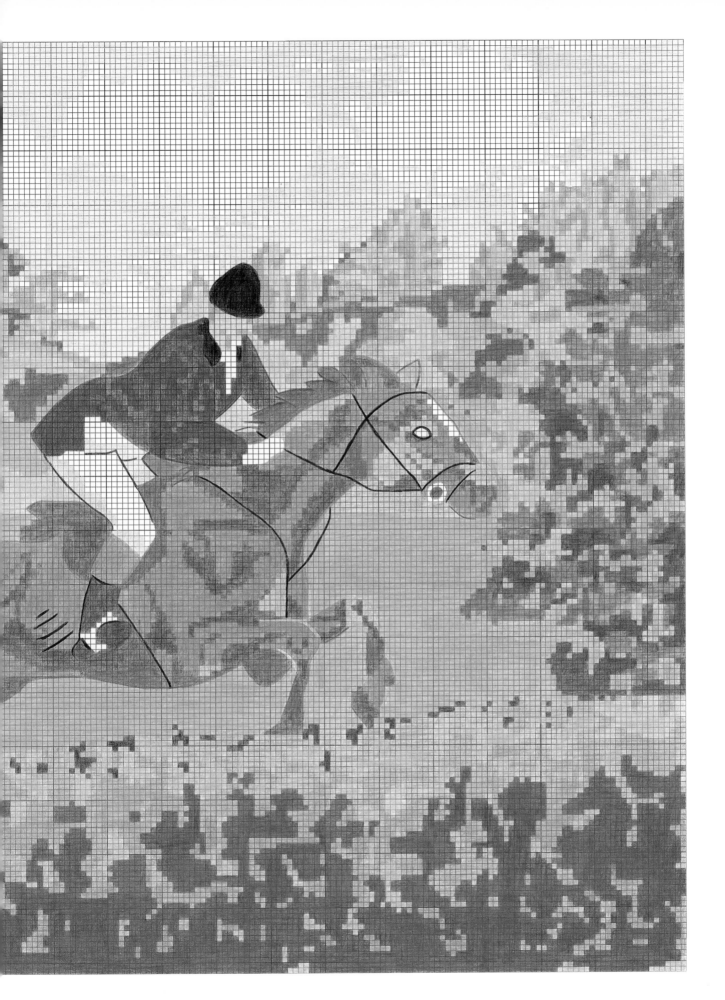

Kilim stool

For yarn quantities and stitching instructions, see overleaf

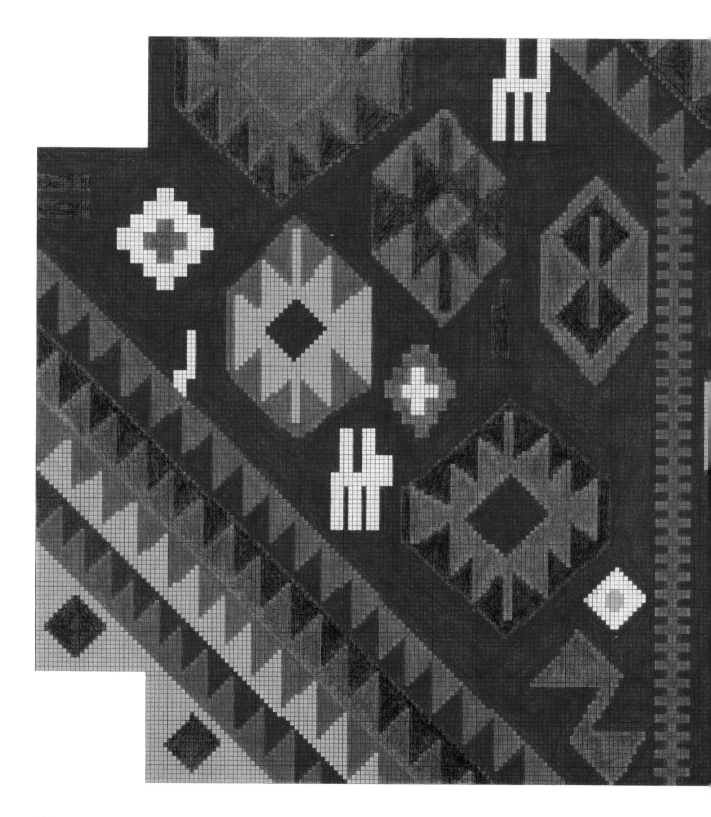

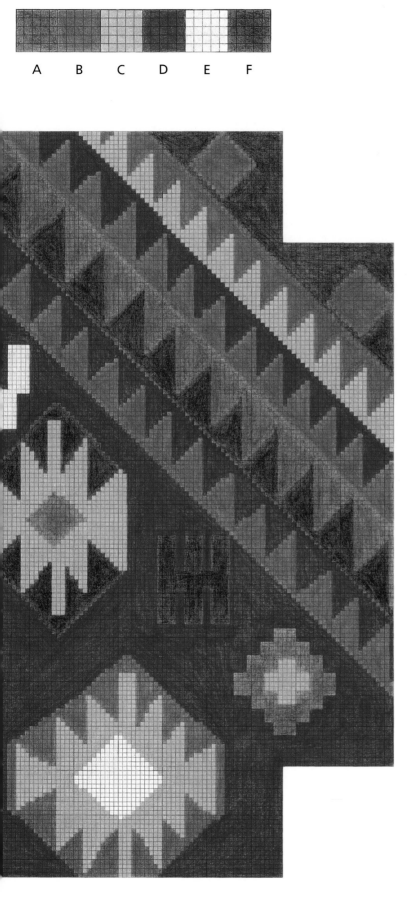

A B C D E F

Kilim stool
Featured in Kilims on pages 108-9

Finished size of design
31 x 21½in This design would also
make a wonderful church kneeler
stitched on 10- or 12-gauge canvas in
tapestry wool, using just one thread
instead of two.

Yarns

Key	Anchor Tapisserie Wool		Skeins
A	8740/9796	Marine	9 of each
B	9384/9386	Honey	3 of each
C	8330/8352	Maroon	23 of each
D	9596/9508	Peach	7 of each
E	9598/9620	Bois de rose	12 of each
F	9658/9660	Taupe	9 of each

Canvas
7-gauge cream interlock rug canvas
Size: 35 x 25in

Other materials
Tapestry needle, size 16
Ruler or tape measure
Masking tape for binding the canvas
Sharp scissors for cutting the canvas
Embroidery scissors
Sharp HB pencil or fine permanent
marker in suitable color
Eraser

Chart
See previous page

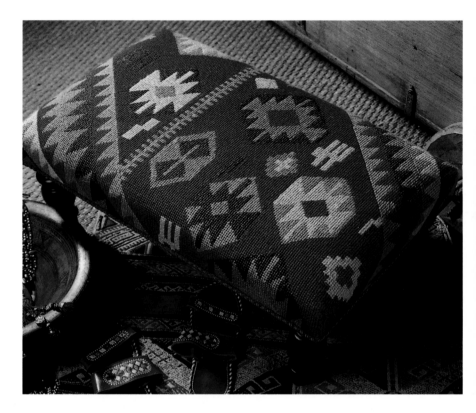

Following the chart
Cut the canvas to size and bind the
edges with masking tape. The design
does not have to be marked out on the
canvas; just follow the color chart on
the previous page. Remember that the
squares represent the canvas
intersections, not the holes. Each
square represents one TENT stitch.

The chart is divided into units of 10
squares by 10 squares to make it easier
to follow. Before beginning to stitch, it
may be helpful to mark out your canvas
in similar units with an HB pencil or
permanent marker in a suitable color.
Mark the top of the canvas so that if
you turn the canvas while stitching, you
will still know where the top is.

The colors on the chart are shown
stronger than the actual yarn colors to
make them easier to see. The
corresponding yarns are given in the
color key.

Stitches used
TENT stitch (1) is used throughout. For
stitch instructions, see page 182.

Stitching the design
The thread has been used double
throughout. Thread one thread of both
colors in each color group, eg if
stitching key code A, put one thread of
8740 and one of 9796 into the same
needle. This will give your stitched
needlepoint a hand-woven shaded
effect, typical of old carpets. Stitch all
the colors in this way.

Begin in any area you wish. It may
be easiest to start at the top right-hand
corner 1½-2in in from the corner,
working horizontally from one block of
color to another. We suggest that you
stitch this design in the direction as
shown on the chart on the previous
page so that the TENT stitch follows
the 45-degree angle of the canvas with
an unbroken line.

Making-up instructions
When the design has been sewn, the
needlepoint may need to be stretched
back into shape (see page 183). Then
make it up into a stool as shown on
page 189.

Kilim vest
Featured in Kilims on pages 102-3

This vest is shown in one size only. It can be adjusted when making up, to fit small, medium or large.

Finished size of design
Each side of the vest measures
10 x 24in

Yarns

Key	Anchor Tapisserie Wool	Skeins
A	8330 Wine	10
B	8328 Terracotta	8
C	9596 Mushroom	6
D	9064 Soft green	9
E	9068 Gray green	9
F	8838 Navy	8

Type of canvas
10-gauge white mono deluxe
Size: 27 x 29in. If you want to work the two pieces separately, each piece of canvas will need to measure 14 x 29in

Other materials
Tapestry needle, size 18
Ruler or tape measure
Masking tape for binding the canvas
Sharp scissors for cutting the canvas
Embroidery scissors
Sharp HB pencil or fine permanent marker in suitable color
Eraser

Charts
See overleaf and pages 174-5

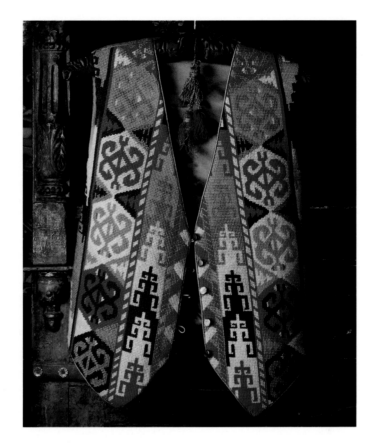

Following the charts
Cut the canvas to size and bind the edges with masking tape. The design does not have to be marked out on the canvas; just follow the color charts overleaf and on pages 174-5. Remember that the squares represent the canvas intersections, not the holes. Each square represents one TENT stitch.

The charts are divided into units of 10 squares by 10 squares to make them easier to follow. Before beginning to stitch, it may be helpful to mark out your canvas in similar units with an HB pencil or permanent marker in a suitable color. Mark the top of the canvas so that if you turn the canvas while stitching, you will still know where the top is.

The colors on the charts are shown stronger than the actual yarn colors to make them easier to see. The corresponding yarns are given in the color key.

Stitches used
TENT stitch (1) is used throughout. For stitch instructions, see page 182.

Stitching the design
The whole thread is used throughout. Begin in any area you wish. It may be easiest to start at the top right-hand corner 1½-2in in from the corner, working horizontally from one block of color to another.

Making-up instructions
We suggest you take the vest to a professional who will line and back the vest – see useful addresses at the back of this book.

Kilim vest

For yarn quantities and stitching instructions, see previous page

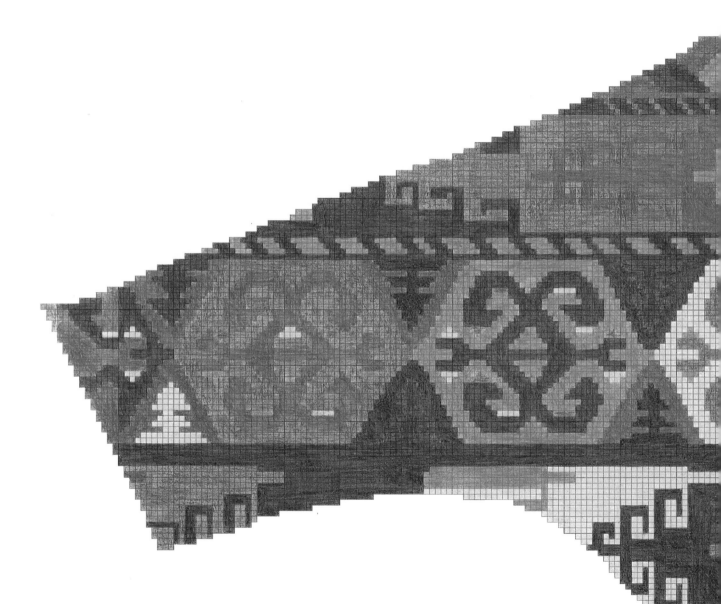

A B C D E F

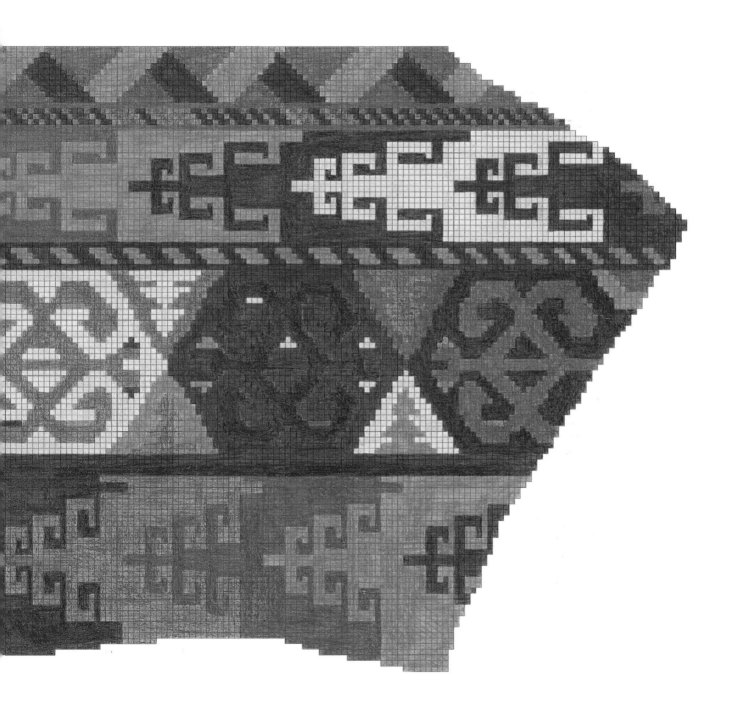

Kilim vest (continued)

For yarn quantities and stitching instructions, see page 171

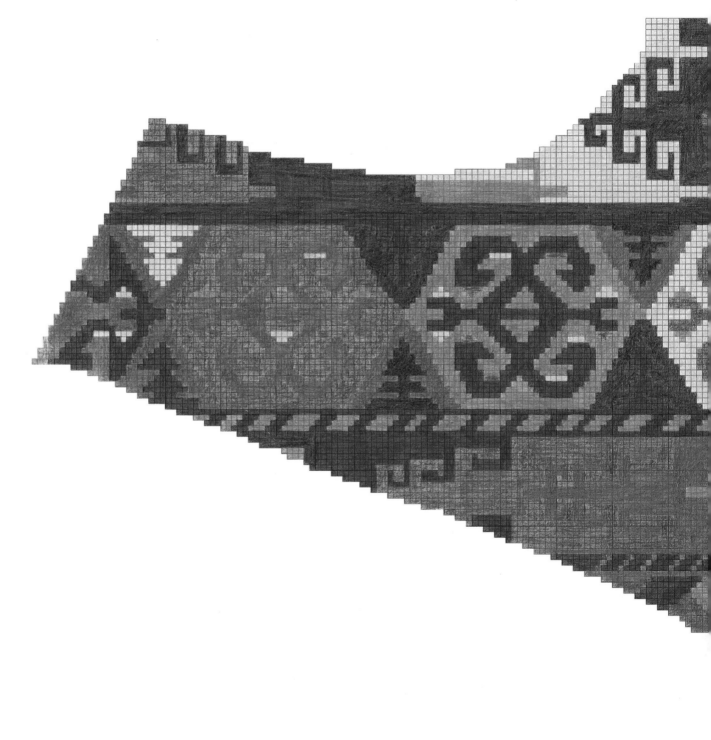

A B C D E F

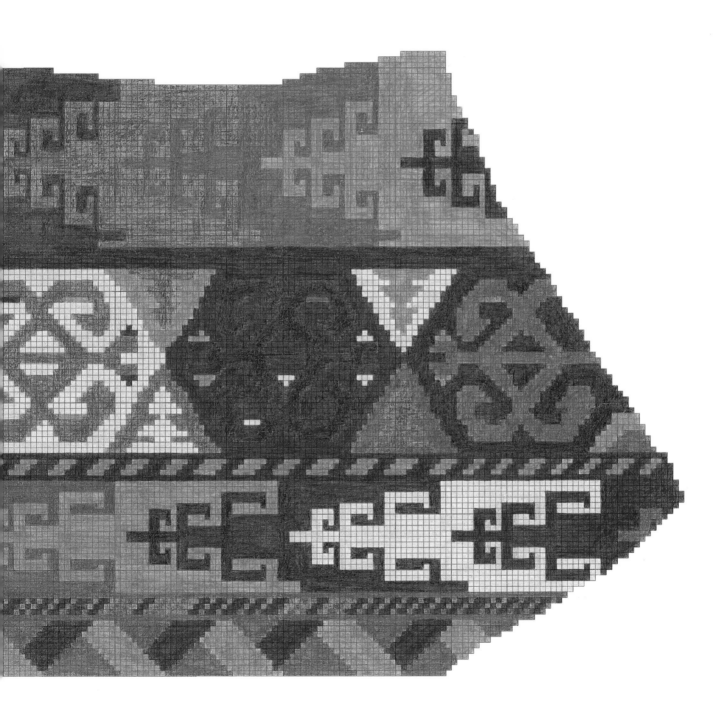

The blue vase

For yarn quantities and stitching instructions, see overleaf

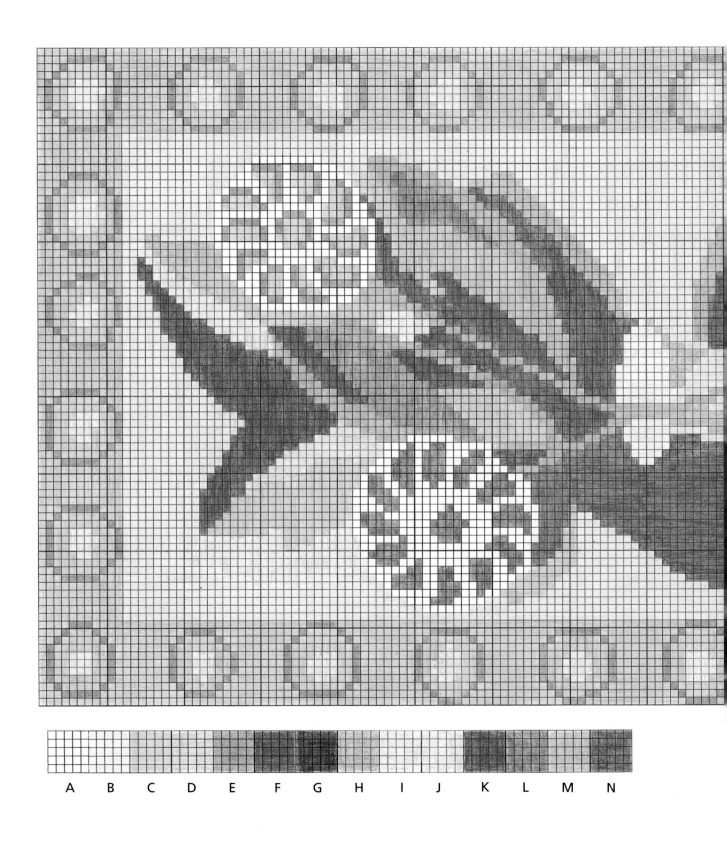

A B C D E F G H I J K L M N

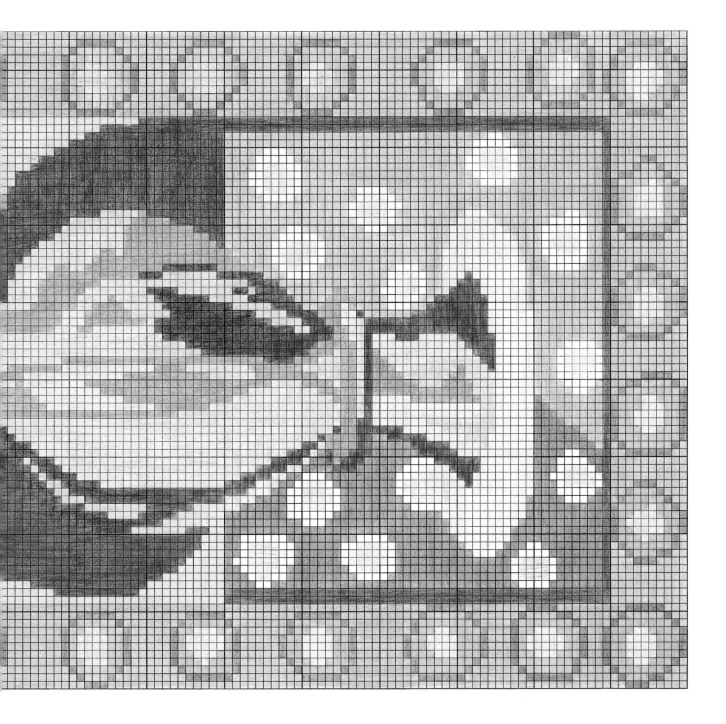

The blue vase

Featured in Design nostalgia on pages 110-11

Finished size of design

7 x 15in

Yarns

Key	Anchor Tapisserie Wool	Skeins
A	9502 Cream	2
B	9402 Honey	2
C	8054 Gold	2
D	9444 Light orange	4
E	9510 Dark orange	2
F	8366 Pink	1
G	8788 Mid-blue	1
H	8832 Light blue	1
I	8814 Sky blue	2
J	8892 Gray	1
K	9066 Gray green	1
L	9054 Olive green	1
M	9056 Light olive green	1
N	9620 Bois de rose	3

Canvas

12-gauge white mono deluxe
Size: 11 x 19in

Other materials

Tapestry needle, size 20
Ruler or tape measure
Masking tape for binding the canvas
Sharp scissors for cutting the canvas
Embroidery scissors
Sharp HB pencil or fine permanent
marker in suitable color
Eraser

Chart

See previous page

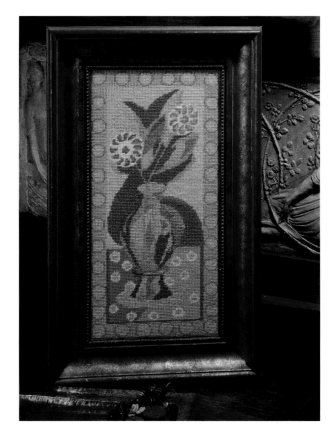

Following the chart

Cut the canvas to size and bind the
edges with masking tape. The design
does not have to be marked out on the
canvas; just follow the color chart on
the previous page. Remember that the
squares represent the canvas
intersections, not the holes. Each
square represents one TENT stitch.

The chart is divided into units of 10
squares by 10 squares to make it easier
to follow. Before beginning to stitch, it
may be helpful to mark out your canvas
in similar units with an HB pencil or
permanent marker in a suitable color.
At the same time, mark the top of the
canvas so that if you turn the canvas
while stitching, you will still know
where the top is.

The colors on the chart are shown
stronger than the actual yarn colors to
make them easier to see. The
corresponding yarns are given in the
color key.

Stitches used

TENT stitch (1) is used throughout. For
stitch instructions, see page 182.

Stitching the design

The whole thread is used throughout.

Begin in any area you wish. It may
be easiest to start at the top right-hand
corner 1½-2in in from the corner,
working horizontally from one block of
color to another.

Making-up instructions

Many needlepointers feel experienced
enough to stretch and make up their
needlework designs into cushions, but
we always feel that a needlepoint
picture should be framed by a
professional, who has experience at
stretching and framing needlepoint.

Arts and Crafts pictures
Featured in Design nostalgia on pages 114-15

Finished size of design
Each picture: 4¼ x 5½in
Yarns
All four designs together

Key	Anchor Stranded Cotton		Skeins
A	885	Cream	2
B	872	Mauve	1
C	887	Gold	1
D	1047	Orange	1
E	74	Sugar pink	2
F	895	Rose pink	2
G	877	Dark green	3
H	858	Light green	3
I	338	Terracotta	20

Lily

Key	Anchor Stranded Cotton		Skeins
A	885	Cream	1
D	1047	Orange	1
E	74	Sugar pink	1
F	895	Rose pink	1
G	877	Dark green	1
H	858	Light green	1
I	338	Terracotta	5

Pansy

Key	Anchor Stranded Cotton		Skeins
A	885	Cream	1
B	872	Mauve	1
E	74	Sugar pink	1
F	895	Rose pink	1
G	877	Dark green	1
H	858	Light green	1
I	338	Terracotta	5

Rose

Key	Anchor Stranded Cotton		Skeins
A	885	Cream	1
F	895	Rose pink	1
G	877	Dark green	1
H	858	Light green	1
I	338	Terracotta	5

Narcissus

Key	Anchor Stranded Cotton		Skeins
A	885	Cream	1
C	887	Gold	1
D	1047	Orange	1
G	877	Dark green	1
H	858	Light green	1
I	338	Terracotta	5

Canvas
14-gauge white mono deluxe
Size: 6 x 7in for each of the pictures; or
13 x 16in if you are stitching all the

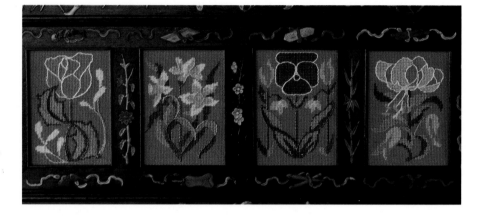

pictures on one single piece of canvas

Other materials
Tapestry needle, size 20
Ruler or tape measure
Masking tape for binding the canvas
Sharp scissors for cutting the canvas
Embroidery scissors
Sharp HB pencil or fine permanent
marker in suitable color
Eraser

Charts
See overleaf

Following the charts
Cut the canvas to size and bind the
edges with masking tape. The design
does not have to be marked out on the
canvas; just follow the color charts
overleaf. Remember that the squares
represent the canvas intersections, not
the holes. Each square represents one
TENT stitch.

The charts are divided into units of
10 squares by 10 squares to make
them easier to follow. Before beginning
to stitch, it may be helpful to mark out
your canvas in similar units with an HB
pencil or permanent marker in a
suitable color. Mark the top of the
canvas so that if you turn the canvas
while stitching, you will still know
where the top is.

The colors on the charts are shown
stronger than the actual yarn colors to
make them easier to see. The
corresponding yarns are given in the
color keys.

Stitches used
TENT stitch (1), STEM stitch (2)
(optional). For stitch instructions, see
page 182.

Stitching the design
The whole thread (6 strands) is used
throughout.

Begin with TENT stitch in any area
you wish. It may be easiest to start at
the top right-hand corner 1½-2in in
from the corner, working horizontally
from one block of color to another. We
have used STEM stitch to outline the
flowers and the leaves. Please refer to
the color photograph and the charts for
the positioning of the STEM stitch. It
will probably be easier to outline at the
end. If you find there are spaces once
you have worked the STEM stitch, 'fill
in' with TENT stitches in the relevant
colors. However, if you work the whole
design in TENT stitch, go to the nearest
square. It is impossible to show the
outlining in some cases on the charts,
eg the dark green leaves on the pansy
are outlined in green stranded cotton,
so please refer to the photograph.

Making-up instructions
Many needlepointers feel experienced
enough to stretch and make up their
needlework designs into cushions, but
we always feel that a needlepoint
picture should be framed by a
professional, who has experience at
both stretching and framing
needlepoint.

Arts and Crafts pictures

For yarn quantities and stitching instructions, see previous page

General information

Stitching

The colors shown on the charts are stronger than the actual yarn colors to make them easier to see. The corresponding yarns are given in the color keys that accompany each chart. When working from a chart, start at the top right-hand corner 2in in from the edge. Stitch horizontally from one block of color to another. If a large area is to be stitched, we suggest you use the basketweave method of tent stitch as it does not put a strain on the canvas and you also achieve a more even tension. White yarn should be left until last to keep it clean. Don't let the ends of other colors get caught into the stitches.

Stitches

Only two types of stitches are used on the designs in this book. They are TENT stitch (and a variation called REVERSED TENT stitch) and STEM stitch. Each is described to the right and illustrated below. All the instructions in this book are for right-handed stitchers. If you are left-handed, simply read left for right, and right for left.

1 TENT stitch

TENT stitch, which forms a fine background of short slanting stitches, can be worked in a number of different ways. Continental TENT stitch (below left) is worked horizontally across the canvas. Work from right to left. At the end of the row, turn the canvas upside down and work the next row, again from right to left.

Basketweave TENT stitch (below right) is worked diagonally from the top-right hand corner without turning the canvas. This is the best stitch to use on larger areas of background as it does not distort the canvas as much as continental TENT stitch tends to. Vertical TENT stitch should only be used for single vertical lines, eg for outlining.

1a REVERSED TENT stitch

This stitch is used in a few of the charts and is worked so that the stitches slant in the other direction.

2 STEM stitch

This is useful for flower stems or outlining. Work from left to right using stitches of a similar length (see illustration opposite). Each stitch overlaps the previous one. When using

Anchor tapisserie wool it is sometimes better to outline in STEM stitch using only two strands. This will give a finer look. Where this is appropriate for any of the designs in this book we have specified the number of strands with the chart. To split the wool in two, hold one end with your teeth and, beginning in the middle, split the thread with your hands, pulling gently and slowly apart. Note that not all tapestry wool can be split.

Yarn

We have used Anchor tapisserie wool, stranded cotton or metallic thread in all our projects. **Anchor tapisserie wool** is 100% pure new wool, color-fast and of a tightly twisted construction. It comes in 475 color-matched and coordinated shades in 10m (11yd) skeins. **Anchor stranded cotton** is a superior 6-strand, mercerized cotton embroidery thread available in 8m (8 ½yd) skeins and in 444 color-balanced and coordinated shades. It is divisible into separate strands. **Mez ophir silver thread** is 60% viscose, 40% polyester metal.

Continental tent stitch

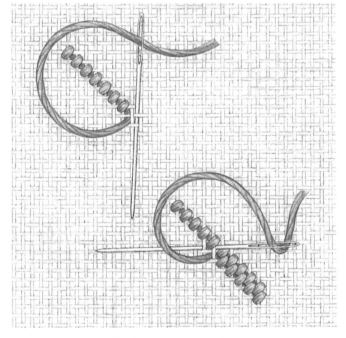

Basketweave tent stitch

Working methods

Always leave a border of at least 2in of unstitched canvas around all the edges of the design for stretching. When marking out a canvas into squares of 10 threads by 10 threads use a permanent marker, an HB pencil or a water-erasable marking pen.

We suggest you use a frame when stitching, but this is a personal choice. There is no question that the finish is better and a more even tension is achieved, but if you are more comfortable working without a frame, that is fine. Just try not to pull the yarn too tightly.

Some people need a thimble, and at some point in your needlepoint career you may well need a seam unpicker! Cut your tapestry wool into lengths of approximately 30in; cut stranded cotton and silver thread into 15-20in lengths.

To begin, knot the wool temporarily on the front of the canvas about 1in from where you want to start, in the direction in which you will be working. As you work your canvas, the stitches on the back will anchor the 1in thread.

When you reach the knot, cut it off and the thread should be quite secure. When you re-thread your needle to continue sewing the same area, there is no need to knot the wool; simply run the needle through the work on the underside.

To finish, do the same in reverse. It is worth keeping the back of the canvas tidy for two simple reasons. First, having lots of ends hanging at the back can eventually make it difficult to get your needle through the canvas. Second, the work will lie flatter when it is made up. So cut your threads short when you have anchored them.

Adapting charts and artwork

When following a chart, you can easily change the gauge of canvas you choose. If you decide to use a 7-gauge canvas where we have suggested 12, remember that the design will be almost twice the size when stitched. It is important to change the yarn to a more suitable thickness, and also the needle size. Likewise, if we suggest a 10-gauge canvas and you use an 18-gauge canvas, the size of the finished needlepoint will be almost half the size. Artwork can be reduced or enlarged on a photocopier.

Stretching

A needlepoint must be square before finishing, and if you would like to stretch your own needlepoint use the following method. You will need blotting paper, a clean flat board, and some tacks, staples or drawing pins. Lightly dampen or spray the needlepoint and leave it for a few minutes to soften the canvas. Then gently pull the needlepoint square and pin it out, right side down, onto the blotting paper on the clean flat board. Use the tacks, staples or drawing pins and pin outside the sewn surface. Do not strain the canvas too tightly or the needlepoint will dry with a scalloped edge. When the needlepoint is thoroughly dry (this may take two to three days), remove it from the board. If you are making a needlepoint picture, we feel that it should be stretched and framed by a professional who has particular experience in stretching and framing needlepoint.

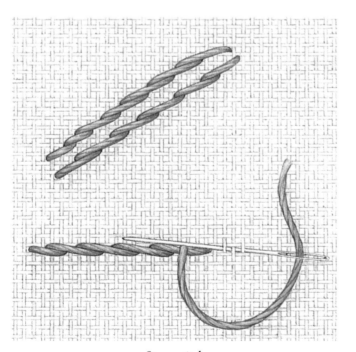

Stem stitch

Making up

Many needlepointers feel experienced enough to make their needlework designs into cushions, stool tops and a variety of other items, and instructions for making up each project in this book are given below and overleaf.

For a cushion backing, we would suggest that you look for a firm cotton, chintz, brocade or moire which are all easy fabrics to work with. Medium-weight velvet also makes an attractive backing but is a little more difficult for beginners to handle. We don't recommend upholstery velvet, which is very thick.

Ready-made cushion pads can be bought in various sizes. For a flat effect, use a pad the same size as the needlepoint cover. However, we prefer a plumper cushion and so use a pad that is 2in larger than the cover. Boxed cushions should have a pad with a gusset. Ease the pad into the cushion cover gently to avoid putting any strain on the zipper, pushing it carefully into the corners to fill them out.

Making a corded cushion with knots

Materials
20in fabric 48in wide
Zipper 3in shorter than width of finished cushion
Twisted cord 28in longer than the measurement around the cushion
Pins
Clear adhesive tape

1 Stretch the needlepoint back into its original shape (see page 183) and cut away any excess canvas, leaving ½in of unsewn canvas for turning.
2 Cut out the cushion back to the same size as the canvas, adding 2in to the width measurement for the zipper seam. Fold the fabric in half from side to side and cut along the crease to form the zipper opening.
3 At each end of the zipper opening and with right sides together, stitch a 2in seam, taking 1in turnings. Press the seam open. Sew in the zipper (Fig 1)

Fig 1

remembering to leave it open to turn the cushion through.
4 Pin and baste the fabric to the needlepoint with right sides facing. Machine around the edge of the needlepoint leaving about a 1in opening at the bottom. Double stitch or overlock the seams and then carefully turn the cushion right sides out through the zipper opening.
5 Sew on the cord by hand starting from the opening at the bottom and leaving a small tail covered with adhesive tape to prevent it from fraying (Fig 2). To make a knot on each corner, form a slip knot and pull the longer length of cord until the center loop is level with the knot. Secure with a couple of stitches. When you have stitched all around the cushion, weave the ends of the cord together and secure with a few stitches. Wrap the remaining end with adhesive tape before cutting away any excess cord. Tuck the ends into the opening and neaten by sewing in.

Fig 2

Making a corded cushion with loops at each corner
Materials
20in fabric 48in wide
Zipper 3in shorter than width of finished cushion
Twisted cord 22in longer than the measurement around the cushion
Pins
Clear adhesive tape

1-4 Follow steps 1-4 of Corded cushion with knots.
5 Sew on the cord by hand, starting from the opening at the bottom and leaving a small tail, as in step 5 of Corded cushion with knots. Sew to the corner and make a loop. Secure the loop with a few stitches. Repeat when you reach the other three corners. (Before cutting the cord, wrap the ends with adhesive tape.)
6 Join the cord by weaving the ends together and securing with a few stitches. Wrap the join with adhesive tape befor cutting away any excess cord. Tuck the ends into the opening and neaten by sewing in.

Making a simple piped cushion
Materials
20in fabric 48in wide
Zipper 3in shorter than width of finished cushion
No. 5 piping cord to go around the cushion
Pins

1 Stretch the needlepoint back into its original shape (see page 183) and cut away any excess canvas, leaving ½in of unsewn canvas for turning.
2 Cut out the cushion back to the same size as the canvas, adding 2in to the width measurement for the zipper seam. Fold the fabric in half from side to side and cut along the crease to form the zipper opening.
3 At each end of the zipper opening and with right sides facing, stitch a 2in seam, taking 1in turnings. Press the seam open. Sew in the zipper (Fig 1)

remembering to leave it open to turn the cushion through.

4 For the piping, cut enough 1½in-wide bias strips of fabric to go around the cushion once. Sew the piping strips together with right sides facing. Press the seams open and trim off projecting points (Fig 3).

Fig 3

5 To attach the piping, fold the piping strips in half lengthways with right sides out. Insert the piping cord into the fold and baste in place. Then pin and baste the piping around the edge of the needlepoint, keeping close to the finished needlepoint. Clip the piping strip at the corners for easy turning. For the final joining of the piping, cut away excess piping fabric leaving enough for joining together. Butt the two ends of cord into each other, wrap a length of cotton thread around them and insert back into the strip; machine into place.

6 Pin and baste the back of the cushion to the front with right sides facing. Machine and double stitch or overlock the seams, and turn right sides out through the zipper opening.

Making a cushion with ruched piping
Materials
20in fabric 48in wide
Zipper 3in shorter than width of finished cushion
No. 5 piping cord to go around the cushion
Pins

1 Stretch the needlepoint back into its original shape (see page 183) and cut away any excess canvas, leaving ½in of unsewn canvas for turning.
2 Cut out the cushion back to the same size as the canvas, adding 2in to

the width measurement for the zipper seam. Fold the fabric in half from side to side and cut along the crease to form the zipper opening.
3 At each end of the zipper opening and with right sides facing, stitch a 2in seam, taking 1in turnings. Press the seam open. Sew in the zipper (Fig 1) remembering to leave it open to turn the cushion through.
4 For the piping, cut enough 1¾in-wide bias strips of fabric to go around the cushion twice. Sew the piping strips together with right sides facing. Press the seams open and trim off projecting points. Fold the piping strips in half lengthways with right sides out. Insert the piping cord into the fold, making sure you pin the cord to the fabric at the beginning. Machine together, pulling the piping cord through as you go to approximately double the fullness (fig 4). Cut away the excess canvas leaving ½in of unsewn canvas.

5 To attach the ruched piping, pin and baste it around the edge of the

Fig 4

needlepoint, keeping close to the finished needlepoint. Clip the piping strip at the corners for easy turning. For the final joining of the piping, cut away excess piping fabric leaving enough for joining together. Butt the two ends of cord into each other, wrap a length of cotton thread around them and insert back into the strip; machine into place.
6 Pin and baste the back of the cushion to the front with right sides facing. Machine and double stitch or overlock the seams, and then turn the right sides out through the zipper opening.

Making a square boxed cushion with piping
Materials
20in fabric 48in wide
Zipper 3in shorter than width of finished cushion

No. 3 piping cord to fit twice around gusset
Pins

1 Stretch the needlepoint back into its original shape (see page 183) and cut away any excess canvas, leaving ½in of unsewn canvas for turning.
2 Cut out the cushion back to the same size as the canvas, adding 2in to the width measurement for the zipper seam. Fold the fabric in half from side to side and cut along the crease to form the zipper opening.
3 At each end of the zipper opening and with right sides facing, stitch a 2in seam, taking 1in turnings. Press the seam open. Sew in the zipper (Fig 1) remembering to leave it open to turn the cushion through.
4 Cut four gusset pieces 3in wide and the length of the sides of the canvas including turnings. As a precautionary measure, size each border separately (in case the canvas sides are slightly different in length) by laying the fabric and needlepoint together with right sides facing and cutting away any excess fabric that may be protruding over the canvas.
5 For the piping, cut enough 1½in-wide bias strips of fabric to go around the cushion twice – once for each side of the gusset. Then make up two lengths of piping as for the simple piped cushion opposite.
6 Pin and baste the top gusset to the side gussets and the bottom gusset to the sides, taking ½in turnings.
7 Notch the cushion front at the bottom, and also the bottom gusset. Machine the gusset seams together to make a ring (Fig 5).

Fig 5

8 Pipe the gusset all around along both edges (as for the simple piped cushion), taking ½in turnings.

9 Baste the gusset all around the needlepoint cushion front with right sides facing and matching the notches on the bottom edge. Carefully clip the gusset seams to turn the corners. Then baste the cushion backing to the gusset. Finally, machine and double stitch or overlock the seams and then turn the right sides out through the zipper opening.

Making a round boxed ruched cushion
Materials
1yd fabric 148in wide
Zipper 3in shorter than width of finished cushion
No. 5 piping cord to go around the cushion twice
Pins

1 Stretch the needlepoint back into its original shape (see page 183) and cut away any excess canvas, but leave ½in of unsewn canvas all around the edge for turning.

2 Cut the back of the cushion the same size as the overall needlepoint from top to bottom and 2in wider from side to side. Also cut two strips to measure 3 x 48in and cut enough 1¾in-wide bias strips to go around the cushion four times.

3 Fold the backing fabric in half lengthways and cut along the crease to form the zipper opening. At each end of the zipper opening and with right sides facing, stitch a 1½in seam, taking 1in turnings. Press the seam open. Sew in the zipper (Fig 1) remembering to leave it open so that you can turn the cushion through.

4 Using the needlepoint, including the unsewn edge, as a pattern, place the right side of the needlepoint to the right side of the backing. Pin into place and cut the backing to the same size as the needlepoint. Unpin the needlepoint from the backing.

5 Make up two strips of piping and ruche to approximately double fullness as for the cushion with ruched piping

on the previous page (Fig 4).

6 Stitch the two border pieces together at one end. Then place the border and the needlepoint together with right sides facing and pin around the tapestry very carefully, clipping the edges as you go. When you have gone all around the needlepoint, overlap the open end of the border by 1in and cut away the excess to allow a ½in turning. Stitch this seam to close the open end of the border.

7 Unpin the border from the needlepoint and baste the ruched piping to the border. For the final joining of the piping, cut away excess piping fabric leaving enough for joining together. Butt the two ends of cord into each other, wrap a length of cotton thread around them and insert back into the strip; machine into place. Baste the piped border to the edge of the needlepoint with right sides facing and then machine.

8 Pin and baste the back of the cushion to the other border edge with right sides facing. Machine and double stitch or overlock the seams all the way around the cushion, and then finally turn the right sides out through the zipper opening.

Making a fringed cushion with a border
Materials
20in fabric 48in wide
70in tassel fringe 2in wide
Zipper 3in shorter than width of finished cushion
Pins

1 Stretch the needlepoint back into its original shape (see page 183) and cut away any excess canvas, leaving ½in of unsewn canvas for turning.

2 When cutting the back of the cushion add 4in to the size of the needlepoint from top to bottom and 6in from side to side. This allows for the border around the needlepoint. A ½in turning has been allowed for all seams, except for each side of the zipper for which we have allowed 1in. Cut out the back and fold in half lengthways. Cut along the crease to

form the zipper opening.

3 Cut two strips for the top and bottom borders (A), each 2½in by the same width as the needlepoint plus 1in for the turnings. Cut two more pieces for the sides (B), each 2½in by the height of the needlepoint, plus the top and bottom width border measurements (2in plus 2in). Pin and baste the top and bottom borders (A) onto the needlepoint with right sides together and machine. Repeat for the side borders (B) (Fig 6).

4 Pin and baste on the fringe close to the needlepoint. Miter the fringe at each corner and machine into place.

5 At each end of the zipper opening and with right sides facing, stitch a 2in seam, taking 1in turnings. Press the seam open. Sew in the zipper remembering to leave it open to turn the cushion through (Fig 1).

6 Pin and baste the back of the cushion to the front with right sides facing and taking care not to catch the fringe. Machine and double stitch or overlock the seams, and then turn the right sides out through the zipper opening.

Joining the English floral roses squares
Materials
Anchor Tapisserie wool
8364 (Pale pink) 12 skeins
8878 (Turquoise) 13 skeins
9314 (Olive) 21 skeins
Strong cotton thread for basting

These instructions relate to the chart on pages 150-1.

A

SINGLE
PINK
ROSE

A OVERLAPS B

MAUVE
ROSE

B

B OVERLAPS C

C

SINGLE
PINK
ROSE

5 ROWS

WHEN A, B AND C ARE JOINED, THEY SHOULD OVERLAP D, E AND F

D

MAUVE
ROSE

D OVERLAPS E

E

SINGLE
PINK
ROSE

E OVERLAPS F

F

MAUVE
ROSE

Fig 7

Fig 8

Order of working
1 Stretch the canvases
2 Lay out the canvases in the correct formation
3 Join the three canvases for the left side of the carpet
4 Join the three canvases for the right side of the carpet
5 Join down the middle to connect the two panels
6 Finish the border
7 Make up with backing fabric.

Before joining together the squares to make a rug, make sure that each of your stitched squares measure exactly the same. The chart is 120 x 120 stitches so check that your canvases also measure exactly 120 stitches square. **If not, they will not line up when joined.** Then work one row of 8364 Pale pink around each square and another row outside that of 8878 Turquoise. Stitch in TENT stitch using the wool double. Your squares will now be 124 x 124 stitches square.

1 Stretch the canvases as shown on page 183.
2 Lay out the canvases in the correct formation as shown in Fig 7.
3 Join the three canvases for the left side of the carpet. Position canvas A over canvas B so that the first three unworked rows at the bottom of A overlap the first three unworked rows at the top of B.

To make the joining easier, it is essential to baste the canvases together with strong cotton thread. To do this, we suggest that you stitch the central of the three 'joining' rows in tent stitch so that the two pieces stay in position. The three rows are then worked in 9314 Olive in TENT stitch using the wool double as before (Fig 8).

First work the row nearest to the last stitched row of A, and then the second. As you work the third row (ie that nearest the top stitched row of B) trim away the canvas, about 6in at a time, to prevent fraying. You must trim close enough so that the canvas spikes don't show when stitched, but not so close that they fray. If any canvas does show, you can touch it up with an indelible felt-tipped pen, or acrylic paint with a fine brush.

Join canvas B to canvas C in the same way.

4 Join the three canvases for the right side of the carpet in the same way, joining D to E and E to F. By now you will be an expert.
5 Join down the middle to connect the two panels. Join the left panel to the right by overlapping down the centre, and basting, stitching and very carefully

trimming as before. Be aware that sometimes you'll be sewing through four thicknesses of canvas and this will be more fiddly, but the principle is the same. Just continue to work slowly and methodically.

6 For the border, work three additional rows of the joining colour, 9314 Olive on each side, again sewing through the overlapping thickness where the canvases join. Finish with a row of 8878 Turquoise and then the outside row of 8364 Pale pink.

7 Finally, make up the carpet with backing fabric.

Materials

Carpet backing 1in bigger than the completed size of the carpet (this can be obtained from Glorafilia, see Suppliers on page 190)

When the squares of a rug are joined, you may need to re-stretch (very gently) or steam the whole thing back into shape. When it is dry, trim away excess canvas from the back, leaving several threads to prevent fraying.

Lay the carpet face downward on a table, turn back the selvages and stitch down. Then lay the backing over the carpet, smooth out and turn under the surplus of about ½in all around and stitch the edges of the backing to the edges of the rug. It is advisable to run a row of stitches across the width at about 1in from each end of the backing. This will prevent bunching.

If using Glorafilia's backing fabric, use the foam side for uncarpeted areas and the hessian side for carpeted areas.

If your carpet needs to be cleaned, we suggest you take it to a reputable dry cleaner. The backing can be dry cleaned in the same way.

Making the Christmas decorations

Materials

Three 6in square pieces wadding

Pins

¼in-wide ribbon

Three 7in square pieces felt

These instructions relate to the charts on pages 130-1.

1 Stretch the needlepoint back into its original shape (see page 183) and cut away any excess canvas, leaving ½in of unsewn canvas for turning.

2 Pin and baste a piece of wadding to the wrong side of the needlepoint. Machine, keeping close to the finished needlepoint. Trim away wadding, close to the machine stitching.

3 Sew a loop of ribbon on the right side of the needlepoints, at the top.

4 Pin and baste the felt to the right side of the needlepoint. Machine over the same machine stitching, leaving a small opening. Turn the right sides through and stitch the opening closed.

5 Press with a damp cloth.

Making the wallhanging

Materials

1yd fabric 48in wide

Tailor's chalk

Batten

2 screw eyes with ring

These instructions relate to the chart on pages 144-7.

1 Stretch the needlepoint back into its original shape (see page 183) and cut away any excess canvas, leaving ½in of unsewn canvas for turning.

2 For the side edgings, cut two strips, each measuring 2½ x 29½in, down the length of the fabric. Cut three more pieces 2½ x 20in across the width of the fabric: one each for the top and bottom edgings, and the third for the batten sleeve, then cut the backing fabric 17 x 27in.

3 Pin and baste the side strips to the finished needlepoint with right sides facing. Then do the same to the top and bottom strips and machine all of them in place, stitching close to the stitched needlepoint.

4 Press the borders flat and miter the corners. Slip stitch the miters together. Press over the border so that ½in shows all around on the right side. Miter the corners on the back. Stitch the turning down all around.

5 To indicate the position of the batten strip, on the right side of the backing use the tailor's chalk to draw two lines: one ½in from the top and the second 1in lower down.

6 Press over the turnings of the batten strip so that it is 1½in wide. Pin and baste it onto the top of the backing along the chalk lines. (The sleeve will be loose to make room for the batten.) Neaten one end by making a pleat with the excess fabric and then carefully machine into place.

7 Baste the backing onto the back of the wallhanging, turning the lining under so that ½in of binding showing. Do this all the way around and slip stitch into place.

8 Very carefully on the right side, machine along the seam of the top border so that it doesn't show. Feed the batten in place, neaten the opening and screw in the hanging rings 1½in from each end.

Fig 9 Cutting pattern for the tea cosy.

Making the tea cosy

Materials

28in fabric 48in wide

White tailor's chalk

Wadding

Pins

No. 3 piping cord to go around the tea cosy

These instructions relate to the chart on pages 148-9.

1 Stretch the needlepoint back into its original shape (see page 183).

2 To quilt the backing, mark the fabric using the tailor's chalk. Draw diagonal lines 1½in apart in both directions to form a diamond pattern. Put the needlepoint onto the wadding, pin and baste in place. Machine along the lines.

3 Cut away any excess canvas, leaving ½in of unsewn canvas for turning. Then, using the needlepoint as a pattern, cut out the back and the lining making them the same size (see the cutting pattern, Fig 9 below left). Also cut out sufficient bias strips of fabric to go around the tea cosy and then pipe (see the simple piped cushion on page 184). Add a loop of the same fabric to the top of the tea cosy.

4 Pin and baste the needlepoint to the backing fabric with right sides facing and machine into place, keeping close to the finished needlepoint. Turn up the bottom and oversew.

5 Pin and baste the two pieces of lining with right sides facing and machine together around the outside edge with a ½in turning. Fit the lining inside the tea cosy, turn up the bottom of the lining and then slip stitch together.

Covering the footstool

Materials

Footstool 25 ½ x 15 ½in top area x 7in drop (can be obtained from Glorafilia)

⅜in tacks

Circular needle

Strong thread

20in lining fabric

50in braid 1½ in wide (optional)

These instructions relate to the chart on pages 168-70.

1 Stretch the needlepoint back into its original shape (see page 183). Then unscrew the legs from the stool.

2 Place the needlepoint face down on a table and center the padded stool top onto the needlepoint with the underside facing you. Pull one of long sides of the needlepoint over to the underside and temporarily tack in place. Do the same to the other long side.

3 When the needlepoint is smooth and even on the top, tack it to the underside of the stool with the tacks, ½in from the edge and ¾in apart. Before doing the same to the short sides, cut the excess canvas from the corners leaving ½in turnings. Fold in the turnings to make neat corners.

4 With the circular needle and strong thread, slip stitch the corners together. Trim away the excess canvas and neaten the base with the lining.

5 Screw in the legs. Glue braid around bottom edge of the footstool if desired.

Making the koalas

Materials

Pins

17 x 20in gray or black felt

Tracing paper

Cushion stuffing

These instructions relate to the charts on pages 158-60.

1 Stretch the needlepoint back into its original shape (see page 183) and cut away any excess canvas, leaving ½in of unsewn canvas for turning.

2 Place the needlepoint on the felt, sewn side down and pin together. Cut out the felt to the shape of the design (including the ½in unsewn canvas).

3 Take a tracing of the pattern (fig 10) for the base, then cut a piece of felt of the same shape. Baste one half of the bottom of the design onto the base. Baste the design to the felt backing, leaving the other half of the base open, and sew into place.

4 Clip all inward shapes of canvas so that it will lay flat when turned to the right side. Turn to the right side and stuff as firmly as required. Then close the opening using slip stitch.

Fig 10

Acknowledgments

Our thanks to Coats Crafts UK for supplying us with yarn and for their help with this project. A special thank you to Alastair McMinn. Thanks to our team of superb stitchers who have worked miraculously to deadline: Mary Clark, Andrea Cooper, Josephine Farhoumand, Clare Goddard, Vicki Henley, Daphne King, Christine Simpkins, Joyce Talbot and Barbara Williams. To Michele Hockley, Sandra Joseph and Sally King for tolerating our invasion of their homes and gardens with the paraphernalia that photography involves, to Shirley Lister for lending us the silver tassel chair (page 30), Judith Todd for the Aborigine wallhanging (page 53), Anne Miller for the Elizabethan figure (page 31), Constance Stobo for the Staffordshire animals (pages 70-1), and the Gallery of Antique Textiles. Our huge thanks to the following for their agreeing to our disruptive photography on their premises: Christopher Moore (Antique Toiles), 1 Munro Terrace, Cheyne Walk, London SW10 0DL; Church Farm House Museum, Greyhound Hill, Hendon, London NW4; Little Holland House, 40 Beeches Avenue, Carshalton, Surrey; Sutton House, 2/4 Homerton High Street, Hackney, London E9 6JQ; The Mill Hill School, Mill Hill Village, London NW7; Joss Graham Oriental Textiles, 10 Eccleston Street, London SW1. Special thanks to David Jordan, who took our photographs with such serenity, and to Denise Bates and Emma Callery at Ebury for their unwavering confidence!

Suppliers

Yarn

Coats Patons Crafts
89-91 Peters Avenue
Mulgrave
Victoria 3170
Australia

Coats Canada Inc
1001 Roselawn Avenue
Toronto
Ontario M6B 1B8
Canada

Coats & Clark Inc
PO Box 24998
Greenville SC 29616-2498
USA
Telephone: 800 243 0818

Coats Enzed Crafts
PO Box 58 447
Greenmount
Auckland
New Zealand

Footstools

Glorafilia Ltd
The Old Mill House
The Ridgeway
London NW7 4EB

Cushion/framing service

Glorafilia, as above

MATERIALS AND KITS SERVICE

Glorafilia can provide all the materials needed to complete each project in this book: canvas cut to size and taped at the edges, the correct needles, enough yarn to complete the design, and various items of equipment that you may need, including cords and tassels. Some of the designs are available as complete kits. If you would like to receive information on which designs are available, or to order materials directly, write to Glorafilia at:

Glorafilia Ltd
The Old Mill House
The Ridgeway
Mill Hill Village
London NW7 4EB
Telephone: 0181 906 0212
Fax: 0181 959 6253

Glorafilia Ltd
510 Weadley Road
King of Prussia
PA 19406
USA
Telephone/fax: 610 688 4864

Index